Cambridge 9/4/91

An ancient Greek vase is a difficult object for the non-expert to come to terms with. Faced with rows of apparently undifferentiated black, red and buff pots, he or she is at a loss as to where to begin. Greek vases are treated as *objets d'art* in the modern world, but how much were they worth in the ancient? They are often used to demonstrate 'the Greek genius' and aspects of ancient Greek society, but why do many of them carry Eastern motifs, and why do so many turn up in Italy? Why were the Greeks not content with simple patterns on their pottery? What did the pictures on the pots mean to them? Why should a vase depict a scene from a play?

These are the sorts of questions that this book attempts to answer. As the title implies, it is a series of 'looks' at Greek vases, offering suggestions on how to read the often complex images they present, and also explaining how they were made and distributed. Chapters have been contributed by a distinguished team of scholars, who have written with a wide readership in mind. The book is intended to be read by students of Greek art in universities and schools and also by museum-goers and any one who feels curiosity about the society and history of ancient Greece.

Looking at Greek Vases

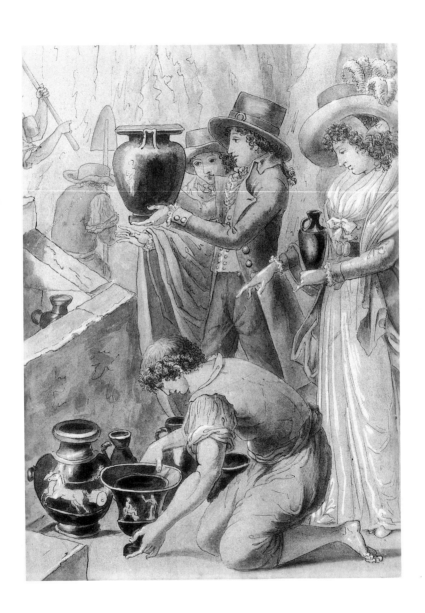

Looking at Greek Vases

EDITED BY TOM RASMUSSEN
AND NIGEL SPIVEY

The right of the
University of Cambridge
to print and sell
all manner of books
was granted by
Henry VIII in 1534.
The University has printed
and published continuously
since 1584.

CAMBRIDGE UNIVERSITY PRESS

Cambridge
New York Port Chester
Melbourne Sydney

Published by the Press Syndicate of the University of Cambridge
The Pitt Building, Trumpington Street, Cambridge CB2 1RP
40 West 20th Street, New York, NY 10011 USA
10 Stamford Road, Oakleigh, Melbourne 3166, Australia

© Cambridge University Press 1991

First published 1991

Printed in Great Britain at the University Press

British Library cataloguing in publication data

Looking at Greek vases.
1. Greek pottery vases, ancient period
I. Rasmussen, Tom II. Spivey, Nigel Jonathan
738.3820938

Library of Congress cataloguing in publication data

Looking at Greek vases / edited by Tom Rasmussen and Nigel Spivey.
 p. cm.
Includes bibliographical references (p.) and index.
ISBN 0 521 37524 X (hard). – ISBN 0 521 37679 3 (pbk.)
1. Vases, Greek. I. Rasmussen, Tom II. Spivey, Nigel Jonathan.
NK4645.L66 1991
738.3′82′0938–dc20 90–2568 CIP

ISBN 0521 37524 X hardback
ISBN 0521 37679 3 paperback

BT

To Robert Cook

Contents

Preface

Greek vases are important. Even in a culture such as our own, enslaved to the lords of cash and quick profit, the importance of Greek vases can be measured in terms of the millions of dollars, pounds and yen annually expended in their trade. The museums of the world, from London to Tasmania, Moscow to Osaka, are stocked with Greek vases. Men go to jail for the sake of Greek vases; academic careers are constructed on expertise in Greek vases; and exceptional students of Greek vases may receive knighthoods.

Greek vases are probably more important now, artistically and commercially, than they ever were in antiquity. This is partly due to their technical accomplishment: although some good forgeries have been produced, it remains extremely difficult, even with the benefit of twentieth-century machinery, to reach the standards of potting and draughtsmanship set over two thousand years ago by the rude mechanicals of sixth- and fifth-century B.C. Athens. But the importance of the vases is also perpetually bolstered by the images they present. Ways of seeing vary from century to century, decade to decade. What was esteemed under George III is reviled under Elizabeth II. What the Marxist art historian of the seventies saw on a Greek vase is not what the feminist of the nineties may see. So the title of this book, *Looking at Greek Vases*, is bound to be confined to some extent by current aesthetics: but we have tried to include variations of angle and perspective, and the book opens with a discussion, by Martin Robertson and Mary Beard, of possible lines of vision. They weigh up the values of two disciplines: attributing Greek vases to painters, and interpreting what was painted on Greek vases. The former enterprise has to a large extent already been accomplished;

which leaves us to attempt the iconology, the 'image-reading' involved in the sensible interpretation of what the painters have left us.

Greek vases mean different things to different people, and the truth is that they would have done so at the time when they were made. Museum-goers may be puzzled that Greek vases on display seem nearly always to bear a label of Italian provenance. Why, if such-and-such a vase was made in Athens, and can be given an Athenian meaning, does it figure amongst the treasured possessions of an Etruscan buried at Vulci? Readers who admit to being puzzled should perhaps begin with Alan Johnston's contribution, 'Greek vases in the marketplace', where an explanation is given of how the vases travelled, and proceed backwards to Nigel Spivey's essay, which focuses upon Etruria as one popular destination of Greek vases, and speculates on the 'Etruscan' meanings that may consequently have been fixed upon them.

The rest of the book is ordered more or less chronologically. *Looking at Greek Vases* is what it claims to be: a series of 'looks', not a comprehensive handbook of the development of styles of Greek vase-painting. We commissioned internationally recognised experts to divulge some of their expertise upon themes of enduring or topical interest: and since the 'figures' on Greek vases are the principal objects of attention, the first 'look' comes from Nicolas Coldstream, and is directed at the earliest properly figurative painting by the Greeks. In the context of this book, it is quite right to subtitle Coldstream's chapter 'birth of the picture'. Once born, the picture grows: in its eventual maturity, plenty of lookers at Greek vases will agree with the pronouncement: 'You cannot draw better, you can only draw differently' (made by J. D. Beazley). But to present Greek vases as achieved solely by that much-invoked force, 'the Greek genius', would be foolish and false. Though the Greeks were well aware of their Hellenic identity, they were open to influences from outside: indeed, some of the best-known painters of Greek vases were outsiders or 'metics'. So Tom Rasmussen's chapter on 'the Orientalising phenomenon' at Corinth is concerned with one good example of Greek receptiveness: whether you call it 'genius' or something else, the Greeks had the gift for transforming what they received into a distinctly Hellenic product.

The Greek vases with which the world is most familiar belong to the period addressed by the central contributions of John Boardman,

Dyfri Williams and Lucilla Burn. One modern attitude towards the vases of this period would make them mere mirrors of what silversmiths were producing: but since the work of Athenian silversmiths has not survived, this attitude does not get us very far. The black- and red-figured vases of Athens that span the years from Solon to Socrates are often used as illustrations for the history of Athens in the sixth and fifth centuries B.C.: it may be that neither Solon nor Socrates ever cared a biscuit for the potters and painters of vases, but without the images of Athenian vases there would be large gaps in our knowledge of Athenian society. The supposed silver vases have gone; the wall-paintings have gone; but thousands of vases survive, and some ancient historians are using their images not just for book covers but as primary documents – witness Kenneth Dover's *Greek Homosexuality* (1978), or Eva Keuls' *The Reign of the Phallus* (1985). In a period active with experiments in politics, art, literature and philosophy, it is tempting to elevate the vase-painters into men of genius, though we know that pottery was only a modest sibling of a highly creative family; but in their examination of the vases, our contributors keep one eye on what is happening outside the Kerameikos, 'the potters' quarter', of ancient Athens.

Iconology is a project that involves more than simply providing a picture with a caption, or furnishing a text with an illustration: but there is a hierarchy of media which determines that pottery will always occupy a lesser position than a play, a temple pediment, or a mural. Even the most committed admirer of the most-admired Athenian black-figure painter, Exekias, would hesitate to claim that a painting by Exekias of Ajax contemplating suicide could later inspire Sophocles to write a soliloquy for that moment. Vase-painters were not slavish imitators, and some may move us with their powers of figurative expression: but essentially we are bound to see their work as reflective, or supportive, of other media. In that capacity, looking at Greek vases is valuable even to those who are not particularly interested in ancient art. As Dale Trendall demonstrates in his contribution, 'Farce and tragedy in South Italian vase-painting', images on pottery illustrate not only dramatic texts with which we are well acquainted, but also some plays that have not survived as texts.

The discovery of Greek vases is a process of archaeology, and the refined chronology evolved for the styles of potting and painting has enabled many excavators of Classical sites to establish sequences of occupation. But not all Greek wares have been studied with the same

degree of refinement: one scholar who has remedied the imbalance is John Hayes, who here tackles the problems posed by Hellenistic pottery. As the decoration fades away, or becomes less complex, so attention turns to the contexts in which the various shapes of pottery were found: in sanctuaries, graves, boudoirs and kitchens. And we finish where perhaps we should have begun: in the potter's workshop, with a practical view from Jaap Hemelrijk of how the vases were made.

Hemelrijk may be the only one of the authors ever to have sat at a potter's wheel; but he is not alone in being a former pupil of Robert Cook. *Looking at Greek Vases* was conceived from a sentiment: a toast of gratitude to Robert Cook, Emeritus Lawrence Professor of Classical Archaeology at Cambridge, from his former students, colleagues, friends and sometimes opponents. His own handbook of *Greek Painted Pottery*, first published in 1960 and still available in its second edition (a third is being prepared for a Greek audience), may consider itself both complimented and complemented by *Looking at Greek Vases*. Robert Cook taught his pupils to regard new ideas with scepticism, but not unduly to venerate the old; and if our collection of essays lacks consensus, then that is a feature of which Robert Cook would approve. He would certainly not have approved of a traditional *Festschrift* (his favourite book is *Candide*, and his favourite character from that book is probably Pococurante): instead of that, we have tried to make a book which will serve not only scholars, but also students of art, connoisseurs of fine pottery, the museum-going public, and anyone who admits curiosity about the society and history of ancient Greece.

Our thanks are due to those who gave their time to write and illustrate this book; to the museums and institutions that allowed us to use their vases as exemplary pieces; and to Pauline Hire at Cambridge University Press, whose support and shaping of the book has been fundamental.

Tom Rasmussen
Nigel Spivey

Feeble pottery has ever borne the impress of man more vividly than marble. From these they quenched their thirst, over these they laughed and joked, and gossiped, and sang old hunting songs till the rafters rang, and the dogs under the table got up and barked.

Richard Jefferies

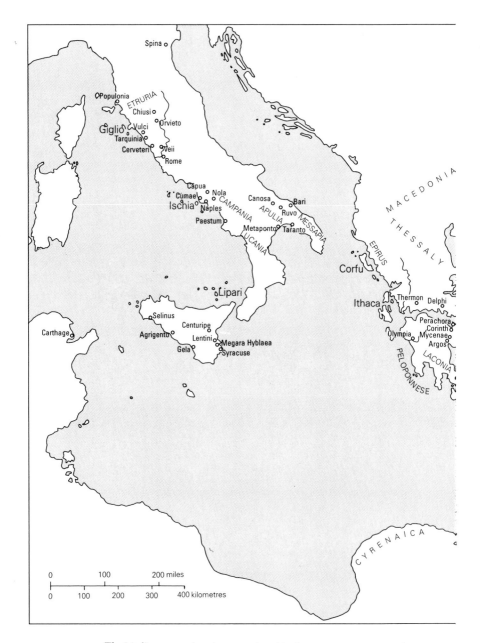

The Mediterranean: locations mentioned in the text

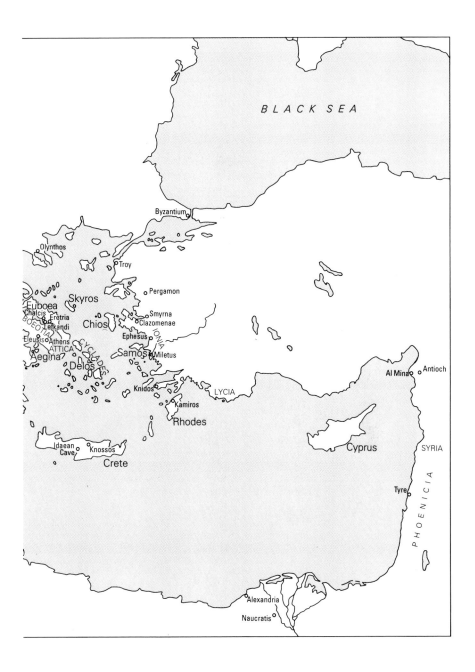

BLACK SEA

Byzantium

Olynthos

Troy

Pergamon

Skyros

Euboea
Chalcis Eretria Smyrna
BOEOTIA Lefkandi Chios Clazomenae
Eleusis Athens Ephesus
ATTICA CYCLADES IONIA
Aegina Delos Samos Miletus

Al Mina Antioch

Knidos LYCIA

Kamiros SYRIA

Rhodes Cyprus

Idaean Knossos Tyre
Cave

Crete

PHOENICIA

Alexandria

Naucratis

1

Adopting an approach

I *MARTIN ROBERTSON* II *MARY BEARD*

I

One approach has been for long the most generally accepted determinant for the study of Greek vases: that of Beazley. Sir John Beazley (1885–1970; professor of classical archaeology and art at Oxford from 1925 until 1956) initiated in the earlier years of this century a revolution in the study. The basic principles of this approach are that it is possible on stylistic grounds to distinguish the hands of individual vase-painters; that they are as worthy of study in this way as the better documented artists of other periods; and that this way of ordering the material clarifies the field better than any other and opens it better for the study of other aspects. Beazley himself applied the idea first to Attic red figure, later to Attic black figure; and others have applied it to the products of other centres.

I adopted this approach myself at the beginning of my career and have worked in it for more than fifty years; and, though it is now under attack from several quarters and I feel great cogency in some of the criticisms, I still believe that it was not only of immense importance in its time but is of great value still – though without question many other ways of looking at the material are needed alongside it. I take it as my brief in this volume to justify that belief; but at the same time I shall point to certain things in this way of approaching the study which do seem to me to produce bad results; and to ways in which these can be got rid of without throwing the baby out with the bath-water as some of Beazley's critics would do.

It happens that I am at present working on a book on Attic red figure, or more precisely on the art of vase-painting in Athens over the period when red figure was produced there (about two hundred years, from the later sixth to the later fourth century B.C.). It is a book I have

thought of writing for many years, but had I written it even ten years ago it would have been distinctly different from what it is shaping as now. It is still based on Beazley's conception of the development of Attic vase-painting in terms of interacting artists whose styles illustrate and define the style of their time; but the approach is modified both after the criticisms of others and through discontents I myself feel. I hope that writing this chapter will give me insights into how to manage that; and at the same time that the particularities of that task will lend substance to what I have to say here.

When Beazley published the article 'Kleophrades', in the *Journal of Hellenic Studies* for 1910, he had already conceived the notion of assigning the majority of the pictures on Attic red-figured vases to individual painters, and so putting the study on the same footing as that of Italian Renaissance painting. From students in that field, like Morelli, he took the method of comparing detailed renderings in the drawing of ears, hands, musculature, drapery-folds and so on, but it is not this method that defines Beazley's work. That is only a particular application of the one basic method all art historians and archaeologists must employ: to look hard at objects, and think hard about what one sees. It is the *approach*, equally taken from Morelli and his companions, that is significant: the notion of studying a class of art-works in terms of the styles of individual artists. It was the likening of Attic vase-painters to the painters of wall and panel in late mediaeval and early Renaissance Italy that inspired Beazley to his achievement. An immensely valuable achievement for the study of ancient art I believe it to have been; but I believe also that the premise from which Beazley started ignores a profound difference between the two manifestations of art, and that failure to recognise this difference has had bad consequences for the study.

I said that the book I am engaged on is about 'the art of vase-painting'. That the best Greek vase-painting can properly be described as art I firmly believe; but the term and the concept are fraught with problems. A verbal distinction between 'craft' and 'art' was never made in antiquity, nor in the Middle Ages or early Renaissance; not, I think, before the early sixteenth century. That the distinction was not verbalised must mean that it was not clearly thought out; but that something had existed, for ages before the verbal distinction was made, on to which we can properly extrapolate our conception of 'art' seems to me absolutely certain. Mediaeval and Renaissance painting and sculpture certainly qualify, and so does

sculpture (and painting too, only so little of it survives) in ancient Greece; but vase-painting cannot without significant reserves be placed in the same category.

Painting and sculpture in trecento and quattrocento Italy were seldom or never 'art for art's sake'. They had always some ulterior purpose, generally religious; and the same is no less true of these arts in ancient Greece. Nevertheless, in Greece and Italy alike, they served those purposes by purely artistic means. A painting or a carving, even if it adorns an object made for practical use (a building or a chest), makes its effect simply by being the work of art it is: picture, statue, relief. This is far less true of a vase-painting. A pot is a utilitarian object which may or may not be decorated, and if there is decoration it may be of a summary or conventional kind which one would not think of qualifying as art. The finely drawn figures which one finds on some Greek vases, often combined in quite complex compositions, are a truly abnormal phenomenon. To my eye they are unquestionably art; but that art does not carry the whole craft with it, and it remains an anomalous area with blurred edges. It is not only that the true artists are a small number among the many craftsmen who are not; it is also the case that these artists are themselves at the same time, indeed primarily, craftsmen like their fellows, engaged in a utilitarian production, and a great deal of what they produce belongs to that aspect of their work.

Beazley himself was in no doubt about the variation in quality, both between his painters and within one painter's work. He found, however, that 'Morellian' principles for distinguishing hands could be applied all across the board, to the worst as to the best, and he did so apply them. That he evidently continued while he did so to think of his pot-decorator painters as a strictly parallel case to the painters of Italy seems to me to have led to a distorted view of the relation of this craft to the history of Greek art. It can be asserted as a rough generalisation that before Beazley's work only vase-pictures of a certain quality were given consideration in that history; and I feel that an effect of what he did has been to lift the whole craft to a position there which it cannot really sustain. Of course there are very many good reasons for studying Greek pottery and vase-painting that have nothing to do with the history of art, and at some of these I shall glance later. In the study of any culture, however, the history of its art is at least as important as any other approach, and vase-painting has a real place in the history of art in ancient Greece. This is the aspect of

vase-painting in which I, like Beazley, am most interested, and so I will stick with that for the present.

I spoke of blurred edges; and the distinction I have made between 'true artists' and the rest is a simplification. Not a very large number regularly touch real heights; others do so occasionally; yet others seem to have that kind of aspiration; while very many more seem content with more or less careful or careless repetition of conventional designs; and there is a great deal of really bad hackwork. Looking at the upper levels, though, we see that Beazley's view presents the artistic side of the craft as the work of individuals whose styles influence others. He seems to me to have established this beyond doubt as the case; and I believe that this is of importance for the study not only of vase-painting but of Greek art in general.

Greek thinkers had great powers of generalisation; but another no less striking aspect of their thought is an intense individualism which loved to express itself in terms of personal rivalry and achievement. Everything had to have an 'inventor'. Epic may have begun anonymously, but later tradition was most anxious to personalise it. The lyric poetry of the seventh and sixth centuries is the work of named individuals who express themselves in passionately personal language. The dramas produced at festivals of Dionysos in fifth-century Athens were presented in cut-throat competition by named poets whose approaches and styles were the subject of strong partisan interest. Obsession with sport is one of the few aspects of Greek culture I find really boring; but its victor-lists, victor-statues, broken records and so on are another illustration of the cult of personality, so noticeable too in Greek politics. A plethora of signed statue-bases bears out the literary tradition that this was just as true in the visual arts; but so little major sculpture (and much less painting) survives that we cannot often see the development in personal terms. Whatever contemporary Athenians may have thought of their painted pottery, the series of black-figure and red-figure vase-pictures is something which has come down to us in bulk; and, thanks to Beazley, we can see it in terms of the mutual influence and rivalry of individual artists, so that it serves as an exemplar of what we are missing in the major arts. That vase-painters and potters themselves thought like this is suggested by the way many of them sign their names and occasionally address remarks to one another.

What *did* contemporaries actually think of this craft? An interesting question, but one to which, it seems to me, only the most tentative

and doubtful answers can be offered. That there is next to no reference to it in surviving literature is surely not surprising or significant, given the tiny proportion of contemporary writing that has come down to us, and its nature; but it does make the question harder to answer. Clearly, painted pottery was a relatively inexpensive line of goods, a fairly humble craft; but the idea which one sometimes sees expressed, that it was of no account at all among well-off Athenians seems to me incompatible with observable facts. Drawing of the skill (and sometimes the minute elaboration) found in the best work simply does not get done if there is no appreciative clientele. That the customers for Athenian painted pottery were not of the poorest is suggested by the occasional application of gold leaf on small details in

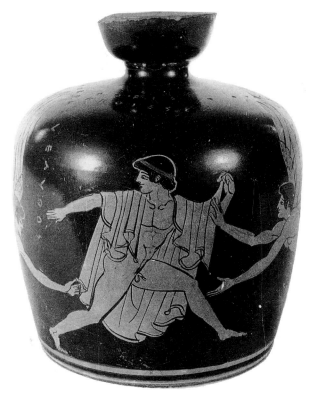

1. Attic red-figure aryballos. Boy between Erotes. Signed by Douris as potter and attributed to him as painter. First quarter of fifth century B.C. Ht 10 cm.

added clay. This is found on some early red-figure cups (for instance by the late sixth-century Euphronios and an early fifth-century painter who has not left his name but is known as the Brygos Painter after a potter with whom he regularly worked) as well as later.

Some inscriptions on vases seem to point the same way; I think in particular of two. An early fifth-century red-figured oil-flask (Fig. 1), with a pretty picture of a boy pursued by a winged Eros with a whip while a second opens his arms to protect him, was found in a grave in Athens. The picture was certainly painted by Douris, who has left his name as painter on some forty vases – though this one he signs as potter. The signature was painted on, in the normal way, before the vase went into the kiln; and at the same time another inscription was added, stating that the oil-flask belongs to Asopodoros. Clearly this was a bespoke vessel, which the owner kept till he died, when it was buried with him.

The second inscribed vase which I would cite in this connection was also made in Athens but some fifty years before. It is a black-figure bowl for mixing wine and water (Fig. 2), now fragmentary, which was found at Cerveteri in Etruria, the ancient Caere. The Etruscans imported a great deal of Attic pottery, but at Caere there was also a Greek settlement, Agylla. The picture is of warships, painted within the rim so that they might appear to be floating when the vessel was full (Fig. 2a). It is certainly from the hand of the painter-potter Exekias, though this vase too bears the signature only as potter. The inscription this time is not painted but incised after firing on the black shoulder of the vase (Fig. 2b). This time too there is a second inscription (Fig. 2c), done in the same way and in the same very neat, strong hand, on the opposite side of the shoulder; surely put there by

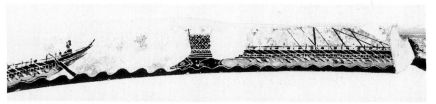

2. Attic black-figure dinos (details). Within the rim, warships. Inscribed as a gift from Epainetos to Charopos. Signed by Exekias as potter and attributed to him as painter. Third quarter of sixth century B.C.

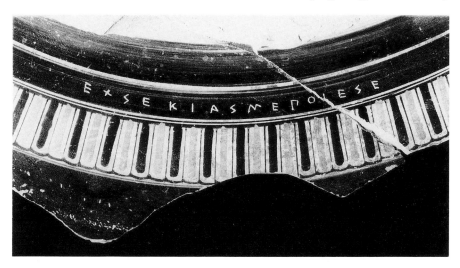

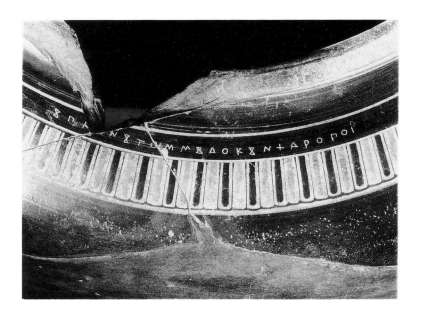

Exekias at the same time as the signature. This states that Epainetos gave the vase to Charopos. While the signature, however, is in the Attic alphabet, as are all other inscriptions on vases by Exekias (all painted before firing), the gift inscription uses two letter-forms, for E and S, which were not in use in Athens. Both were regular at the Peloponnesian city of Sicyon, this form of E nowhere else. There is only one natural explanation for this document. Epainetos came to Exekias' shop and said 'I'll take this one, but I want your signature, and also this other inscription' and gave him a copy in the Sicyonian alphabet. Charopos or Epainetos or both must have been Sicyonian; and either Charopos went to Agylla taking the bowl with him, or he in turn gave it to another friend, or it is evidence for a trade in second-hand vases, as prize pots from the Athenian games found in Etruria seem to be.

With these questions we are moving away from art history, and it is a good moment to consider the value of Beazley's work in other areas. His groupings are obviously of great significance for the study of the organisation of the potters' quarter. Whatever the importance of pottery in Athens relative to other forms of production and trade, it is certainly the area for which most evidence is available, so that anything which helps in its study takes on a more general application. In this aspect the isolation of hands among vase-decorators and the relation of one to another are important for the estimation of numbers of workshops and of numbers of people employed in one workshop. Important research is being undertaken on unfigured black-glazed pottery and its relation to metalwork. It is evident that these black vessels were produced in the same workshops from which red-figured pieces also issued, so that the grouping of red-figured vases by painters, and the relations between those painters, has a direct value for this study. The distribution of the work of different painters over the sites of the Mediterranean world may also have a bearing on the analysis of trade. I spoke just now of a trade in second-hand vases; but, though there does seem to be evidence that such a trade existed, it was surely trivial compared with the trade in new vases direct from workshops. It is sometimes suggested that the price of pottery was so low that trade in it can have been of very little importance, that it served mainly as ballast or 'ballast-cargo'. Since pottery is lightweight (this is especially noticeable in the thin-walled fine Greek wares) and takes up a very large space in proportion to its weight, and is of course also very breakable, it would seem an odd choice for this purpose.

However, even if it were so, and its distribution mainly of indirect interest for other lines of trade, the more we can learn of the details of that distribution the better.

I put in these notes to remind us that in the study of the ancient world art history and archaeology are inextricably bound with one another, and it is foolish for specialists in one side to ignore findings in the other; but undoubtedly the major significance of Beazley's work is for the history of fine art.

Apart from a fascinating foray into Etruscan vase-painting, Beazley almost confined his work to Attic: red figure, white ground and black figure. Others have applied the same approach in other areas: South Italian red figure; Laconian, Chalcidian and Caeretan black figure; Corinthian and Protocorinthian; Fikellura; Attic Geometric; and there are yet more. The red-figure fabrics of South Italy and Sicily show a scale of production and a range of quality which make them closely comparable to Attic; and much of what has been said about Beazley's work is applicable to Trendall's in this field. In the other cases a far smaller number of figure-painters is involved. In most there are fine examples of drawing (in Protocorinthian, in particular, very fine indeed), which gives them a place in the history of art; but because of their narrower range the application of Beazleyan methods in their study is less significant.

To sum up: it seems to me not only good that Beazley and his followers have done what they did, but essential that the work should continue. True, the basic art-historical structure has been established, the principal artists defined; the work that remains to do is partly different. There is much, especially, to be done on relations between painters; but attribution is still important too. Beazley of course was not always right, as he showed that he knew by changing his mind quite often, sometimes in the light of new discoveries, sometimes simply by rethinking. New discoveries continue to raise new problems and spark new insights; and new minds at work on old material produce both too. Beazley established an art history for Attic vase-painting, and it is there not as a monument but as a field to be worked in: a one-man art history must be sterile. The main work *has* been done, though, and other approaches are and should be in the forefront of the study now. My argument is that it is a mistake, indeed a folly, to ignore Beazley's approach and achievement. They are still valid, still central to the study, alongside other ways of looking and thinking. One may note also that concern with attribution is

something which by its nature makes one look very hard at each individual vase, and this is a good foundation for studying it in other ways.

Among such studies iconography is of course of major importance (as Beazley was well aware). It is an approach in which I myself have become increasingly interested, though here too my interest is of rather an old-fashioned kind. I am concerned to reconstruct, through the fragmentary remains of literature and art, how particular stories developed and changed, the forms they took at different periods. I recognise that there may be a deeper interest in questions which arise after that: How did the Greeks of any given time and place view the myths and legends? What did they value in them? How did they make use of them? But for such questions to be intelligently asked, so that tentative answers (they can never be more than tentative) may be offered, the other approach is a necessary prerequisite and must never be neglected.

I further believe, what is now sometimes questioned, that any narrative scene on a Greek vase was intended to illustrate a particular story about particular, named people. An example for which I have heard it suggested that the painter simply drew something out of his head is on a white-ground cup in the British Museum (Fig. 3). This is by an anonymous painter who worked with an outstanding potter, Sotades, and so is known as the Sotades Painter. The picture, from which fragments are missing, shows a monstrous snake rearing up among vegetation and breathing smoke or flame, a man throwing a stone at it, and part of a fallen figure. The Sotades Painter is one of the true artists I have spoken of; at his best he is a great draughtsman by any standard. His drawing, though on a miniature scale, must give one some notion of the style of the famous wall-painters of the period, the second quarter of the fifth century. To judge from other works of his, in which figures are sometimes named, he had a taste for recondite myths; or at least myths which seem to us recondite since they do not figure prominently in surviving literature and few artists illustrate them. The scene on the cup is hard for us to identify. Many names have been suggested, but all leave problems. I am attracted by a recent suggestion of Lucilla Burn, that the fallen figure is Eurydice, the man Aristaios, but this too is unproven. In any case, however, I feel sure that the Sotades Painter intended a specific legend and could have named names; hardly less sure that any vase-painter, however ignorant, would have said that any narrative scene he drew illustrated

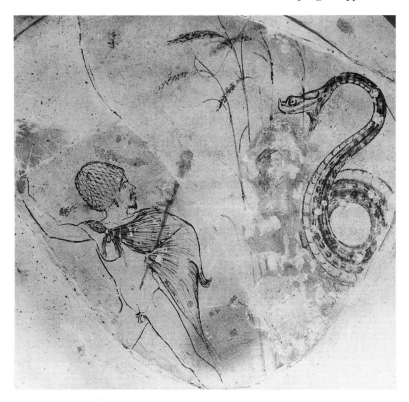

3. Attic white-ground cup. Unidentified scene. The potting attributed to Sotades and the painting to the Sotades Painter. Second quarter of fifth century B.C. Ht of field *c.* 7 cm.

a known story, even if he could not himself tell the story or name the actors.

In all these approaches we are evidently trying to put ourselves in a position to see the pictures on vases as nearly as possible as contemporaries saw them. Much of our work is geared in that direction, trying to get inside the skins of the people we are studying (the recognition of vase-painters' individuality is, as we noticed, a step that way). This is surely an important exercise; but it is surely not the only, or necessarily the most important, way of approaching the past. It is rather like playing early music on period instruments. It may be possible to reproduce with some exactitude the sounds that fell on the ears of Mozart's first audiences. This is an interesting thing to do; but

the exercise becomes a delusion if we suppose we are doing more, are actually hearing the music as those first listeners heard it. That is impossible, because Mozart's music is for us part of the whole body of music of which we are conscious, including Beethoven and Wagner, Schönberg and Britten. Given this inexorable change in musical sound and our appreciation of it, it seems to me likely that we can, for ourselves in our own time, better appreciate Mozart's full range and power if we hear his music played on instruments perfected since his time than we can by hearing it on those he had to make do with. It is good to try to get back to what Homer and Archilochus and Aeschylus meant to their contemporaries (and what Homer and Archilochus meant to Aeschylus' contemporaries, or all three to Callimachus in the Library at Alexandria); but for ourselves it enriches our appreciation of them to remember Dante and Villon and Shakespeare when we read them. In the same way we appreciate Exekias and the Sotades Painter better, and do better by them, if we view them among draughtsmen of the world – Botticelli and Rembrandt, Utamaro and Degas.

II

I am not sure that we are ever quite sufficiently surprised at our capacity to read images. (E. H. Gombrich, *Art and Illusion*, 34)

Making sense of what we see is difficult. As Gombrich suggests, we tend to take the process of 'reading images' very much for granted. We forget that images do not speak for themselves and that it takes years of practice to be able to understand even a very simple picture. It is not just a matter of learning the technical conventions of representation (such as perspective) – although that is certainly a part. It is more a matter of learning enough about our own culture and patterns of communication to give a meaning to the images we see and to make appropriate connections between those images and our own experiences, values and beliefs.

Understanding the images around us

Imagine that you are looking at a magazine advertisement for a particularly expensive brand of French perfume. There are no words

in the picture. The brand is so famous that it needs only the first few letters of its name visible on the bottle that stands at the foot of the page. The rest of the picture, extending behind and above the discreetly packaged product, is the distinctive scene of an up-market Parisian restaurant, at which a young and successful French business-woman is enjoying an increasingly intimate lunch with a glamorous young designer, or maybe architect. The advertisement works by playing rather crudely on our fantasy that this particular fragrance will make us too part of the romantic cosmopolitan life pictured in the restaurant. But more interesting than this obvious technique of enticement is the complex series of deductions we must make, the set of cultural clues we must decipher in order to *read* the scene at all: the definite signs of 'Frenchness' in the marble-topped tables and the long-aproned waiters; a glimpse through the open window of what must be part of the Eiffel Tower, symbol of Paris itself; a briefcase, rather than a handbag, at the foot of the immaculately dressed woman, marking her out as a woman of business not (only) of pleasure; a portfolio of drawings resting against the chair of the more casually dressed man – an artist of some sort, whose foot (as we can observe under the table) is moving ever closer to his companion, while his hand reaches out almost to touch hers.

This is a familiar kind of image and a familiar story. We can probably register the significant details in a split second and get the point without much conscious thought. We do it literally hundreds of times a day. But that process of recognition and understanding, however instantaneous, however common, is not 'natural' – we do not 'naturally' appreciate the different significance of a briefcase and a handbag! It is a process that depends on our having *learned* to look and on long-practised skill in the decipherment of visual and cultural signs.

Our reading of images is not, of course, just a question of decoding one single meaning. The interpretations of images change in different contexts, with different viewers and according to our different expectations. Let us return to the Parisian restaurant. Imagine now that the perfume bottle has been removed from the bottom of the page. In its place there are just two words: 'AIDS kills'. What now happens to our reading of the scene? Some things, to be sure, do not change. We still identify Paris. We can still decode the occupations of the man and woman concerned. But the gesture of his hand as it moves towards hers no longer seems part of a romantic approach. It is

comforting, or perhaps poignant. And the rich Parisian setting is no longer resonant of enviable glamour and high fashion, but of sadness, even transgression, behind the lavish façade.

'Meanings' of pictures are necessarily plural. No female nude pinned up in a rugby club can ever signify quite the same as in an art gallery. No Muslim understands an image of the Crucifixion in the same way as a Christian; no Catholic, for that matter, in quite the same way as a Protestant. We may prefer one reading to another. We may be able to reach broad agreement within our own group on what a particular picture is 'saying'. We may even have reason to believe that one reading is closer than another to what the artist originally 'intended'. But we must nevertheless recognise that images are being constantly interpreted and reinterpreted. Their meanings proliferate.

Learning to look is as vital as learning to read. Without the skills of visual understanding and visual recognition, we would be strangers in our own country. This is partly a matter of practical day-to-day living – knowing that a red light means 'stop', or recognising the direction of the hands on a clock-face. But it extends much deeper in our cultural traditions than that. Power, prestige, religious beliefs, politics, history, national pride are all expressed in visual symbols. Think, for example, of the portrait of the Queen on British coins: partly an image of a real person; partly an idealised image of monarchy itself; partly a display of royal power and prerogative; partly, paradoxically, a symbol of the democratic constitution that the royal power upholds. Now imagine that you could not recognise the portrait, or even that you believed it to be an image of the Prime Minister. Such a mistake would not simply be a sign of surprising ignorance of a rather well-known 'fact'. It would entail a failure, on an absolutely massive scale, to understand British political life. These visual symbols are central to our culture and to our ability to operate within our culture. If we cannot understand the images of society, we cannot understand society itself.

The visual world of ancient Greece: city of images

The ancient Greek city was a city of images: sculpture, painting, decorated gold and silverware, designs on textiles, pictures on pots, carving in wood and ivory. It is difficult now to recapture the sheer profusion of visual images that surrounded the inhabitants of most Greek cities. Partly, of course, it conflicts with our own 'tasteful',

slightly 'sanitised' view of what the ancient world was like. We think of the Athenian Acropolis, for example, as a barren, rather bleak, rock, interrupted only by the grandeur of the ruined Parthenon and other sacred buildings. It comes as a shock to read the one substantial ancient description of the site, by Pausanias, writing in the second century A.D. For he writes of a site full of things to look at – not just temples, but statues of gods and goddesses, and of animals, portraits of generals and leading statesmen, paintings and lavish votive offerings. Pausanias, of course, describes the accumulation of centuries, much of it from the Hellenistic and early Roman periods. But the impression he gives is still broadly true, even for earlier periods. Even in the fifth century B.C. it was not a question of climbing up the hill for an open view of a few impressive buildings. Everywhere you turned there was something to catch the eye: the Acropolis was a rich feast of viewing.

Most of these images, on the Acropolis and elsewhere, have now been lost: bronze statues have been melted down; marble has been smashed; wall-paintings have long been eroded. By far the best survival is painted pottery. Of Athenian production alone (and it is Athens that will form the focus of this chapter) more than 50,000 decorated, painted pots survive, in black-figure and red-figure style, from the late seventh century B.C. to the late fourth century. This is probably still a very small proportion of what there once was, perhaps as little as 1 per cent of the original production of Athens over three centuries. But a combination of factors – the indestructability of pottery; its intrinsic worthlessness (unlike, say, bronze); its common use in burials and so its relatively protected resting-place in the tomb – has meant that thousands of more or less complete examples of decorated Athenian pots have come down to us. This is the one area of the artistic production of Classical Greece where we can have some sense of the original range and variety of material, its subjects, themes and quality. How are we to deal with this wealth of material?

Questions to ask

When we think of 'art history', we tend to think of questions of dating, of attribution and of style: what is the difference between an 'early' and a 'late' Titian? how do we distinguish a work of Rembrandt from one of his followers? how far was Dürer influenced by the style of his Italian contemporaries? And it is questions of precisely this type

that underlie the majority of studies of Athenian painted pottery. Most books offer us a way of classifying and understanding that vast body of visual material through the identification of the work of particular artists, the chronology of their careers and their stylistic relationship one with another. It is an approach modelled on the art history of later periods, but with one crucial difference. From the early Renaissance onwards painters regularly signed their works, and we have reliable documentary and literary evidence of their careers and commissions – in letters, archives, contracts, deeds of sale, as well as in contemporary or near-contemporary biographies. By contrast, only a very small proportion of Athenian potters or pot-painters (for not all potters painted their own pots) signed their work; and not one of them is identified by name in any ancient writer, still less discussed in detail. Unlike the artists of the Renaissance and later, the craftsmen who produced the sometimes exquisite scenes on Athenian pottery are almost entirely anonymous.

This gap of anonymity was first systematically bridged by the work of John Beazley. As Martin Robertson has described, Beazley 'identified' hundreds of Athenian pot-painters by focusing on, and grouping, characteristic features of their drawing – a distinctive handling of eyes, for example, or of chest muscles or of chariot wheels. And he gave to each painter a name: his 'real' name, if he had in fact signed some of his work; more often a nickname drawn from some distinctive subject in his painting (the 'Pig Painter' for example), or from a known potter with whom he appeared to have been associated (the 'Brygos Painter' for the painter associated with the signed potter Brygos).

In any terms Beazley's achievement is outstanding. He provided for the first time a comprehensive framework of analysis for Athenian pottery painting, and a way of dating and classifying (by artist and group of artists) an enormously varied body of material. And if his identifications are broadly correct (as is generally assumed, but can almost never be proved), then Beazley's work is little short of quiet, systematic genius. Certainly nothing is to be gained now from disputing details of his attributions. For the problem of the 'Beazley method' is not whether it works – whether it is strictly correct in assigning particular pots to particular artists at a particular period. The more serious problem is what these identifications add up to and where they lead us.

Beazley's artists prove to be shadowy figures. We cannot know

where they were born, their social status, their level of education, their relationship with each other or how and where they were trained. We cannot be sure how long they practised their craft, how many pots they painted or how far their output and their manner of painting changed over the length of their careers. The reason for our apparently hopeless ignorance is clear. Unlike the artists of the Renaissance, these painters have no existence, no social or historical reality that we can investigate outside the pots themselves. They are notional constructs from the style of the painting – at the same time *expressions of* and *explanations for* the close similarity of particular groups of pots. They 'exist' only in so far as there is a group of surviving objects that bears their name. There is nothing to be said about them that cannot be said about the pots themselves. It is, of course, perfectly reasonable to assume that observed similarities of style stem from the characteristic manner of individual artists. The problem is that these 'artists' take us little further than that simple observation. They do not help us *make sense* of the range of Athenian pot-painting. If anything, by focusing studies on the moment of production and by tantalising us with the vain hope of recovering artistic 'personalities', they actually take our attention away from more fundamental issues of the meaning and function of visual images within Athenian society.

No one, of course, should claim that there is only one right question to ask about Athenian painted pottery. But it is all too easy to be dazzled by the skills of connoisseurship, by the complex arguments used to assign a pot to one particular artist or one very precise date – and so fail to see that there are more immediate and, for most of us, more central questions to ask: What do the images on Athenian pottery tell us about Athenian culture, society and ideas? How can we understand this quite alien system of visual meaning? This is a very different agenda from the traditional agenda of art history and it changes our focus of interest in two particularly important respects. First, our attention has to shift away from the artist-producer towards the viewer, towards those in Athenian society who looked at, made sense of and thought about (or thought *with*) the images on the pots. It is a question of how the image worked, not of who created it – Myson or the 'Pig Painter', Euphronios or Euthymides. Second, the problems of detailed chronology lose their central importance. It takes some courage to claim this in a scholarly world dominated by the search for accurate dating – but, for most of us, the first aim is to

understand a system of visual meaning that is common to several centuries of Athenian image-making, a system of meaning that is distinctively Athenian. Although chronological developments are sometimes important, on most occasions it matters very little to our understanding of the system whether a particular pot was produced in 470 or 460 B.C.

To study Athenian painted pottery in this way, outside the framework of Beazley's artists, involves taking up the challenge of understanding our own systems of visual meaning. It involves reflecting (as I did at the beginning of this chapter) on the complex ways in which they determine and reflect our own views of society and of social values. It involves using the insight we gain into our own 'ways of seeing' in order to understand the complexities – some similar, some different – in the ancient material. In short, to study Athenian pottery in this way is to attempt to reconstruct *in our own terms* (for we cannot do otherwise) what it was like to be an Athenian *viewer*.

Changing the focus of the questions to be asked does not remove all the problems – particularly the problem of simple lack of information. We must admit at the outset that there are many things about Athenian pots that we do not know; many things, in fact, that we would consider an almost essential part of understanding comparable objects in modern culture. We do not, for example, know how costly these pots were. There are, it is true, what some believe to be scribbled prices on the bottom of a few specimens (below, pp. 224ff.), but there is no agreement on their interpretation. Perhaps more important, we have very little idea of even the relative value and prestige that these pots enjoyed. Throughout the classical period, there was certainly an important tradition of decorated gold and silverware, precious vessels that are now almost entirely lost to us but that once would no doubt have graced the tables of the wealthiest Athenians. Does this mean that the pots, however attractive, were by contrast rather low-status, everyday objects, even perhaps mere imitations of more expensive metal equivalents? Or, as their traditional name 'vases' implies, were they themselves rather special, valued pieces – made more for the china cabinet than humping water from the well. We do not, of course, know exactly what any individual piece was used for. The conventional names given by modern scholars to particular shapes of pots often imply certain types of use – an *amphora* for holding wine or oil, a *hydria* for carrying water,

and so forth. But, even where these names reflect attested ancient names (as is not always the case), we cannot be certain that the actual range of use was so specific. After all, *we* commonly use jam-jars to hold pencils; the ancients were probably equally, if not more, flexible. And what, finally, of the many Athenian-produced pots found in Etruscan tombs? Did they reach Italy as casual 'ballast' in ships transporting other, more valuable, cargo? Or were they made specifically for an Etruscan market? Did they have a long household use before ending up in the tomb? Or were they aimed and designed for the rituals of death?

These questions raise intense controversy in the study of painted pottery. They stimulate all kinds of claims, counter-claims and ridiculously over-optimistic, firm 'answers'. That is because the questions *matter*. It would make an important difference to our understanding of the images if we could be certain that some pots belonged to the women's quarters of the Athenian house, used and looked at almost exclusively by women – or that others were only brought out in the essentially male environment of the symposium. It would also make a difference if we knew whether the pots were the utensils of the upper echelons of the Athenian elite or were the everyday crockery of the average family. It might even more transform our interpretations if we knew exactly how, why and in what context so many 'Athenian' pots ended up in Italy. But given that (on the present state of the evidence) certainty is impossible, it is much better to admit our ignorance and to think constructively about how different answers to such questions would lead to different interpretations of the images. And it is better to start not from such insoluble problems, but from what we can know and see: the images themselves, and their context in Athenian society.

Painted pottery and the human figure

The most striking fact about Athenian painted pottery is that it is dominated by the human (and divine) figure. 'Black-*figure*', 'red-*figure*', '*figured* decoration' means exactly that. Everything else is secondary. There are only a few traces of landscape. Buildings are normally represented by just a schematic column or door. Even animals, after having some prominence in the Late Geometric and Protoattic styles and in the earliest phases of black-figure, appear mostly as adjuncts – horses pulling chariots, dogs following at the

heels of their masters. All attention is concentrated on the figures of men, women and their Olympian counterparts.

It is conventional to divide these figured scenes into two groups: on the one hand, scenes of 'everyday life' – the symposium, the potter's workshop, women at the well; on the other hand, scenes of 'myth' – Dionysos with his maenads, Europa abducted by the bull, Achilles bandaging the wounded Patroklos. Such a division is misleading for two particular reasons. First, the term 'everyday life' implies that we can read these images as documents of social history; it implies that they are evidence for 'what actually happened' at an Athenian banquet or behind the closed doors of the women's quarters, almost as if they are photographs. In fact these images cannot be simple replicas of reality. They may draw on and select elements from the world round about – for that is how they are 'recognisable'. But the very process of selection and juxtaposition within the restricted frame of the pot necessarily converts the reality of everyday life into something very different: an *image*, a *representation*, an *intellectual construct*. We cannot read a scene of the domestic world, such as that in Fig. 4, as if it were a photographic replica of life in the Athenian home: What sort of room is it? Was the Athenian house really so sparsely furnished? Could any woman continue to spin so attentively while a man leans so close as almost to knock over her wool basket with his stick? This is not a *picture of*, but a *statement about* domestic life – selecting, reordering and carefully juxtaposing elements of 'reality' to make (as I shall show in the next section) a heavily loaded, ideological point.

The second problem lies in the division itself between scenes of myth and scenes of everyday life, the division between the 'imaginary' world of the gods and the 'real' world of human experience, of feasting and fighting, of spinning and weaving. For us, this may seem a perfectly reasonable way of classifying the varied repertory of Athenian images. What could be more sensible than to deal in one chapter of a book with representations of Zeus, Aphrodite and Herakles (who, after all, never existed) – and in a quite separate chapter with the images that in some way reflect the real-life behaviour of thousands of Athenian men and women? But for the Athenians themselves such a distinction would not make such obvious good sense. Gods and the characters of myth did not inhabit a separate world, a set of vague, rather remote symbols. They were part of human experience; they intervened directly in human life; they were a necessary means of *re*-presenting and of making sense of the world. Like Athenian drama, Athenian pots celebrate the interrelationship in

many different ways. Sometimes a named mythological figure is balanced on the other side of a pot by an anonymous figure of 'real life'. Sometimes an individual or group of figures is understandable in mythological *and* 'everyday' terms: a scene of a warrior saying farewell to his wife, for example, may represent the Homeric Hector taking his leave of Andromache, but it could also be the tender farewell of any Athenian fighter leaving home; the Maenads in the entourage of Dionysos, mythical women of the wild, may not be easy to distinguish from the 'real' women of Athens. It would be a crude oversimplification to try to determine in each case what precisely is represented, to try to invent a single, unproblematic title for each scene. The meanings of these images depend on the subtle interplay of both registers: myth and 'real life'. We are not just dealing with a figure who is *either* Hector *or* an Athenian hoplite; we are dealing with a figure who can be and is *both*.

In the rest of this chapter I want to develop the themes and approaches I have already discussed by concentrating on just one type of figure – the female figure, both human and mythological. The nature of the oppression of women in classical Athenian society is well known: their exclusion from public and political life; the legal restrictions on their conduct; and (at least if they were of the upper classes) their almost 'oriental' confinement to the home. More important, and at the same time more interesting, is the 'cultural fixation' on the status of women that accompanied this oppression; Athenian literary, dramatic and artistic forms constantly discussed, debated, questioned and justified the role and function of women. The dominance of female characters in Athenian tragedy is familiar to us. Women are also prominent in the images on Athenian pots. The examples I have chosen form only a tiny part of the complete range. But they are enough to show, I hope, that an understanding of these images and of the complex ways in which they 'signify' is an essential part of understanding Athenian society.

Representations of women: norm and stereotype

Images of women on Athenian pots served to define proper female behaviour. They reinforced the elite ideal of the woman's role within the home – skilled in domestic tasks (particularly spinning, weaving and the working of wool) and the bearer of children to her citizen

husband. At the same time they paraded an image of a very different type of woman; she was the courtesan or prostitute, the partner of the Athenian man in sexual pleasure, who was by definition not his wife. These images did not simply reflect the common standards of Athenian behaviour. They played an active part in defining and establishing what was expected of women, what was not expected and how they were perceived and classified. In this sense, we may call them '*normative*' images.

Consider the pot illustrated in Fig. 4. It is, in the terms of traditional scholarship, an Athenian red-figure hydria dating from the third

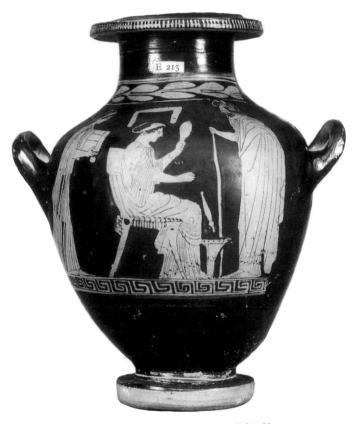

4. Attic red-figure hydria. Seated woman spinning. Behind her, an attendant; in front, a bearded man (probably her husband). Third quarter of fifth century B.C. Ht 20.6 cm.

quarter of the fifth century B.C., assigned by Beazley (rather unglamorously) to the 'Painter of London E215'. (Its own accession number in the British Museum is E215; and it is, as it happens, the pot which gave its name to the painter – whose hand Beazley detected in this and two other hydriai in the British Museum). The image you see is the only image on the pot; on the reverse, hidden from view, is just another handle to aid in dipping and pouring the contents of the vessel. The central figure is a seated woman spinning, at her feet the distinctive form of a wool basket. Above her head is a 'sash', which we can understand as hanging from the wall or ceiling of a room – a sign that the scene we are watching is taking place indoors. Behind the seated woman stands another female figure, a servant carrying a small square box or chest; while close in front stands a bearded man resting on a staff – her husband, we may guess. None of the figures look out at the viewer or return the viewer's gaze. Nor do they engage with each other; for although both standing figures direct their attention at the seated woman, she continues at her spinning, her head slightly bowed. The viewer of the pot is outside all this, the unnoticed witness of a static, self-enclosed tableau.

What then does this pot 'say' about the role of Athenian women? First, and most obviously, it asserts their domestic function. The central figure is certainly leisured, comfortably seated and the focus of attention both of serving-maid and husband. But she is productive too, engaged in the processing of wool and the making of textiles, a task regularly associated with women in Athenian literary texts. The pot also asserts a woman's place on the *inside* of the house, not only by the sign of the hanging sash, but also by the contrast set up between the women and the man. For he is equipped with the staff, the mark of the outside, public world; and breaking through the decorative frame at the neck of the pot he seems literally too big for the domestic space which he has entered. It is as if he belongs to the public spaces of the city and, although the master of the house, can only be a passing visitor in the confines of the women's quarters. This image confidently assigns a role and a place to women – an idealising stereotype perhaps, but reassuring in its apparent simplicity. That reassurance in part derives from the emblematic quality of the design. There is no narrative here; there is no dialogue taking place between the characters that we could wish to overhear; there is no story to be told that might make us rethink the image. It is pared down, economical, a visual shorthand for women's proper role.

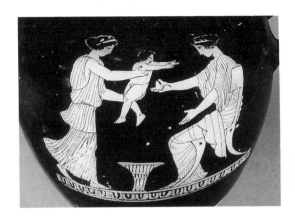

5. Attic red-figure hydria. A seated woman takes her baby boy from a servant. Third quarter of fifth century B.C. Ht 17.5 cm.

There is one major (perhaps *the* major) function of an Athenian wife not alluded to in this image; that is the production of citizen children. But another hydria from the British Museum (Fig. 5), a pot of about the same date as the first (this time ascribed by Beazley to the 'Painter of Munich 2538'), puts clear emphasis on the wife's role as mother. We can recognise some of the same visual signs. A woman sits on a high-backed chair, a wool basket at her feet. But she is not here actually engaged in spinning (although the basket serves to remind the viewer of that task); for the servant girl is handing her a baby, to whom she reaches out, offering a piece of fruit. There is no male visitor in this scene. There seems to be no male at all – until we spot that the baby is clearly depicted as a *boy*. This tiny detail, at first sight of trivial interest, would have been a clear indication to the Athenian viewer that this woman had fully discharged her obligation to reproduce the (male) citizen line. This was an image to be applauded, a standard at which to aim.

Other visual images can underline the very different functions of different types of women. For not all women at Athens were the wives of Athenian citizens; there were other roles to be filled. Prominent among these other groups are the courtesans or *hetairai*, literally 'companions' of men, who joined in their banquets, their drinking and the pleasure of heterosexual love. If the job of the wife was to bear children for the citizen, then it was the role of the hetaira to provide him with erotic delight.

Fig. 6 shows an Athenian *kylix* (or cup) from around 470–460 B.C., painted according to Beazley by the 'Tarquinia Painter', to whom

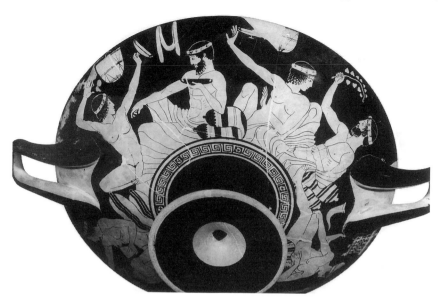

6. Attic red-figure cup. A drinking party. Two naked women recline with their partners. *c.* 470–460 B.C.

about 100 pots and fragments are attributed. Kylikes are broad, shallow drinking-vessels with two handles, traditionally associated with the Athenian symposium or drinking-party; and, in fact, three of the participants in the symposiastic scene shown on this particular kylix hold precisely this type of vessel. Kylikes were commonly decorated around the outside of the bowl, with scenes that would be visible to the drinker when the cup was held up. There was also normally a circular figured scene inside the cup, visible when the drinkers tipped the cup towards themselves, or as they drank. In this case, the internal scene (not shown here) represents a young athlete with his trainer. The outside decoration shows another aspect of an Athenian citizen's life, the symposium, and the hetairai with whom he enjoyed it.

The participants on this side of the cup, two men and two women, recline on cushions, probably on couches. The men are half clad, the women completely naked. They drink and play games as a prelude, we imagine, to love-making. The hetaira on the right, who to modern eyes seems to be balancing her cup rather artfully on one finger, was probably instantly recognisable to an Athenian viewer as a player in a

game of *kottabos*. The aim of kottabos was to hit a target with a few drops of wine flicked out of the bottom of a kylix – and it was well known as a flirtatious prelude to more serious erotic games.

The contrast between these hetairai and the 'respectable' women of the two other pots is clear. It is not just that these are naked while the others are clothed – although that is obviously an important visual sign and suggests a world of sexual enjoyment quite absent in the previous images. It is not just that these women *recline* as symposiasts in contrast to the upright seated pose of the others – although that again is an important mark of separation between the two types. More fundamental is that these hetairai are not shown in the confined domestic 'female' spaces of the home, but in the male territory of the drinking-party, joining with men in the (for the Athenians) male pursuits of drinking, conversation, play and pleasure. This distinction, of course, partly mirrors the different functions normally associated with the pots themselves. The kylix belonged at the symposium; the drinkers saw their own world represented and confirmed on the outside of their cups. The hydria, we generally suppose, had its place in the more domestic female tasks of the home; it was stamped with a clear message about the status of those who used it.

Undermining the stereotype

So far, reading these pots has seemed relatively straightforward. It is true that there have been some points of potentially difficult 'cultural decoding' even in these simple images. We have needed to understand the cultural associations of the game of kottabos, just as we needed to understand the point of the briefcase in the Parisian restaurant. We have needed to recognise the distinctive shape of a wool basket and spot the significance of a male, rather than a female, child. But, once they are decoded in this way, the sense of the images and their operation in Athenian society has appeared unproblematic.

The images I have dealt with are typical. There are hundreds of surviving drinking-cups and other vessels portraying the activities of men and hetairai at symposia, often indeed much more sexually explicit than the one I have chosen. There are somewhat fewer, but still very many, that show the accepted roles of the Athenian wife – with her tools of wool-working, attended by her servants, displaying her baby. This simple profusion of images makes the 'stereotype'

seem even clearer. Athenian pots constantly presented to the women of the city images of how they could and should behave; and to Athenian men they presented images of their women behaving according to the different established rules. These images in part reflected the realities of behaviour and the realities of the division between, say, wives and hetairai. But more than that, by their constant repetition, their constant presence, they served to establish that behaviour and those distinctions as the norm.

The interpretation of images is, however, more complex than this brief analysis would suggest. The notion of stereotype is certainly helpful up to a point. But to accept it wholeheartedly as the simple, single way in which these images make sense is to miss the necessary plurality of meaning that I discussed earlier. Consider just the different meanings that come with different viewers and different contexts. We have so far implicitly assumed a respectable Athenian wife (or her husband) as the audience of the first hydria (Fig. 4). Imagine instead that the viewer is a servant girl; or a hetaira, on the other side of the female divide; or even an adulterous wife, for whom the ideal paraded in the scene was just a bitter reminder. How could these different viewers interpret what we have seen as a simple stereotype? More to the point, imagine these pots as offerings in a tomb (as the two hydriai almost certainly were), part of the rituals of burial – no doubt of women. The images then take on another sense – not simply models of behaviour for women, but also memorials of a woman's life. Imagine even that the second hydria (Fig. 5) was an offering in the tomb of a woman who died in childbirth. That change of context could involve a change of reading as striking as the change of caption in the advertisement with which I began this chapter: a change from model and precept to poignant memory.

An even more fundamental problem concerns the notion of norm and stereotype itself. It is not simply that different viewers may make their own variant readings of the stereotype; it is that, for obvious reasons, stereotypes are most insistently stressed in areas where they are most difficult to establish and where they are least self-evident. We may perhaps at first be convinced by the apparently simple idea (repeated in literature and visual images – and for that matter in modern scholarship) that there were two types of Athenian woman: the respectable wife, by whom the citizen produced his children, and the hetaira, with whom he enjoyed conversation, wit and sex for pleasure. It was certainly a useful division for the Athenian male, who

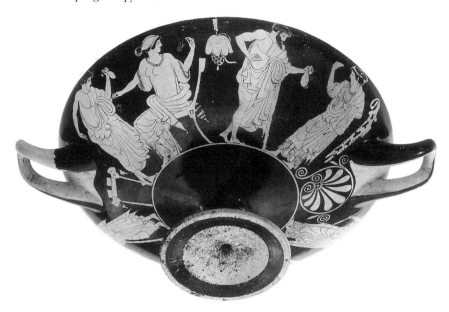

7. Attic red-figure cup. Courtesans negotiating with their clients, who hold money bags. Early fifth century B.C. Diam. 29 cm.

desired the purity of his own citizen line as well as freedom for sexual gratification. But a moment's thought will show how difficult a division it would be to sustain. Was there really no resemblance between the wife and the hetaira? Did the wife, unlike the hetaira, have no erotic desire? Was the wife incapable of providing the companionship expected of a mistress? The function of the insistent stereotype was to mask those awkward questions (and the even more awkward answers) and to attempt to 'naturalise', to make seem obvious, normal or self-evident, what was in fact an arbitrary, ideological cultural rule. Neither in literature nor visual images could it fully succeed. In fact some of the most interesting visual images turn back on the stereotype itself, directly or indirectly to suggest the fragility of its foundations.

Fig. 7 shows one side of the outer decoration of an early fifth-century cup, attributed to the artist Makron. We see two couples. In each the man holds out a purse of money and the women, with more or less enthusiasm, appear to accept their advances. These are paid hetairai taking their clients. Behind the woman on the right hangs one

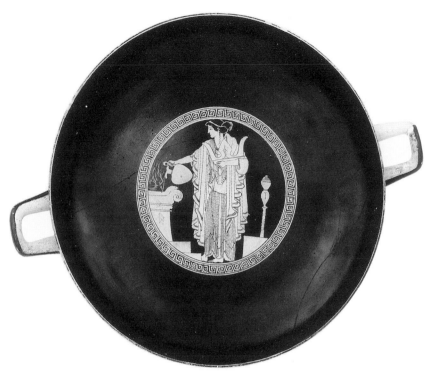

8. Interior of cup shown in Fig. 7. Woman offering libation at an altar.

of the tools of her accomplished profession – a flute; between the two groups hang articles from the gymnasium (a sponge, strigil and net of marbles) that the men have, temporarily, left behind.

Imagine that you have picked up this kylix at a symposium. You hold it up to admire the scene on the outside, then turn it towards you and look into its bowl. What do you expect to see as the inner decoration? A scene of love-making, perhaps – the sequel of the episodes represented on the outside? In fact, what you see is shown in Fig. 8. It is once again the Athenian wife, here shown in another of her accepted roles, religious worship. She is pouring an offering onto a blazing altar and holding a large, crown-shaped, sacrificial basket in her other hand. Behind her stands a gently smoking incense-burner. It is an image of the wife's proper conduct in relation to the gods.

What is the point of this strange collocation? Perhaps it is a simple joke. Some other kylikes make play with the relation between the inside and the outside decoration of the cup. A kylix by the Brygos Painter, for example, shows scenes of carousing around the outside and a young man being very sick on the inner bowl. So maybe with Makron's cup the joke is on the symposiast, unwontedly reminded of 'the little woman back home', just when he had been led to expect a suitably 'symposiastic' image in the middle of his kylix. But there is more to it than that. This intrusion of the wife into the world of the hetaira necessarily raises the question of whether the division between them can so easily be maintained. Simply to see the wife where you expect to see the hetaira is to begin to question the validity (or reality) of the stereotype.

Similar questions are raised by a later fifth-century hydria (Fig. 9) by the so-called 'Washing Painter' (named after his images of women washing). It looks at first glance familiar. A woman sits on a high-backed chair, a sash above her head; another spins, apparently taking instruction from the seated woman. What is surprising is that the spinning woman is completely naked, but for a band round her thigh – her clothes left on a chair behind her. How can this be explained? Perhaps it is simply a slightly eccentric version of everyday life – everyday life in the brothel, where even hetairai must do their spinning like good girls. Perhaps it is a joke about a certain similarity between dancing and the positions adopted in spinning. Whatever the answer (and there are many), the most important thing is the implied questioning of the stereotype. Once, however jokingly, the symbols of the respectable wife have been associated with the naked hetaira, those categories can no longer be taken for granted; once the hetaira is ambivalent, so also is the wife. Visual images can subvert as much as establish and uphold the norms.

Transgression displayed

Images of myth have an important part to play in defining a woman's place. So far, I have not considered any images that explicitly refer to the divine or mythological inheritance of the Greeks. But, for an Athenian, to think of *women* was not just to think of those he saw from day to day, it was also to involve a range of other characters – Maenads, Amazons, Gorgons, Muses, Furies and, of course, the female deities of the Olympian pantheon. It was often in this

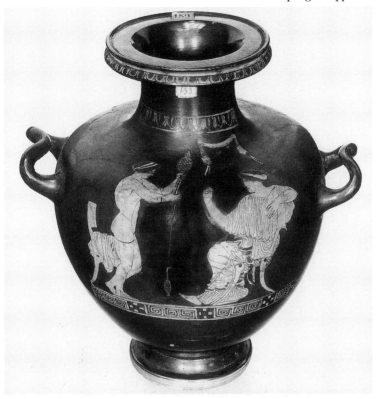

9. Attic red-figure hydria. Seated woman instructing naked hetaira, who spins. Late fifth century B.C. Ht 18.7 cm.

repertoire of myth that the problems of gender were *re*-presented to the Athenians and the stringent male control of women was explained and legitimated. The Maenads, for example, the wild followers of Dionysos, not only suggested the potential of *any* woman to break out of the proper norms of civilisation and the *polis*; they also, precisely because of that potential, served to justify man's heavy-handed policing of the female sex.

In this final section, I want to consider two images of Amazons. The Amazons were a mythical race of warrior women, living without men on the margins of the Greek world. They kidnapped men, it was

said, solely for the purpose of procreation; they reared only their female offspring; they cut off one breast – so that, according to some writers, they might more easily wield their bow and arrow, but perhaps more tellingly as a symbol of their rejection of woman's nurturing role. They stood for everything that Athenian women were not; or rather everything that it was vital that Athenian women *should not* be. For these were women in power, women fighters, women who dominated men. Their transgression was widely displayed in the visual images – as was, rather more reassuringly, their defeat by the Greeks. The Amazons fought, but did not ultimately win.

The first pot (Fig. 10) is a large *krater* (a deep mixing-bowl, commonly assumed to be for wine) painted about 460 B.C. by the so-called 'Niobid Painter'. It shows in its main band of decoration battles between Greeks (here with distinctive crested helmets and round shields) and Amazons (wearing patterned trousers under armour). In the scene in front of us the Amazon and the Greek are about to engage in deathly combat; she has brought up her sword above her head, to swing it down upon the Greek, who is pointing his spear into her chest. Behind the central Amazon a Greek warrior is moving in with his spear to kill an opponent who has already fallen, her trousered leg just visible on the far right.

There is no doubt that the Greeks will be victorious in this battle. But the interest of the pot lies not so much in the Greek victory, as in the way the conflict between Greeks and Amazons is juxtaposed and conflated with two other conflicts between Greeks and 'outsiders' – one mythical, one 'real'. First, round the neck of the krater is represented the battle between Lapiths (a people of North Greece) and Centaurs. These Centaurs were half man, half horse and, like the Amazons, flouted the proper norms of marriage – in this case by disrupting the wedding feast of the Lapiths and attempting to rape the Lapith women. Second, in the strikingly oriental style of the Amazons' armour is a clear reminiscence of the Persians, and so also of Greek victory over the Persians some 20 years before. This collocation of Amazons, Centaurs and Persians is not unique to this pot; it is evoked, for example, in the sculptural decoration of the Parthenon. What is important is the paraded interrelationship of one myth with another, and of the mythological inheritance with the realm of 'real history'. Within this conflation, the Amazons become as 'real' an enemy as the Persians; the Persians as monstrous as the Amazons, as monstrous, that is, as the most transgressive women.

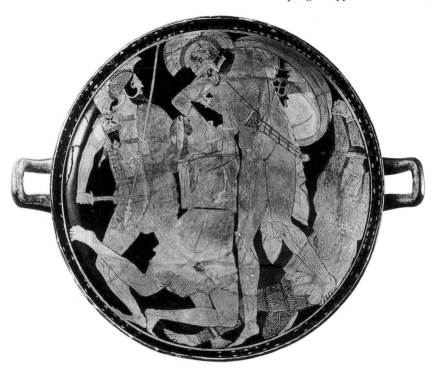

11. Attic red-figure cup (interior). A Greek kills an Amazon, probably Achilles and Penthesilea. *c.* 455 B.C. Diam. 43 cm.

a whole variety of different connections between the images and the traditions of Greek literature, mythology, history and the norms of everyday life. This approach moves away from the methods of Beazley and his concentration on the artist–producer to focus instead on the viewer – both ancient and modern. Such a shift necessarily raises problems that we cannot neatly or simply answer. But it is in those problems that the interest of 'looking at Greek vases' lies.

12. Neck-handled amphora. Attic Middle Geometric I,
c. 850–825 B.C. Ht 77.5 cm.

2

The Geometric style: birth of the picture

J. N. COLDSTREAM

About one kilometre north west of the Acropolis, a small cemetery of Athenian nobles buried during the eighth century B.C. would have presented a sight strange to modern eyes. The burials lay near the later Dipylon Gate, erected when Athens had become a walled city in Classical times. Near by was the Kerameikos, the Potters' Quarter, a major burial ground over many centuries; many Classical tombs there are marked with marble gravestones showing the dead taking their leave of the living, in sculptured relief. In the eighth-century Dipylon cemetery, however, the aristocratic burials were marked by gigantic pots, enlarged to a degree which would have been absurd in domestic life; high-footed kraters stood above the graves of men, belly-handled amphorae above those of women. These vessels are exceptionally ambitious works of the Attic Geometric style in its late and most developed stage, when figured motifs were combined with the rectilinear geometric ornament after which the style is named. Each grave-marker carried a scene of mourning over the dead body lying in state. On the kraters for men there were also chariot processions, and battle scenes both on land and at sea. These are among the very earliest of extended figure scenes in Greek vase-painting. Did the notion of figure drawing occur to Greek vase-painters, in the first instance, to do honour to the dead? We must return to this question later. Here it is enough to note differing types of grave memorial in different periods: sculptured stone relief in Classical times, vast painted vases in the eighth century.

Various views have been advanced concerning the status of vase-painters in Classical times; but during the eighth century it is clear that the Attic Geometric vase-painter was at times called upon to practise a major, monumental form of art. Indeed, in a Greece recovering from the long Dark Age which followed the collapse of the Late Bronze Age civilisation of the Mycenaean palaces, he had little

13. Pyxis in the form of a chest, with model granaries on its lid. Attic Early Geometric II, *c.* 850 B.C. Ht 25.3 cm.

competition from those who worked in other media. Life-size stone sculpture was as yet unknown. Large-scale pictorial art had decorated the walls of Mycenaean palaces, but after their destruction and before the rise of monumental temples in the seventh century B.C., there were no walls worth decorating. Other fine arts – gold jewellery, relief metalwork, gem-engraving and ivory-carving – had all undergone a similar recession, and were now beginning to enjoy a revival with the recovery of freer communications with the Near Eastern sources of the raw materials. A spectacular symptom of that revival is the manufacture of vast tripod cauldrons in bronze, as prestigious votive offerings at Greek sanctuaries, notably at the rising Panhellenic sanctuaries of Olympia and Delphi.

The potter's craft, by contrast, needed no such revival. Clay vessels, throughout the Dark Age, had always been essential to daily life, and indispensable as offerings to the dead. Contemporarily with the eighth-century revival in other arts, an important novelty in pottery

decoration is the rise of a figured style, which forms the central theme of this chapter. Our first concern, however, is with the Geometric repertoire of shapes, most of which can boast a continuous development in profile and decoration from the close of the Bronze Age, and are themselves ancestral to the shapes of Attic black- and red-figure pottery. We must review their functions, both in domestic life and as grave-goods. To begin with, we shall concentrate on the period before the rise of the Attic figured style, when pottery decoration was almost exclusively abstract and geometric, and when cremation was the normal Attic burial rite.

The *amphora*, the leading closed shape, is a necked jar with two handles, designed for storage. As a domestic chattel it contains wine or olive oil. In cremation graves, amphorae made with special care often serve as ash urns. The placing of handles varies according to the sex of the deceased: for men, vertically from neck to shoulder (Fig. 12); for women, horizontally on the belly.

The *pyxis*, a clay box with a fitting lid, is suitable for more choice possessions, and is capable of many variations. An unusually intricate one, from a female cremation of the mid-ninth century, takes the form of a long rectangular chest, with a lid crowned by five models of granaries (Fig. 13). This amazing extravaganza looks like the status symbol of a noble family rich in arable land and grain. Even a century earlier than the figured Dipylon grave-markers, so it seems, some potters were already being commissioned to make special efforts for leading Athenian families. The lids of later Geometric pyxides often carry figurines of another aristocratic status symbol, the horse.

The container for precious liquids – unguents, perfumes and the like – was the *lekythos*, a small, slow-pouring vessel with a long and narrow neck; from the late eighth century onwards a popular alternative is the short-necked *aryballos*. Both shapes are known to us mainly as burial gifts.

Wine, even in the Greek Dark Age, was an important part of social life. After a death, sets of drinking-crockery would be supplied for the funeral party, and then deposited in the grave. Unless served to a Polyphemus from whom an Odysseus planned to escape, the rough and heady wine of ancient Greece was prudently diluted. Hence the need for a large mixing bowl, the *krater*, king of the symposium set and, in a funerary context, often the most lavishly decorated of all

vessels. The three-handled *hydria* is well-designed for drawing, carrying and pouring water: the single vertical handle allowed it to be easily lowered down a well, or used as a water jug at table; when it was carried from the well, the two horizontal handles enabled it to be lifted up on to the head in the traditional manner. A miniature hydria, alluding to its sobering function at a symposium, crowns the lid of a vast ovoid krater (Fig. 14), probably made in Euboea and exported to Cyprus. The diluted wine would be ladled from the krater in the *oinochoe*, whose trefoil lip then ensured easy pouring; when Hesiod (*Works and Days* 744) urges 'Do not place the oinochoe upon the krater' he seems to say 'Do not be a mean host'. Of the drinking-vessels, the type with two vertical handles is called the *kantharos* because it resembles the favourite bowl of Dionysos in Attic black-figure scenes. Much more frequent is the *skyphos*, with two horizontal handles, ancestor of the Archaic and Classical kylix, and a personal chattel essential to daily life: the kind of object which, in the earliest days of Greek literacy even before 700 B.C., a man liked to inscribe with his own name. The skyphos may well have been used for eating, too; Geometric plates exist, but were never common either in domestic deposits or as grave-goods.

As in later periods, the vast majority of complete and well-preserved Geometric vases which have come down to us are finds from cemeteries, where their chances of survival are always better than from the scarce and flimsy remains of contemporary settlements. If we also remember the extra care devoted to the making and painting of the funerary vases, it at once becomes obvious why it is to the contents of the graves that we owe our knowledge of the pottery sequence throughout the Early Iron Age. During the Dark Age, when there was relatively little communication within the Aegean world, each region of Greece was left to its own devices, and evolved its own local style of pottery. Of these the Attic style was by far the most influential, and the best-known, thanks to the volume of finds from carefully excavated single graves. The earlier development of Attic decoration can be traced through a long Protogeometric phase (*c.* 1050–900 B.C.) when concentric sets of circles and semicircles, neatly drawn with compass and multiple brush, were the most usual motifs. With the arrival of the full Geometric style, circular ornament is displaced by rectilinear. On the larger grave-vases, throughout the

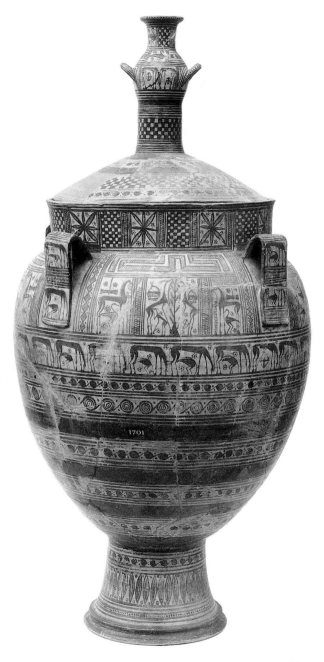

14. Ovoid krater with lid. Euboean Late Geometric I. *c.* 750 B.C. Ht
115 cm.

Early and Middle Geometric phases, designs of increasing complexity are built up round the hatched key meander, now the leading motif. A warrior's cremation amphora (Fig. 12) and the rich lady's chest-pyxis (Fig. 13) are ambitious products of the mid-ninth century, combining a strictly controlled composition with fastidious draughtsmanship.

All through this long Attic development of geometric decoration, any picture of a living creature is exceptional. Very rarely, single figures of horses, birds or humans may appear inconspicuously beside the complex abstract designs, like strange intruders into a well-ordered formal garden. Then, shortly before 750 B.C., came the sudden florescence of Attic figured drawing, mainifested – as we have noted – in scenes of death and burial. Indeed, such is the authority of the Attic figured style, with its vast funerary monuments standing over the graves of the aristocracy, that we are tempted to assume that the chief motive for the evolution of figured vase-painting was the wish to do honour to the dead. As in later Classical literature and history, so also at the beginning of Greek figured art, we should at least be aware of an Athenocentric point of view. We should first look at Late Geometric figured work in other parts of Greece, if only to appreciate the Athenian achievement in the context of its time, and to see how extraordinarily unusual was its preoccupation with the needs of the dead.

Several regional Geometric styles produced no figured painting at all; of those that did, I single out for comparison the Late Geometric figured styles of the Argolid and Euboea, and also the figured work of Crete.

In the Argolid, where figured painting is almost as frequent as in Attica, the same subjects occur on grave offerings and in settlement deposits. Potters made no distinction between the requirements of the living and the dead, and the scenes themselves seem to refer to life rather than death. Most frequent by far is the tamer of horses, controlling either one or two horses: a theme natural to the Argive plain, the Homeric pasture land of horses. The same man-plus-horse combination appears also in three dimensions, as figurines soldered on to the ring handles of the vast tripod cauldrons in bronze, dedicated at Olympia perhaps on the occasion of the quadrennial games in their earliest days, and reasonably identified as Argive offerings.

The Euboean school of figured painting, thanks to recent excava-

tions in the homeland and in the Euboean western colony of
Pithekoussai on the island of Ischia, now emerges as one of the most
important Late Geometric figured styles. Recent finds enable us to
claim for Euboea an exported masterpiece, the enormous ovoid krater
found by L. P. di Cesnola at Kourion in Cyprus (Fig. 14). Its painter,
though influenced by the style of the Dipylon grave-monuments,
nevertheless presents a quite different iconography. When this krater
was made, around 750 B.C., its three figured themes were all new to
the Greek mainland. The Euboeans were then an outward-looking
people, already trading freely with the East Mediterranean. It is no
surprise that pride of place is given to an oriental theme – the Tree of
Life, flanked by heraldic animals. The other two subjects are the horse
at the manger, and the frieze of grazing horses. This conspicuous
display of horse pasture, indoors and in the field, is appropriate for the
aristocrats of Chalcis and Eretria, who could afford to commission
such splendid vases, and for whom the well-fed horse was a symbol of
wealth, power, status, and above all the possession of good pasture
land in that small but miraculously fertile Lelantine plain, over which
the two Euboean cities eventually went to war late in the eighth
century B.C. Horses were to play an important part in that war;
Plutarch mentions the valour and prowess of the Eretrian knights
(*hippeis*), broken only by timely aid to the Chalcidians by a Thessalian
ally, Cleomachos of Pharsalos. The mounted warrior was never a
frequent subject in any local Geometric school, but on Euboean
pottery is less infrequent than elsewhere.

 In Euboea, then, as in the Argolid, it is possible to relate the rise of
figured art to daily life, and to the mundane interests of its patrons. In
Crete, as always, the story is very different. During the Dark Age,
Cretan potters attempted more experiments in figured art than in any
other part of Greece. Open to them, and to them alone, were two
special sources of inspiration: the pictorial art of their own Minoan
past, and a precociously early view of East Mediterranean art long
before the so-called Orientalising movement which put an end to
Geometric pottery styles elsewhere. Both sources of ideas are apparent
on two deep bell-kraters from chamber tombs at Knossos, contem-
porary with a retarded Protogeometric style; and here we see the
earliest known figured scenes in Greek vase-painting. One krater,
c. 900 B.C., combines the usual concentric circles with a hunting scene:

two huntsmen, with hound, close in upon a deer, a large bird and an agrimi goat. A similar hunt, with assorted prey, is among the repertoire painted on Minoan clay coffins (*larnakes*) of the fourteenth and thirteenth centuries B.C., and such coffins would have been easily visible to those who, during the Early Iron Age, frequently reused Minoan family tombs.

The other Knossian krater, of *c*. 850 B.C., looks eastwards for its inspiration. On one side is a heraldic pair of sphinxes with a long-necked bird, the sphinxes wearing conical helmets of oriental character. The dynamic and violent scene on the other side (Fig. 15) shows a warrior struggling desperately against two lions; kicking one beast in the teeth, he tries to plunge his sword into the other. That lion, meanwhile, hopes to bite off his head. This gruesome theme reappears a century later in Attic Late Geometric vase-painting, but has no precedent in the Aegean past, and no counterpart in Greek

15. Bell-krater. Man attacked by two lions. Cretan Late Protogeometric, *c*. 850 B.C. Ht 31.4 cm.

mythology; a Greek Herakles would never be shown at such a painful disadvantage. The source of this theme is not wholly clear, but some earlier renderings are known on Cypriot bronze stands and cylinder seals of the Late Bronze Age.

A third early figured vase from Knossos is a straight-sided cremation urn of the late ninth century, showing the first obvious representation of a deity in Greek vase-painting. A long-robed and winged goddess of nature, standing on a winged platform (an abbreviated chariot?), is flanked by birds and trees on both sides of the vase. To judge from a deliberate contrast in the character of the trees in each picture, a contrast of seasons is intended. On one side, the goddess seems to arrive amid the luxuriant leafage of a Greek spring; on the other, she departs at the onset of winter. Details of these scenes display a mixture of Minoan and oriental influences. To account for the oriental element at such an early date, there is some evidence that eastern metalworkers were actually settling at Knossos from this time onwards: first a goldsmith, buried with his stock-in-trade and some of his gold masterpieces in a reused Minoan *tholos* tomb; shortly after, the arrival of a guild of oriental smiths who, with their local pupils, created the bronze votive shields dedicated at the cave sanctuary of Zeus on Mount Ida, covered with figured scenes embossed in concentric zones. During the eighth century it is on the relief metalwork, rather than on the pottery, that the further progress of Cretan figured imagery can be followed.

So much, then, for the Cretan repertoire of figured themes, very precocious in its early start, sometimes looking back to the Minoan past, often deeply influenced by the Orient, but always quite unconnected with any other Greek Geometric school; the repertoire includes long-robed goddesses of nature, hunting scenes, lions who fight and overwhelm men, flying birds, sphinxes and other fabulous monsters. We first see these themes on tomb-vases; but all recur on the Idaean shields, and so were thought equally suitable on offerings to the gods.

Let us now return to the Attic school, the leading school of the Greek mainland, where we can watch the growth of a very different figured repertoire. In contrast to the strong and sometimes ill-digested oriental element in the Cretan scenes, here we shall find much more scope for native invention.

Athens was the original home of both the Protogeometric and the Geometric styles: styles where the vase-painter, with no greater

pictorial art to distract him, falls back on the abstract ornament in which he found the simplest and most satisfactory way of decorating his curved surfaces. For a long time, as we have seen, he was extremely chary of admitting any figured motifs; before the end of the Middle Geometric phase we find only single figures, usually horses, and always in inconspicuous places so as not to disturb the strict symmetry of the main geometric design. Well back into the Dark Age these single figures seem to have had funerary connotations. Already in the tenth and ninth centuries B.C. there are a few rare instances of Attic vases being used as grave-monuments, much enlarged beyond their normal size for domestic use. Belly-handled amphorae, larger versions of the normal cremation urn for women, marked some rich female burials. For men, the monument consisted of a large krater upon a tall pedestal, an enlargement of the *sine qua non* of a man's symposium in daily life. For both types of monument it was the custom to pierce a hole through the base before firing, perhaps so that libations could be poured through them to the dead persons below. Most of these grave-markers survive in a very fragmentary state, having been frequently displaced by burials of later periods; it seems that no special respect was paid to them by subsequent generations. Enough survives, however, for us to trace the beginnings of Attic funerary imagery long before the monumental Dipylon vases. A fragmentary krater of *c.* 850 B.C., used as a marker for a rich grave in the Kerameikos, bears two silhouette figures tucked unobtrusively beside a handle: a horse, and a mourning woman, the first human figure in Attic art.

In the early eighth century single horses, now neatly enclosed in panels flanking the main geometric decoration, are occasionally found on grave-kraters and on other large funerary vessels. Then, around 770 B.C. near the end of the Middle Geometric phase, entirely new ground is broken by a bold pioneer, the painter of the grave-krater New York 34.11.2. There, for the first time, the central geometric ornament gives way to an extended figured scene, a funerary *prothesis* where the deceased man lies in state on his bier, surrounded by mourners. Down below is a continuous frieze showing what was to be the other constant theme of large Attic funerary vases: the battle, in this case an extended naval battle where warriors fight each other with sword, spear and bow, all in the same picture. This krater thus sets a precedent for later Geometric and Archaic narrative vase-painting,

where the painter conveys a time dimension, compressing several episodes of a story into the same picture.

The scene is now set for a veritable eruption of Attic figured vase-painting. Very soon afterwards, at the outset of the Late Geometric phase, there emerges the first great personality in Attic art, distinguished by an easily recognisable style in his rendering of humans and animals. He is named the Dipylon Master, after the small aristocratic cemetery where his major works have been found. Indeed, his major efforts were reserved for making monumental kraters and amphorae to stand over the graves of his aristocratic patrons. He was clearly working to satisfy a growing demand; in contrast to their paucity in earlier times, thirty-five monumental kraters and amphorae are known from the time when he was active, of which twenty-one are painted by his hand or by close associates in his workshop. These huge and splendid vases must have been specially commissioned by the Athenian nobility; one could hardly credit that a potter would encumber his shop with them, unless he were certain of selling them without delay. Sometimes one can detect two or more hands at work on the same krater; in those cases it seems that the potters were working against time to complete an order, to meet the urgent requirements of a funeral.

On the Dipylon Master's amphorae for women of high rank, Athens 803 and the frequently illustrated 804, the figured work is limited to funerary ritual only. A *prothesis* is shown on 804, where the woman's corpse, laid out on the bier, is attended by mourners, standing, seated, and kneeling. On the remainder of the vase a vast symphony of geometric ornament, always executed with fastidious care, is interrupted only by narrow friezes, on the neck, of grazing deer and reclining goats. These are among the first animal friezes in Greek vase-painting; the notion is oriental, inspired either by imported ivories, or by the more varied animal friezes embossed on gold bands of oriental character, found in graves of the same period as the Dipylon monuments. On Athens 803 we see the *ekphora*, the next stage in the funeral ritual, where the woman's body on the bier is conveyed towards the place of burial on a four-wheeled hearse.

On the pedestalled kraters, the monuments for men, the *prothesis* is accompanied by a chariot procession and a retinue of fully armed soldiers; and there are also scenes of war. None of the Dipylon Master's kraters is preserved complete; but Louvre A517 (Fig. 16), the

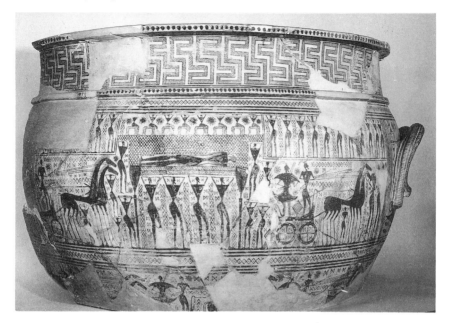

16. Pedestalled krater, upper part. Prothesis. Attributed to the Dipylon Master. Attic Late Geometric I, *c.* 750 B.C. Present ht 58 cm.

largest fragment, allows us a comprehensive view of his figure style, his drawing conventions, and his handling of space. Easily recognisable are his geometricised human figures, their chests reduced to a tall isosceles triangle. Apart from the deceased figures on the biers (draped women on the amphorae, undraped men on the kraters) we are not told whether they are male or female; but their action is always clearly defined. This clarity is achieved by combining two different viewpoints in the same figure. The chest and arms are frontal, so that we can see the mourners tearing their hair, and the charioteers holding reins and whip; lower body in profile, to separate the legs. With no established figured tradition behind him, the Dipylon Master was a most creative innovator, who at once found a way of expressing any human activity. For this purpose he explores a conceptual vision, painting not what he sees from any one angle, but everything that he knows to be there. Above the bier the chequered shroud must be drawn back, so that we can see the deceased man. In the chariot teams, two horses must needs show eight legs; the warrior and charioteer, who would be standing side by side, are clearly separated and shown

one behind the other; likewise the two chariot wheels. The need for separation, especially of the human figures, is dictated by the simple black silhouette without any means of showing inner detail; any overlapping would cause dire confusion, except where overlapping is essential to what is being portrayed. The same conceptual principle even allows the painter to compensate for the lack of a third dimension through a 'bird's-eye' perspective: thus, looking at the standing mourners shown below the bier and the seated mourners appearing above it, we find no difficulty in understanding that 'below' means 'in front', while 'above' means 'behind'. As a vast manifestation of a figured tradition still in its infancy, the clarity of the whole tableau is highly impressive: the work of a man who worked out his own principles of representation, made his own rules, and kept to them consistently.

Under the preserved handle of this krater is a warship, strenuously propelled by four rowers, with fish in the sea below. No part of the reverse side is preserved, but it is likely that the ship was in some way associated with a scene of naval warfare on the reverse side. Several krater fragments from the Dipylon workshop show naval battles, displaying the same conceptual principles: ships showing both port and starboard sides, drowning sailors each carefully separated one from the other with no overlapping.

The largest preserved battle scene is on land. The fragmentary krater Louvre A519 (drawing, Fig. 17), if not by the Master himself, is the work of one of his closest associates. If a scrap of a *prothesis* scene has been correctly attributed to the same krater on grounds of style and interior paint, the battle would certainly have been placed on the reverse side of this male grave monument. From the angle subtended by the rim we can deduce that slightly less than half the scene is preserved. It is sad that not a single krater from the prime of the Dipylon workshop survives anywhere near complete; for a complete krater, with its spacious funerary and battle scenes, would have presented over a hundred human figures; and no more vase-painting on this grand and ambitious scale was to be attempted for a very long time, until the major works of Attic black figure like the François vase.

Whatever the painter's intention may have been, a battle rendered in simple silhouette must inevitably seem generic to our eyes; but it is not without narrative. At the right-hand break we see part of what was probably the central event in the whole scene. A huge warrior,

17. Pedestalled krater, upper part (drawing). Battle scenes. Attributed to the Dipylon workshop. Attic Late Geometric I, *c.* 750 B.C. Present ht 38.5 cm.

collapsing from the platform of a chariot, is about to lose his helmet to an opponent armed with a square shield. He himself wears the so-called Dipylon body shield, distinguished by the scallops cut into each side. To his right, partly preserved, is the doubled-up corpse of his charioteer. Among the other soldiers, fighting in twos and threes, long-range archers and swordsmen in close combat are packed into the same picture, another instance of the 'time dimension' of Geometric narrative painting. The action, however, is clear, and we can even distinguish the two armies by the presence or absence of the square shields. Clearly the square-shield army is having the best of the fray, but in the lower register a file of Dipylon-shielded reinforcements are hastening to the rescue of their falling comrade. The predatory-looking birds which accompany them impart a sense of doom, like the *oionoi* of epic battles (*Iliad* 1.5). Other details, too, combine to convey an impression of warfare set in the heroic past, coloured perhaps by the circulation of epic poetry: for example, the use of a chariot, which had no place in Greek warfare after the end of

the Bronze Age; possibly even the Dipylon body shield, if – as some have claimed – the painter consciously modelled it on the Mycenaean figure-of-eight shield; and especially the concentration of individual duels, feats of valour and the taking of booty, recalling the *aristeiai* of the *Iliad*. It must be conceded, however, that the generous spacing of the combatants is dictated by the needs of the simple silhouette technique, to avoid any overlapping, and any consequent loss of clarity. Even the dying warriors, further to the left, have to be carefully separated out, so that they do not at any point encroach upon one another.

What, then, are we to make of an apparently four-legged human figure at the left of the lower register, confronting a warrior with sword and spear? In view of the Dipylon workshop's very strict rule elsewhere about the avoidance of human overlaps, it is difficult to believe that the painter violated that rule here – and here alone – merely to show two warriors fighting side by side. Here, then, we have two human beings who cannot be separated: a pair of Siamese Twins. What, then, have the Twins to do with the grave-monument of an eighth-century Athenian nobleman? One of the foremost aristocratic families then in Athens was the Neleid *genos*, who claimed descent from King Nestor of Pylos. Among that old hero's exploits, in his younger days, was his victory in single combat over the Aktorione or Molione (*Iliad* 11.709–10) whose bodies, according to Hesiod (fr. 17b, ed. Merkelbach and West), were joined together. In later Geometric art the Twins appear nine more times; their most circumstantial appearance is in an extended scene wrapped round the belly of an Attic oinochoe (Agora P4885), painted in the Dipylon tradition around 730 B.C. This scene, too, includes a chariot, with its 'heroic' connotations; the Twins, hiding behind a single square shield, attempt to make an inglorious escape on their vehicle as their opponent attacks them with spear and sword. Thus, when the Dipylon Master first brought the Twins into his workshop's repertoire, he was portraying an *aristeia* performed by the hero Nestor, ancestor of a leading noble clan of his own day. The duel with the Twins, separated off from the main scene of action, looks like a family crest. In this curious way began the art of mythical representations in Greek vase-painting, as a form of family history.

If the Twins are rightly identified, their obvious physical deformity enables us to recognise a particular story in the Trojan saga; but how could an Attic Geometric vase-painter, working in an impersonal

silhouette figure style, convey a particular story to us when all the agents are normal human beings? Painted inscriptions, naming individual deities or heroes, were not used on pottery before the seventh century. Thus any Geometric picture of normal human activity might seem no more than a genre scene from everyday life, unless we are shown some circumstantial details identifying a specific tale from heroic saga.

In this respect the shipwreck scene on the neck of an Attic oinochoe of *c.* 730 B.C. (Fig. 18) provides a borderline case. One man, perched upon the upturned keel, is clearly going to survive, while his ten mates flounder hopelessly in the sea and eleven fish await their prey. Could the scene refer to the shipwreck of Odysseus, who alone survived when all his companions perished after impiously slaying the cattle of Helios (*Odyssey* 12.403ff.)? If so, this would be the earliest reference to the *Odyssey* in Greek art. At all events, whatever this painter may have intended, his theme could easily be distorted by later imitators, and thus lose any clear reference to a particular story. About a generation later, a krater from Pithekoussai shows a much less precise picture of a shipwreck: five men, eighteen greedy fish, no survivor, and no obvious reference to any epic story known to us. Thus, in looking for early experiments in portraying mythical scenes, we must search out the work of progressive innovators, before their new ideas become distorted and fragmented in subsequent imitations.

18. Oinochoe, neck scene. Shipwreck. Attic Late Geometric II, *c.* 730 B.C.

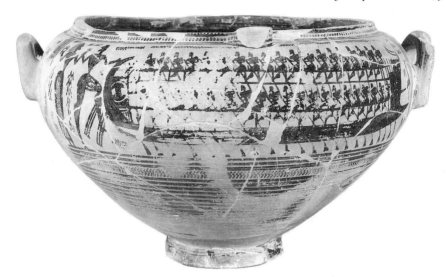

19. Spouted krater. Ship scene. Attic Late Geometric II, *c.* 735 B.C. Ht 30 cm.

One such innovator painted a spouted krater now in the British Museum (Fig. 19), slightly earlier than the Attic shipwreck oinochoe. Although strongly influenced by the Dipylon tradition, his iconography breaks much new ground. On the reverse is the first Attic horseman (a subject rather more to Euboean taste, as we have seen) and also one of the first charioteers to wear a long robe, nearly three centuries before the famous bronze statue from Delphi. On the front side we see the first woman convincingly shown as such, with long hair and latticed skirt; and also the first ship with two ranks of rowers – presumably the port and starboard rowers on the same level. Given this artist's originality in other respects, was he also trying out a new experiment in the ship scene? A man steps towards the departing ship, gripping a woman's wrist. To judge from his energetic forward gesture, he is haling her on board. The circular object which she so ostentatiously flourishes in her right hand should warn us against dismissing this picture as a mere genre scene. Later vase-painters from the seventh century onwards often identified mythical figures by personal attributes, like Zeus's thunderbolt, or Herakles' bow; could this inventive Geometric painter have set a precedent for them? Several heroines have been proposed, but a good case has been made for Ariadne, whose recognised attribute (Pausanias 5.19.1) was the

Crown of Light with which she lit up the Labyrinth while Theseus slew the Minotaur. This scene would show her escaping with Theseus from Crete, when no Crown of Light might be needed; but the purpose of the attribute, as in later vase-painting, is simply to identify a mythical character rather than to lend circumstantial detail to the scene portrayed.

Taking the Theseus story as an example, let us now see how our painter's new notion might soon be garbled by his followers and imitators. Several amphorae and hydriai in the last years of Attic Geometric (*c.* 725–700 B.C.) show women carrying similar crown-like objects, now linking hands in a dance. If we follow the Ariadne hypothesis, perhaps an allusion was intended to a later episode in the same story: the Crane Dance which the young followers of Theseus and Ariadne performed on Delos, in thanksgiving for their deliverance from the Minotaur. One suspects, however, that the theme very soon became generic, and that the latest Attic Geometric painters may have lost touch with any intended mythical connotation. Even so, we can see a daring improvisation on the theme of the ship krater, painted in a Subgeometric style of *c.* 690 B.C. on the neck of an oinochoe (Fig. 20) by a Euboean expatriate somewhere in Italy. The field allows space for only five dancers, but this is no ordinary dance. Men and women alternate; and, very explicitly, the two women wear topless and flounced dresses in the old Minoan and Mycenaean manner, as if they belong to a remote past. The usual linking of hands is significantly broken at one point, where the central man caresses a woman's breast; and she conspicuously flourishes a circular object similar to that held by the lady in the Attic ship scene. If that lady is Ariadne, then here we see her again, together with her lover Theseus and some of her companions, engaged in a dance. By making the outermost figures plant their oars in the ground, the painter is telling us that the party has just arrived by sea. There is also a large marsh bird which emphatically breaks the rhythm of the usual filling ornaments; indeed, this Crane is allowed to proliferate all over the vase. In brief, the painter has combined in one picture all these attributes and circumstantial details, together with the archaising female dress, to distinguish a particular story – the Crane Dance on Delos – from what would otherwise have been an ordinary genre scene. The sacred island of Delos did indeed receive visitors from Euboea at this time, to judge from the imported Euboean pottery found there among the votives; and by 700 B.C. the great sanctuary of

20. Oinochoe. Euboean colonial
Subgeometric, *c.* 690 B.C. Ht 35 cm.

Apollo and Artemis would already have witnessed the recitation of
Ionic epic poetry, especially of stories about Delos. Given the
wide-ranging travels of the Euboeans elsewhere, and also their lively
interest in the Ionic epic tradition, we should not be too surprised to
find a Euboean vase-painter in the far West making an early attempt at
mythical representation.

Geometric figured art may have had many different aims, varying
from region to region. In the Argolid, and in earlier Euboean work,
we have seen some extracts from daily life, with a special concern for
the taming and rearing of horses. The Cretans, at a surprisingly early
date, present a repertoire of pure fantasy: sphinxes, griffins and
man-eating lions, inspired from the East; at the same time, hunting
scenes and goddesses of nature, inherited from the Minoan past. In

Athens there appears, almost out of nowhere, a grand tradition of monumental vase-painting in honour of the dead. As an offshoot from that tradition, the family pride of the Neleid clan conjures up the strange apparition of the Aktorione–Molione Twins which, as a freak of nature, constitute the first intelligible reference to a mythical story known to us from epic poetry. Finally, we have followed the legend of Theseus and Ariadne to trace the first faltering steps of Greek vase-painters in the rendering of heroic stories concerning ordinary human beings. Not very far into the seventh century, the technique of presenting heroic and mythical scenes had been fully mastered, through personal attributes, through circumstantial details and – when needed – through painted inscriptions naming the characters. The Late Geometric scenes allow us a tantalising glimpse of an experimental stage, when the first attempts to convey mythical subjects might well have been in advance of their time. We have seen how easily these attempts could be misunderstood, simplified and garbled by imitators, and thereby reduced to genre scenes, or even to mere decoration. The art of portraying a mythical story was not learned in a day; but much valuable experience was gained by the imaginative pioneers of the late eighth century B.C., one of the most creative periods in the history of Greek art.

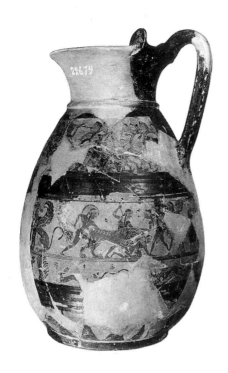

other colours are to the fore, notably purple, and – most significant – shades of brown for many details including all male flesh parts. Corinthian vases often show a marked taste for polychromy, but this particular polychrome style, with its inclusion of a brown wash, is found only in the years around and slightly before this vase. The richness of effect is further heightened by added white motifs (which have partly flaked off) painted on dark areas of the vase: floral designs on the rotelles, neck, and top of the shoulder; between the upper and middle friezes a narrow band of coursing dogs, deer and wild goats (visible at the bottom right of Fig. 22), and white dots on the raised ridge between shoulder and neck.

It was vases like this that set the fashion for long, narrow friezes which were to dominate the decoration of larger shapes at Corinth and elsewhere for a long time. The vase-painter then had to use his ingenuity to fill their whole length with a sufficient number of figures. To most contemporary Corinthian artists this provided no problem: they simply stocked their friezes with rows of animals, parading or arranged heraldically. But the Chigi olpe is one of a comparatively

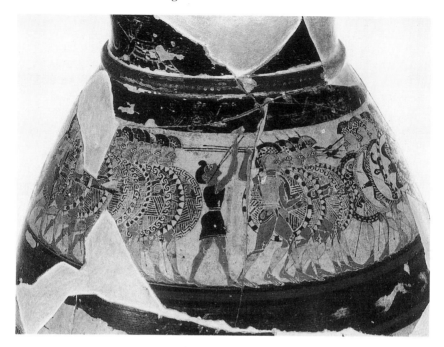

22. Detail of olpe of Fig. 21. Hoplites in battle formation.

few Protocorinthian works where the human figure is dominant. Here
there is in fact only one animal in the major friezes that is outside any
narrative context: the winged sphinx in the central frieze (Fig. 21*b*);
and no ordinary sphinx, this, but – another probable 'first' – one of the
double-bodied monsters (the left half is mostly missing) often seen at
Corinth from now on. The sphinx is a creature from Egypt, and the
original home of double-bodied mutants is even further east, as one
sees them on Sumerian cylinder seals and later on Iranian goldwork;
but the conceit of combining the two ideas may well have been
thought up at Corinth. Greek Orientalising is very rarely straight
copying of Oriental.

The same applies to the adjacent lion hunt. Xenophon (*Cynegeticus*
11) wrote that in order to hunt lions one had to go to 'foreign parts'
(such as Asia Minor); though according to Herodotus (7.125) they
were common enough in the fifth century near the frontiers of
northern Greece. But in any case the lion here is not drawn from real

life; it is markedly Assyrian in style, and it stands right at the head of a very long line of lions of this type on Corinthian pottery. The human-mauled-by-lion motif is a commonplace in the Near East, especially on ivories; but with the figures of the huntsmen, who are far more animated and intent on their task than any of their Eastern counterparts, the vase-painter has lifted the narrative above the level of mere Oriental grisliness.

The scene to the right of this, under the handle, is very fragmentary. Looking at the figures of Hera, Athena and Aphrodite, of whom Fig. 23 shows just about all that remains, one is reminded of Homer's favourite epithet for goddesses: 'with beautiful tresses' (*euplokamos*). Each may have held a flower as they are led by Hermes,

23. Detail of olpe of Fig. 21. Hera, Athena, Aphrodite.

24. Detail of olpe of Fig. 21 (drawing). The Judgement of Paris.

the tip of whose staff alone survives, into the presence of Paris (Fig. 24), here given his alternative name of Alexander. This is the earliest extant Judgement of Paris, and the inscriptions provide one of the first sets of legible captions in Corinthian vase-painting.

The last sequence in this zone is a parade of horsemen led by a charioteer. Whether we are still in the realm of myth here or of everyday life is uncertain, as is also the case with the upper frieze, though there the depiction of armour and battle formation is contemporary (Fig. 22). The latter scene has always been much admired for the ambitiousness of its composition of cleverly overlapping massed soldiers and the sheer brilliance of its detail, from the intricate shield emblems to the cheek-strap of the piper. One small detail further round the vase recalls another myth: a *gorgoneion* (Gorgon's head) on one of the shields. The story of Perseus was soon to be one of the most popular in vase-painting, and the fearsome severed Gorgon's head, of which this again is one of the first known, was appropriate enough for the decoration of armour. The Chigi Painter (alias the Macmillan Painter) painted another below the handle of a small perfume-flask, a work no less famous than this one: the Macmillan vase in the British Museum.

Finally, the hunt at the bottom is one of innumerable such scenes on Corinthian vases. Usually they are cursorily executed, often reduced to mere hasty silhouette – but not this one, which is easily the most elaborate. The illustration could well be a slice of contemporary Greek life; indeed the pursuit of hares on foot accounts for the greater part of Xenophon's treatise on hunting already mentioned. But the inclusion of reeds and stylised thickets recalls a number of Egyptian and Phoenician hunting scenes, and this unusual consideration for the natural setting may well have been inspired, even if only in a general way, by Near Eastern art.

It is just conceivable that someone with sufficient ingenuity could find a connecting thread running through all the major scenes on the Chigi olpe; or they might be illustrative of some epic poem now lost. But it is unlikely. Many Greek vases of all periods show quite unrelated scenes at different levels or on opposite sides, and there is no need to search for unity of theme at this early date even on such a rigorously planned work.

Corinth between East and West

Although innovatory in so many ways the Chigi olpe is an exceptionally mature work, effortlessly casting Oriental elements of style and subject-matter in a form that is entirely Greek. Such elements may not be dominant in the decoration of this vase, but earlier they had been the trigger for the Protocorinthian style; and they are ideas borrowed from the Near East, especially from Phoenicia and North Syria, which in turn were in close touch with Egypt and Assyria with their extremely long traditions in representational and narrative art. The new interest in the East (or rather, renewed, as there had been close contact in the Bronze Age) was one facet of the expansionist movement that began in the eighth century B.C. and resulted in the foundation of Greek colonies around the whole Mediterranean basin. Even before this time impact from the East was felt in various parts of Greece, notably on Crete (p. 43) where it gave rise to the strongly curvilinear designs of the vase-painting style that has been given the cumbersome name of 'Protogeometric B'. But the role of Crete in the transmission of eastern motifs to the rest of Greece, though once considered important, seems now to have been small, and its Oriental-style vase-painting an isolated experiment that had little influence beyond the ninth century. Orientalising proper begins at Corinth about 720 B.C., a couple of decades or so earlier than any other centre in Greece. A small round aryballos (perfume-flask) of around the turn of the century gives a spirited rendering of the new style (Fig. 25), which Humfry Payne characterised as 'the power to draw with a free hand', and which is visible not only in the figure-drawing but equally in the exuberant plant ornaments (for later examples of these see also Fig. 27). All the motifs in the main frieze are new to the Corinthian tradition, and they are painted with remarkable freedom and vitality, especially the lion (or hound) in pursuit of the deer. The technique is a mixture of outline drawing, silhouette, and, for the deer, flecks of incision. In comparison with this piece the austere discipline of the earlier Geometric style seems something of a strait-jacket.

We talk of 'influence', 'impact', 'transmission', but the mechanism of influence seems not to have been straightforward and is certainly far from clear today. It was not eastern pottery that the vase-painters were inspired by, for that was for the most part given minimal decoration. It was work in other media, perhaps in monumental

25. Opposite sides of
Protocorinthian
aryballos. Name-vase of
the Evelyn Painter. *c.* 700
B.C. Ht 6.8 cm.

sculpture which Greeks would have noticed in the Neo-Hittite states
of North Syria, though vase-painters are unlikely to have seen this at
first hand; more likely it was work in ivory, metal, terracotta and
perhaps textiles, which was being imported in quantity, accompanied
in some cases by the craftsmen who worked these materials. Hence it
is no surprise that some of the closest (and earliest) Greek approxima-
tions to Oriental style are in metalwork, where no transference from
one medium to another was involved as it was for pottery. But why
were the Corinthians first off the mark with Orientalising vase-
painting? Their relations with the Near East do not seem to have been
especially close, for although their city controlled major ports, the
considerable quantities of eastern goods that have been found in its
territory, at the Perachora sanctuary in particular, are no more striking
than in other areas of Greece; nor is there any evidence that Corinth
showed much interest in the movement to set up trading-stations
along the Syrian coast. Of course there may be some specifically
Corinthian emporium still awaiting discovery in this area, but at Al
Mina, founded *c.* 800 B.C., there is no Corinthian material among the
Greek pottery from the site before the early seventh century, and that
need not have been carried there by Corinthians. It is usually argued
that the new style was adopted purely as a matter of artistic choice:

Corinth's Geometric had a far narrower range of motifs than Attic, which was preoccupied with scenes with human figures, whereas the former did not admit them and even excluded all fauna but for birds; Corinth was therefore ripe for change. Yet it could equally be pointed out that much of the latest Attic Geometric is ragged and appears in real need of some new stimulus, whereas Corinthian has fewer pretensions but a delicate self-assurance. Athens might easily have been the first to break the Geometric mould.

In any case the adoption of Orientalising at Corinth must have been a conscious decision on the part of a particular potter (or his client or an entrepreneur), presumably the man who was the instigator behind what is now known as the First Outline Group, to which the painter of the pot shown in Fig. 25 was a successor. It may also be significant that the first pots to receive the new style of decoration seem to have been the round aryballoi, small flasks designed as dispensers for perfume or scented oil. These were exported far and wide, but no doubt many of them were filled at Corinth itself, which clearly was trading in perfumes and unguents as well as in the containers for them. According to Pliny (13.2) Corinthian scent was famous, but neither he nor anyone else says anything about its source; however, some of it is likely to have been imported from the Levant, as well as from Asia

Minor and later from Egypt, all areas which traditionally were renowned for such products. A few years ago Martin Robertson pointed out the coincidence of the new Orientalising style appearing on flasks with probably eastern contents, and one could argue further that the decoration was designed specifically to draw attention to, in fact to advertise, the exotic substances within. The new style then spread almost immediately from the aryballoi to the larger shapes, the oinochoai (jugs) and *kotylai* (cups). This line of argument is only hypothetical, but can now begin to be tested by scientific techniques capable of analysing residues on the insides of pots. Corinth was in an ideal position for trading her products, with harbours on both the Saronic and the Corinthian Gulf, and the majority of the earliest Orientalising aryballoi went to the west Mediterranean, especially to Cumae and to the Corinthian colony of Syracuse. During the next generations this export was greatly increased, and there were convenient staging-posts for westward-bound Corinthian traders at Ithaca and their own colony at Corcyra (Corfu). By the end of the seventh century Corinthian vases were in demand everywhere, but the western trade (including that with Etruria) remained the most important.

Decorative techniques

Novel themes as decoration encouraged new painting techniques. On Fig. 25 the old silhouette technique of Geometric is retained only for the horse and deer, the rest is all done in outline. In scenes of any complexity the ungainliness of the Geometric style, where overlapping has to be avoided and inner detail is lacking (p. 49), is immediately apparent, but outline painting provided greater flexibility. Yet despite its advantages the outline style – in this form – was remarkably short-lived, lasting only for a generation; later it would be taken up again for the depiction of details such as the flesh parts of female figures (as on Fig. 23), where the natural colour of the clay highlights the lighter flesh tones, and in the last half-century of Corinthian figured vase-painting it has an important part to play in narrative scenes (see below). But at Athens outline was in vogue throughout the greater part of the seventh century, and elsewhere Orientalising styles such as the Wild Goat pottery of Rhodes and Samos, of which Fig. 26 shows a fine-quality example of much the same date as the Chigi vase, persisted with a mixture of outline and

silhouette even longer. The most likely reason why such an obvious and easy technique of vase decoration was so quickly dropped in Protocorinthian is that it does not allow the figures to stand out clearly from the overall decoration. It is especially the case when the vases, or at any rate the friezes, are on a very small scale, even more so when this is combined with lavish use of filling ornament.

A later Protocorinthian perfume-flask of a new shape (*alabastron*) shows the black-figure technique that ousted outline painting (Fig. 27), and which in effect returned to the clarity of the earlier silhouette style of Geometric with added provision of inner details. The process of incising through a layer of gloss-paint to show up the light clay underneath is a far from obvious vase-painting technique but one that is closely related to that of much Near Eastern metalwork that was now being imported into Greece on a large scale. The parallel that springs quickest to mind is the Phoenician metal bowls of the ninth to seventh centuries, where the decoration in the interior is carried out in a combination of repoussé and engraving. But whereas on these the

26. East Greek Wild Goat oinochoe, detail. *c.* 640 B.C.

27. Protocorinthian alabastron. Griffin. *c.* 670–650 B.C. Ht 5.7 cm.

engraving is carried round the contours of figures, in black figure the incision is used primarily for interior detail, only sparingly for outlines. It was not only Corinthian vase-painters whose work was influenced by the Phoenician bowls: they had their effect at Athens too, where an extensive group of Late Geometric cups has a frieze of animals (now geometricised) painted in an identical position in the interior.

Corinthian black figure often includes added colours, but a small group of vases of the central two decades of the seventh century takes this further with the inclusion of a brown wash which has already been noted on the Chigi olpe. The result is a true polychromy where the main colours – brown, black, and purple – are fairly evenly balanced against the light background. Later, in the following century, the painters of the red-ground vases (Fig. 29) achieve rather similar effects, but their work is on a larger scale and the colour balance is different. The fact that on the Chigi vase and its fellows the polychromy is usually combined with ambitious narrative scenes has induced many to argue that the vase-painters are here to some degree indebted to contemporary Corinthian monumental painting, for the existence of which there is some evidence. First there is the testimony of Pliny (35.15), who states that painting was actually 'invented' at Corinth or nearby Sicyon. Then there are the painted metopes of Thermon, which are quite close in style and colour scheme, and which too are of fired clay. Finally, two early Corinthian temples had at least parts of their interior walls painted; in one case, a predecessor of the present Temple of Apollo, these were simply plastered and painted solid black or red, though a painted terracotta plaque from here shows what may be a tree painted in brown. The other is the Temple of Poseidon at Isthmia a few miles away, where fragments of wall-plaster (probably from the interior) show designs such as a meander and even part of a horse's neck, painted in a wide colour range that includes dark purple and light yellow. Admittedly these are scraps only, but they are of the mid-century for both temples, and sufficient to indicate that at this early date monumental figurative painting did exist. However, they do not solve the question of how far the Chigi Painter was indebted to it. Apart from the colour scheme which he presumably in part borrowed, he may have come closest to it with the battle scene of Fig. 22 with its crowded, animated composition and subtle depth of field, but this is only the finest of a number of such

Protocorinthian infantry engagements (which vary in their detail) and there is no need to postulate a particular 'lost prototype' for it as Payne did. Polychrome vase-painting is also found in other parts of the Greek world at this time or soon after, and it is possible that much of it, including some well-known pieces produced at Megara Hyblaea in Sicily, was inspired by Corinthian example.

Mythological narrative

Chapter 2 has shown how Late Geometric vase-painters developed scenes with narrative content, to which in certain cases a specific mythological interpretation can be applied; but the first unambiguously mythological scenes occur in Protocorinthian early in the seventh century. Such vases, it is true, form a very small percentage of total production at Corinth, but before the time of the Chigi olpe and its Judgement of Paris they include a Suicide of Ajax (which is more popular later), a Rape of Helen, battles with the Centaurs, Bellerophon and the Chimaera (twice), and later their number and frequency increase greatly. To treat vases as vehicles for story-telling was an entirely novel approach, but one of its consequences is that to appreciate the narrative one has to a certain extent to ignore the shape of the vase. Nowhere is this more true than for Protocorinthian, where friezes are long and narrow, and vases often slender (especially the increasingly attenuated aryballoi). Hence the criticism frequently levelled at this whole branch of Greek art, that it is not really vase-painting at all, but paintings on vases. From this standpoint it is worth comparing the Chigi olpe (Fig. 21) with the Evelyn Painter's aryballos (Fig. 25).

Where did the idea of decoration in the form of mythological narrative spring from and what need did it fill? There is no general agreement here, but many possibilities. Some have gathered evidence to show that there was in this period increased awareness of the Mycenaean past and of the stories surrounding it, of which Homer's epic poems are but one strand. Others would give an explanation wholly in terms of Oriental influences, and would argue that the myths themselves are mainly of eastern derivation; whereas a convinced structuralist would only expect to find similarities (similar creation stories, monsters and so forth) in two such rich mythologies

as those of Greece and the Near East, and would account for them in terms of universal modes of human thought rather than of borrowing. But we ought to distinguish between the idea of story-telling in art and the content of the stories portrayed. The Greeks could easily have learned the former from eastern example, from imported metalwork and the like; they are also likely to have picked up at least some tales from the East, but on retelling them – whether in poetry or pictorial art – they quickly adapted them to their own cultural environment.

An obvious Oriental figure is the Chimaera. Moreover, the encounter between Bellerophon and the monster was thought to have taken place in the eastern Mediterranean, in Lycia; and a rare variant form in Protocorinthian showing the creature with a human head, not a goat's, growing from its back, has very close parallels in Neo-Hittite art with a relief slab from Carchemish now in Ankara. Less clear-cut is the case of the Hydra, whose destruction by Herakles is shown as early as *c.* 700 B.C. on Boeotian engraved bronze *fibulae* (brooches) and is suddenly popular on Corinthian vases of the first half of the sixth century. In the East too the story of the struggle between a hero or god and a many-snaked monster was commonly told, and we see the encounter not only on a Hittite relief (where this should be the Storm-god overcoming the fiendish Illuyankas) but also on Meso-potamian cylinder seals of the 3rd millennium B.C. Some stories in Greek mythology may have been invented to explain images in Near Eastern art which the Greeks did not comprehend: so the Chimaera comes to grief at the hands of the thoroughly Greek hero Bellerophon from Corinth, while the Hydra sequence is 'naturalised' by being set firmly in the environs of Argos.

Inscriptions

The sequence of soldier and rider on the aryballos of Fig. 25*a* has been interpreted recently as the ambush of Troilos by Achilles outside Troy. The fact that the scene would then have no connection with that on the other side (the attack on the deer) is of little consequence, as the Chigi olpe shows. But the interpretation does not convince: the figures are without attributes, there is no hint of a setting (which should be at a fountain), and 'Achilles' seems in the wrong pose for an ambush. Another possibility is that the rider goes with the two

animals, is in fact out hunting, but that still leaves the hoplite warrior unexplained. In short the scenes are ambiguous (at least to us). The same difficulty exists with many other early representations, especially in Attic Late Geometric where the painter is still more hampered by limitations of technique. Even after the adoption of black-figure at Corinth such ambiguity often remains – until the appearance of painted inscriptions (Fig. 23). Of all the borrowings from the East the adoption of the Phoenician alphabet had the most far-reaching consequences and it was soon being put to uses which were unfamiliar in its area of origin, where writing as a means of clarifying the subjects of figure scenes on portable objects was extremely rare. That the Greeks appreciated the inclusion of these aids as much as we do (who know the cultural/mythological background far less well) is apparent from Pausanias' description of the carved cedar-wood 'Chest of Cypselus' dedicated at Olympia. Probably made at Corinth in the seventh or sixth century, the chest was decorated with registers of mythological scenes, many of the figures labelled with winding archaic writing that Pausanias (writing in the second century A.D.) had to struggle with. But he tells us (at 5.19.7) that where there are no labels he can only guess at interpretation, except in cases like Herakles and the Hydra for whom no inscription was needed 'because Herakles is easily recognised by his labour and pose'. Similarly we today would have no real difficulty in recognising the Judgement of Paris on the Chigi olpe, simply from the way it is composed, though it is helpful that the labels confirm it. Conversely some captions are no help at all, and it is doubtful that even Pausanias would have made much headway with the scene shown on Fig. 29: one of the warriors is labelled 'Charon', but this cannot be the Ferryman of the dead and gives no clue as to what battle is intended.

Painted inscriptions were also added on occasion for potters' and vase-painters' signatures. It was a practice that became common at Athens after the middle of the sixth century (see Chapter 10), but Corinthian painted pottery was virtually dead by them, and so the names of only two Corinthian vase-painters have survived. Timonidas was a painter of some competence, but the other (Chares) cannot be ranked too low. The Chigi Painter is of course nameless, but what his letter-forms (Fig. 23) tell us is that he was not in fact Corinthian after all, although everything about his style is. He may have originally come from the island of Aegina.

28. Corinthian pyxis. *c.* 600 B.C. Ht (with lid) 13.7 cm.

The animal style

Most Corinthian vases display animals and floral ornaments only. Here the links with the Near East, where animals had been a staple in all media for centuries, are very close. Many species, both real and fabulous, are borrowed outright: including the Neo-Hittite and Assyrian types of lion, the sphinx, griffin, even the domestic cock (the 'Persian bird' as Aristophanes calls it). The Oriental influence extends to the way the animals are represented, not only in files (Fig. 28) but also heraldically confronted as on the fine alabastron of Fig. 27, where two griffins are shown confronted either side of a tall floral ornament or 'sacred tree'. There is no narrative element in most of these representations; even the lion tearing at its prey is avoided. Furthermore the religious/mythological significance of motifs such as griffins or the 'sacred tree' seem to be completely ignored (in Assyria

griffins and griffin-demons possessed formidable supernatural pow-
ers): it is the image alone that is borrowed, not the meaning that it
once may have conveyed in its original context in Assyria or Egypt.
That was in any case often already diluted when these subjects were
transposed to the small-scale decorative art of North Syria that
provided most of the models. The vase-painters were more interested
in experimenting, adapting their models, creating new visual effects
and fantasies. Oriental lotus friezes are subtly changed into designs
(Fig. 27) that would form the basis for Greek floral patterns for
centuries to come. Instead of friezes of animals all facing in one
direction, as in Oriental and Greek Late Geometric practice, there is a
preference for the flow to be interrupted: by the male and female
panthers heraldically disposed, on the lid of the pyxis (trinket-box) of
Fig. 28, and by the right-facing panther on the body. The predators,
quickly tamed, pad around the vases unmenacingly, mostly oblivious
to the presence of their fellow creatures, while the imported monsters
give rise to new generations of unlikely hybrids: lion-sirens,
griffin-birds, even a double-bodied gorgon-siren.

There is much more animal-style (Ripe) Corinthian pottery than
there is Protocorinthian; the Transitional style that divides them (on
the continuum) lasts from about 630 to 620 B.C. or a few years later.
Many recent studies have been directed towards distinguishing the
work of individual Corinthian painters, some of whom display a
competent standard of draughtsmanship and composition. But the
quality is highest in Protocorinthian, especially in precision of contour
and incision, and where the animal style is concerned Corinthian has
little to add to these earlier achievements other than deterioration in
execution as the popularity of the style throughout the Mediterranean
results in increased mass-production. A good index of the latter is the
filling ornament which thickens and develops at an even pace. In
Protocorinthian it consists of a light scattering of varied ornaments,
not just rosettes; whereas neat stalkless dot rosettes are the hallmark of
Transitional, and incised rosettes (often hastily executed) are one of
the indicators that the Corinthian style has arrived (Fig. 28) or is just
about to.

Greek vase-painters show a penchant for filling ornament from the
time of the earliest figure friezes in Late Geometric, where it serves to
ensure that the figures do not stand out too much to disrupt the overall
balance of light and dark of the decoration. But the thick filling of the

Corinthian animal style is of a different order, the rosettes and blobs tending to take up more space in the field than the animals. The effect is almost tapestry-like, and influence from imported textiles has even been seriously proposed, but that does not explain the gradual build-up of filling over several decades. The taste for incised rosettes is carried from Corinth to workshops in other parts of the Greek world, though to varying degrees. At Athens the avidly Corinthianising Polos Painter follows the trend wholeheartedly, while the Gorgon Painter in his animal friezes copies (and refines) the Corinthian menagerie while keeping the background mainly swept clear of filling – and to most modern tastes that in itself is a distinct improvement.

Red-ground vases

Vases with human figures are always in a minority at Corinth. After a minor surge of them around the middle of the seventh century they appear again in far greater numbers from towards the end of the century onwards. Their subjects are dealt with at length by Payne and Amyx. Some are very unusual, even unique, such as Herakles entertained by Eurytus, and a rare detailed depiction of the Trojan Horse on a large aryballos of *c.* 580 B.C.; others enjoy a mainly local popularity such as the padded dancers (which are taken up later at Athens and elsewhere) and the monstrous beings of varying degrees of humanity – with snake-tail (Typhon), fish-tail (Triton), all-man but winged (Boread) – which singly are frequently wrapped around the entire circumference of large alabastra.

A final flowering of human-figure scenes comes just before the mid-sixth century with a sequence of mostly larger vases painted by a talented group of artists who use plenty of added colour and paint the background with an orange-red wash. Again the mythology is varied, and there are also scenes of genre such as banquets and processions. The artist responsible for the lekythos (oil-flask) of Fig. 29, though typical in his fondness for white paint, is unusual in using it for entire male nude figures, achieving a result rather similar to red figure with inner lines painted in; by this means he even manages to draw in a rolling pupil for the eye to suggest loss of consciousness, an effect that Athenian red-figure artists were trying out again fifty years later. But

what is most significant about these vases is the red wash: this was obtained from a different clay from that of the fabric of the pot, for the standard Corinthian pottery clay is without iron compounds and fires normally to an off-white. The reason, often asserted, behind such an elaborate procedure may be that this was a last-ditch attempt to compete for export markets which Attic vases were now beginning to seize, by aping the colour of Attic clay. If this was indeed the case then the disputed market seems to have been Etruria, for the majority of

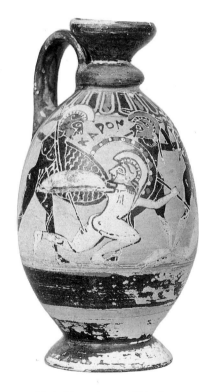

29. Corinthian red-ground lekythos attributed to the Tydeus Painter. *c.* 560 B.C. Ht 15 cm.

red-ground work has been found there (especially at Cerveteri). There are also other factors one can point to that show that Attic production was being carefully monitored at Corinth at this time: for example, all the vase shapes illustrated in this chapter (excluding of course the East Greek jug of Fig. 26) are inventions of Corinthian potters – with the exception of the lekythos of Fig. 29, which is one of several Attic shapes the Corinthians had now begun to copy. But another school of thought sees the innovation of red ground entirely in terms of artistic choice, and would argue that a darker background was created simply to enhance the overall colour scheme, and that added white in particular is set off better against an orange-red colour than an off-white. In fact the two theories are not mutually exclusive: red ground was perhaps introduced initially for commercial reasons, whereupon the aesthetic potential of the change may have been immediately apparent and was then exploited further.

The mid-sixth century sees the end of Corinthian vases with figure scenes; but work continued in the Potters' Quarter on a large scale with the production of plainer ware with banded and floral decoration, also coarse ware, storage vessels and transport amphorae. Later in the fifth century there is even a little figure work again in the form of Athenian-inspired red figure and vases with outline painting (the Sam Wide Group).

A floral pot

Much of this chapter has focused on a quite exceptional work, the Chigi vase. It may end with a final illustration (Fig. 30) from the opposite end of the spectrum, one which takes us back again to Orientalising. The aryballos here is the remodelled round shape of Ripe Corinthian, and Payne has traced the ultimate origin of its quatrefoil ornament to a design of alternate lotus flowers and cones seen on carved threshold slabs from Assyrian palaces; the flowers have become meaningless lattice-work shapes, the cones bud-like leaves. In this case the medium of transmission was almost certainly textiles, which the stone carving seems clearly to imitate. The complete Assyrian design has a rosette at its centre, but the aryballoi display other devices here, often a small elongated oval. What is unusual about this example is the size and double contouring of the central motif, made to resemble the outline of an Egyptian cartouche, which

can only have been inspired by aryballoi with legible cartouches on their bodies that were actually being made in Egypt at this time and exported from Naucratis.

Great quantities of such perfume flasks (also with cinquefoil and sixfoil and other even simpler patterns) were produced at Corinth in the first half of the sixth century, and they continue well after 550 B.C. Elsewhere too vases with simple floral designs are common, and one may cite as an example the numerous class of Attic lekythoi decorated with palmettes only. Such works are rarely illustrated in books on vase-painting, and yet some of them at least were painted by the same craftsmen who turned out figure work, and they served exactly the same purposes, only at the lower end of the market. The Corinthian aryballoi, floral, figured and patterned, were exported in enormous numbers and quite often ended up in burials in huge numbers as well, but the reason for their purchase in such quantities is far from clear. A

30. Corinthian quatrefoil aryballos. Second quarter of sixth century B.C. Ht 8.6 cm.

certain quantity of scented oil was needed for anointing the body and for purifying the grave; but a single sixth-century grave at Rhitsona in Boeotia is not untypical of its cemetery in producing out of a total count of 297 objects 6 Corinthian alabastra and no less than 253 Corinthian round aryballoi of various categories of decoration, including quatrefoil, but hardly anything of much artistic merit. There is much food for thought here concerning the uses to which painted pottery was put both in daily life and in funerary contexts. But what the evidence from Rhitsona and other sites emphasises is that vase-painting at the major production centres such as Corinth was an industry, and this applies to figured work as well as the plainer products. It would seem that potters, in whatever hurry they had to operate, could always produce work of very fine quality at the wheel, but the greater bulk of the painting is on the level of competence rather than artistry; comparatively rare are the artists of real excellence (on this see Robertson's remarks in Chapter 1). There are exceptional periods, certainly, when the standard is uniformly high: at Corinth this is true of the period of *c.* 700–630 B.C., at Athens of red figure of *c.* 520–470. Yet even these phases are not devoid of modest craftsmen turning out honest but unpretentious work in bulk, and worse, of hacks attempting effects way beyond their level of skill. However, even the most mundane product, like that of Fig. 30, can raise many interesting questions.

4

The sixth-century potters and painters of Athens and their public

JOHN BOARDMAN

It is through no accident that Athens commonly occupies the centre of the stage in Greek studies, be they of art or of literature. Even in pottery studies Athens' role appears to have been crucial as early as the Greek Dark Ages (see Chapter 2), but in the sixth century it becomes dominant in terms of volume of production, of variety of shapes, and of influence on the wares of other cities, which, by the end of the century, fade from serious competition in production of the finer vases. It is not easy to relate this dominance to Athens' political or military status in Greece, nor to any exceptional role she played in Mediterranean trade. We would do better to reflect that dominance in the production of what were among the cheapest decorated objects of the day must be a far less important indicator of status than, for example, the production of fine bronzes; and that the indestructibility of fired clay has determined a grossly unbalanced survival rate in favour of pottery. But for the student 'looking at Greek vases' Athenian black figure, from the second quarter of the sixth century on, offers the first major concentration of shapes and of varieties of figure decoration to challenge his understanding of the purpose of the vases and the message of the figure scenes they carry. This chapter is largely concerned with the problems of deciphering the message of these scenes, of what the painters chose to depict and what their customers expected and understood, but it cannot ignore other aspects of the vases, and indeed of other arts.

There is danger in regarding ceramics as in any respect a closed study and in thinking that pottery, especially pottery which displays the variety of Athenian black or red figure, can be interpreted wholly on its own terms. The pots have functions. They may be containers,

such as amphorae for wine, oil or solids, lekythoi for oil; they can be mixing bowls, such as kraters for wine and water; for carriage – of water from the well-house (hydriai) or wine to the belly (a variety of cups). They may serve ritual purposes – such as the tall-necked *loutrophoroi* with their connotations of death or marriage. And having answered or having been designed for any of the purposes named (and there are many others) they may serve as dedications, in sanctuaries or graves, or as articles of trade. A few may even be designed for dedication or for trade (see Chapter 9). But virtually all these purposes were also served by vessels in other materials, of which either very few (as in metal), or virtually none at all have survived. In the latter category we may count those of wood, which was probably the commonest material for cups and platters, and of skin (leather bottles and buckets). The names and appearance of vessels in these other materials we can judge from texts and from the influence they had on pottery shapes, which probably always represented by far the fullest range because clay is far more versatile than wood, metal or skin. This is most apparent in the turned shapes of some cups, plates and boxes, which derive from lathe-cut woodwork, some metallic spouts and attachments, and the heavy globular forms of skin containers (aryballoi, *pelikai*). Most, however, are determined by the myriad properties of clay, the first (after stone) and most versatile of all natural materials exploited by man.

The decoration of the pottery must also not be regarded as a subject for closed study. It may be doubted whether, with trivial exceptions, the decoration of metal, wooden or skin vessels was particularly influential, but on the Athenian black-figure vases we see figure scenes in panels or friezes such as might have appeared painted on wooden panels or carved in stone, to mention only the most obvious media. We need to decide both whether the vase-painter was to any major degree influenced by such media, and whether the repertory in such media was more extensive, before we judge the visual experience of the sixth-century Athenian largely in terms of what we know of the decorated pots he saw and used.

It is at this point that we face the question of choice of decoration and come to realise the extra dimension given to the study by our ability to distinguish the work of individual painters, and to determine workshop and master–pupil relationships. It is apparent that the painters did largely determine their subjects, otherwise individual preferences would not be so readily detected in their works. Such

freedom of choice must obviously have been answered by a willing market; production responded to customer interest, and customer interest was to a degree schooled by what was offered. So the painters were not working in a self-indulgent vacuum, and we may judge that in a society which was clearly highly conscious of, and presumably responsive to the world of images, our vase pictures might in a way give a good cross-section of what was judged relevant and significant. The value is only enhanced by the consideration that this is not 'high art' or for any specialised market, but is in every sense of the word popular. The general proposition has been explored in Chapter 1; here we explore it in the context of sixth-century Athens.

Given that there was some motivation in the choice of subject-matter, and that the medium had a message, we are required to read the message before we can hope to understand the motivation. The whole operation takes place on different levels, and we look first at what are conventionally regarded as myth scenes, that is, depictions of figures and events involving Greek deities and myth-history. The question – What is depicted? – may be deceptively simple. Figures are seldom, and according to no perceptible pattern, identified by inscriptions, and anything like a caption for a whole scene is virtually unknown (Sophilos' 'Games of Patroklos' is a rare exception). We may however share the ancient viewer's ready identification of many figures by dress or attribute. The importance of this aid even in antiquity is made clear by the many scenes in which the attribute – Poseidon holding a fish, for example – is made prominent despite its incongruity in the narrative involved. The image makes a statement of identity that goes beyond the figure's immediate function. Mood and action can be conveyed by gesture, from obvious belligerence to more subtle indications of, say, dismay, by a hand held to forehead. Most formulae are obvious; some may puzzle us, such as those that seem to suggest argument or demonstration by hand gestures. Sixth-century art may not be much dependent on close observation of life, but it does depend on knowledge of life and we have only to be wary of interpreting some gestures in modern terms. Studies in contemporary behaviour should be warning enough that the same gesture can, sometimes even in the same culture, mean opposite things. In Tibet an extended tongue is a friendly greeting. The gesture of thumb and forefinger forming a circle can indicate satisfaction or obscene abuse, sometimes in the same cultural environment.

The identification of most scenes depends partly on recognition of

dress, attributes and action, which we may largely share with the ancient viewer, and on *our* knowledge of recorded myth history. The ancient viewer's knowledge of *his* myth-history was acquired largely at mother's knee or from recitations of varying formality, from street corner to stage. We easily overestimate literacy from the prevalence of inscriptions and inscribed objects in antiquity (there are telling modern parallels that should warn us), and underestimate the importance of oral tradition and of images themselves as means of communication. Most people did not learn their myth-history from books; there were no canonic versions or texts. An oral tradition can offer as many versions as there are mouths, and they are all in their way valid. Not the least value of our study is to detect versions current long before they are met in surviving literature, and to compare differing versions of the same story either in different parts of Greece, or at different periods in the same city.

A story is developed in episodes, and in each episode there is movement in time and space through the narrative. Greek artists chose not to tell stories by successive images, although their art (the metopes on temples, for example) gave them opportunities for this strip-cartoon style of narrative. They preferred the single tableau, and that involved choice of moment; or, rather, we approach their problem in terms of 'choice of moment' as though they had to choose one shot from a film of the whole action, like a still outside a cinema. This, of course, is absurd. The moment of maximum action is not necessarily the most telling, but it generally is and this was the one commonly chosen. When it is not, this may be because the artist (and few vase-painters were so thoughtful) recognised that a moment of choice of action might be more significant than the action itself. This accounts for the many departure scenes for warriors, almost as numerous as the fights; and a prime example in our period is Exekias' decision to show Ajax brought to his senses after a fit of madness, and preparing suicide, rather than the bloody impalement preferred by most artists.

The presentation of action – generally something violent – offered no problems of identity for him or us, but the artist would characterise his figures not only by identifying attributes but by identifying actions, and he may add figures who are not relevant to the action but who are relevant to the story. This is a common device of pre-camera narrative art and seems puzzling to us only because we have become conditioned by photography to regard the instant of action as the

norm, and to search for reasons for deviation from it. We should rather recognise the ancient method, exemplified in archaic Greek art and especially on Athenian black-figure vases, as the natural one for an artist who has to convey his message in formulae. You will find that 'synoptic' is one of the many words used to describe the process, and it is as good a word as any. In some parts of the ancient world stories, mythical or historical, are told in successive images, sometimes in single large tableaux as on temple walls, but generally the viewer is presented with a single composition, whose action and dramatis personae he can identify and 'read'.

I illustrate an example from an Athenian black-figure vase which is more subtle than most but by no means taxing, and which is often used in demonstrations about Greek narrative. On Circe's island the witch Circe dopes Odysseus' companions, turning them into animals, but one gets away to warn Odysseus, who, fortified by a charm given him by Hermes, threatens Circe. In one tableau (Fig. 31) we have Circe, naked as becomes a witch, offering a cup (the stirring stick shows it is not mere wine) to a Greek, but he and his friends are already part-transformed into animals, and at the right there is one, untouched, who escapes to warn Odysseus; but that worthy is already approaching from the left, drawing his sword on Circe. Each figure

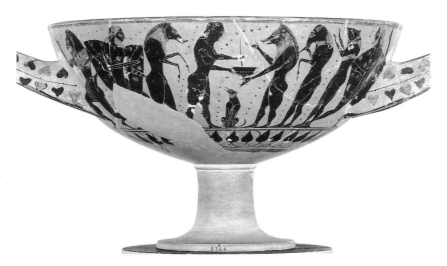

31. Attic black-figure cup. Circe, Odysseus and his companions. Name-vase of the Painter of the Boston Polyphemus. *c.* 550 B.C.

acts his appropriate part in the tale, even though they happened at different times, and their assemblage in one picture enhances the narrative effectiveness and should disturb us no more than it did its original customer.

To this degree we can share an ancient viewer's understanding of the presentation of a scene, but it may take us no nearer understanding the reason for the choice of subject, its ultimate message or messages. We may reasonably suppose that at the vase-painter's level the message was fairly simple, even banal, and that the motivation went little beyond the need to make a living from something marketable. We have to dig deeper to discover whether at that time and place a given scene had a special connotation. This requires knowledge of the environment and society, and in this we have to admit to far less competence than in recognition of myth scenes. The inventor or populariser of a scene, which may be copied by or otherwise inspire the vase-painter, may have had a simple motive and have expected it to be recognised by his public. (We might reasonably expect that many decorated vases were on public display in the Kerameikos, near the city agora, and open to the view of many who could not often afford more than a day's wage to buy one.) The viewers might respond in various ways: they might treat the scene as sheer narrative decoration, or they might recognise whatever special significance led to its use on the vase. They might mistake the message or read into it something that was not intended – easy enough given the way Greeks used their myth-history as parables for contemporary events and problems, a point to which I shall return. We too might easily enough mistake the message, but mainly through our ignorance of the situation in which it was presented. We should at least be able to avoid anachronistic mistakes such as we can detect in antiquity when, say, a second-century A.D. commentator such as Pausanias interprets a fifth-century B.C. work in terms of his own day and not that of its creator. That it must be impossible for us to understand a scene at any level (of its creator or of its viewer, mistaken or not) may be held by some scholars, but they continue to try to do so, and so, correctly, will the optimists among us. The rewards are too great to be thrown away, and the problem is no more demanding than most that face scholars who try to understand antiquity from the lacunose and often biased evidence that has been left us.

So what might determine the myth-historical subject matter of Athenian black-figure vases? At the simplest, vessel function might

suggest subject, and the Dionysiac and symposium scenes of later black figure must owe something to the fact that they appear on drinking-cups, wine-mixing bowls and jugs. The earlier pots too are commonly decorated with scenes of revellers ('komasts') or mummers. But then, these shapes account for a large proportion of the repertory, and they carry many other non-vinous scenes. It is becoming fashionable to think that, even in the sixth century, some formal or informal dramatic or lyric performances could inspire scenes, and it has long been believed that most scenes must derive from texts. This proposition does not stand up to close examination, and we have considered already the role of oral traditions, however informal. When it can be tested in detail, comparing poetic descriptions (as in pseudo-Hesiod's 'Shield of Herakles' or Stesichoros' poem on Geryon) with many vase representations, similarities are found to be generic only, and the sort of detail that a painter might stress is often treated in a quite different manner. It is, moreover, probable that some subjects, as treated in texts, derive from popular images which have various sources, sometimes non-Greek. There must have been many less formal occasions on which myth was recited or performed; and even if such were the inspiration for the painter, we may still enquire about the choice of subject.

When a new cult was inaugurated (a common practice well into the Classical period, often more for political than religious purposes), a myth to explain it was either adjusted or invented (an *aition*). New cults or new prominence given to old cults could also bring forward deities or heroes hitherto relatively ignored. The introduction of many countryside Attic cults to Athens itself seems to have been a feature of sixth-century tyrant-dominated Athens. The 'take-over' of the Eleusinian cult by Athens can account for the many new pictures of the local prince Triptolemos, who is given a special status as purveyor of agriculture to mankind (Fig. 32), riding his magic wheeled throne. The urbanisation of Dionysos from his previously rustic role, and his new status as patron of formal dramatic performances could account for his popularity as much as his relevance to the contents of the vessels decorated. The ubiquity of Athena might seem well enough justified by the fact of her being the city-goddess, but this goes far beyond what seems usual in the decoration of the pots of other cities. Her acropolis, new temple(s) and the reorganisation of her festivals (the Great and Lesser Panathenaia) might have proved enough, with or without new hymns or other performances, to guarantee her

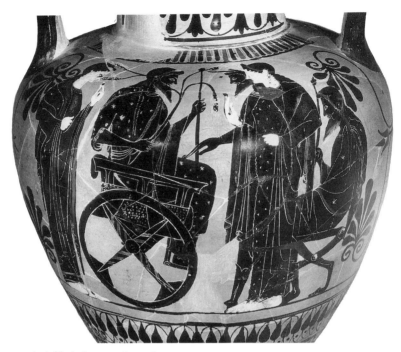

32. Attic black-figure neck-amphora. Triptolemos on his wheeled throne. *c.* 510 B.C. Ht 44 cm.

prominence in the minor arts.

It is easy to imagine a contemporary relevance for such scenes or the presence of such deities; others are more difficult to explain. The Greek use of myth as parable for contemporary events and interests has been remarked. So, a period of warfare might well generate myth scenes of battle or arming and departure for battle, many of them left unspecific and so more readily identified, at some level, with contemporary experience. Quite basic messages of heroism, patriotism, support for comrades, could be conveyed through myth, and thus too in art. When we ask why the exploits of some heroes rather than others are preferred we have to look deeper for the reason. Achilles is the hero of Troy, but on Athenian vases after the mid-century Ajax is prominent, and in the new democracy he will be an eponymous hero of one of the new tribes. He was not Athenian, but ex-Aeginetan and adopted by Salamis. Athens had been busy

acquiring Salamis earlier in the century; her claim could only be enhanced by acquiring Ajax at the same time as a favourite hero.

Theseus was an Athenian prince, and his famous fight against the Minotaur had long been popular in Greek, and becomes popular in Athenian, art. He saved the Athenian boys and girls from the beast, and all this properly Athenian activity is well recorded on the vases. Yet an even more important Athenian role was required for him by the end of the century, after the tyrants had been dismissed and the new 'democracy' created. The vase scenes show that a whole new sequence of adventures had been invented, and no doubt popularised in song, to guarantee Theseus' Athenian birth and build up his general heroic image and status, at least in Athens. In the fifth century he comes to represent Athens and her achievements against the Persians, and to be particularly associated with certain of Athens' leaders. All this is well recorded on the vases, yet why was it necessary if he was already established as an Athenian hero and monster-slayer? Many have observed how the new stories bid to make him look like a second Herakles, and this introduces to us the hero *par excellence* of sixth-century Athens, and his role on vases.

Theseus as a replacement for Herakles implies a role for Herakles comparable with that enjoyed by Theseus from the end of the sixth century on. In many respects this is even more apparent in media where we might expect such official recognition, the architectural sculpture that decorated the temples and public buildings of Athens. Through the sixth century Herakles is far more often represented in sculptured pediments, and especially on the Acropolis, even than Athena herself. Since this popularity far exceeds his appearance elsewhere in Greece, and since none of his exploits was performed in Attica, nor was he even an Ionian, there must have been some stronger, local motivation. This was almost certainly his association with Athena, who appears from Homer on as his patron and supporter against the enmity of Hera. Athena was city-goddess of various places in Greece, but most conspicuously of her namesake Athens, and it was Athens that adopted her association with Greece's prime hero to serve as symbol of the state.

For much of the sixth century Athens was under 'tyrant' rule, so it is Peisistratos and his sons who most, but not exclusively, exploit the association of goddess and hero. Thus, when Peisistratos returns to rule in Athens in the 550s he arrives in a chariot with a woman (Phye) dressed as Athena by his side and is escorted to the Acropolis. The

analogy with scenes of Athena driving Herakles to Olympus was obvious (a later example is shown in Fig. 33). This attitude to the hero was expressed in behaviour of this sort, by the pedimental sculptures and, we may be sure, by songs, poems, popular story-telling. The vase scenes are our most prolific source of information about dominant myth-historical themes and so it is not surprising that Herakles is exceptionally prominent in the repertory of the vase-painters. They were working for a public already totally conditioned to the hero's role in their state. It is not a question of political propaganda in the modern sense, but it does reflect the aspirations and achievements of the *polis* and its leaders, and this is just the sort of way that Greeks used their myth-history in other contexts, in poetry and on the stage. To this degree the vase scenes contribute to the corporate awareness of the community, of their shared interests and responsibi-

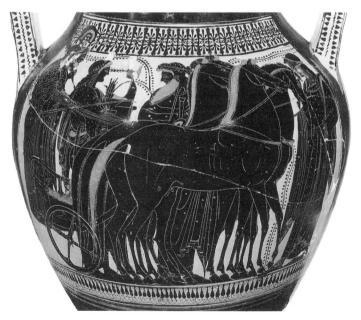

33. Attic black-figure amphora. Herakles and Athena in a chariot, with gods. Attributed to the Priam Painter. *c.* 510 B.C.

lities, of their common patrons. The function is not one that the painter was deliberately exercising but he was able to express it at a more popular level and, through the conventions of his craft, could on occasion enhance the message or vary it. It should be said that this explanation of the importance of Herakles in sixth-century Athens remains a controversial one, but the phenomenon, which is statistically demonstrable, requires explanation, and the one outlined here is in total agreement with what we can understand of the treatment of myth-history by Greeks in other periods and places, most notably in Athens itself of the immediately succeeding generations.

So when a black-figure painter devotes, sometimes, the majority of his myth scenes to Herakles, what is he saying to his public? He is certainly not trying to persuade them of something they did not already know or to impose a personal view, but he is answering a demand by a public that expected, or perhaps preferred, some topicality or relevance of theme. If we can accept that the scenes offer us a fair impression of current interests (though conservatism and idleness will always guarantee the survival of many subjects beyond their immediate period of significance), then they may be quizzed for further information about the phenomenon, since we lack other sources even nearly so prolific. We find many scenes, for instance, which are basically no more than statements of 'togetherness': Herakles and Athena shaking hands, the goddess attending him in an act of libation, or when he is reclining at a feast, the way they are constantly side by side in scenes of the gods on Olympus, where Herakles had been promoted for his service to men and gods. (It was said that Athens was the first place in Greece to worship Herakles as a god, not just a hero.)

Many of the action scenes present the familiar Labours and other exploits, though more copiously than elsewhere in Greek art. Among them we may notice innovations that might have a topical significance: many of them indeed do not outlive (or not by much) the period of tyranny and are confined to Athenian art. It is easier to identify the innovations than to explain them. I shall illustrate just two, to demonstrate the problems, and at the same time identify the clues through which the viewer, ancient or modern, might understand the message; and then consider a (so far) unique scene to see whether we can be confident enough of our understanding of what a sixth-century Athenian would understand to suggest a plausible explanation here too.

34. Attic black-figure amphora. Hermes, Herakles, Kerberos and Persephone.
Attributed to the Lysippides Painter. *c.* 520 B.C. Ht 62 cm.

Herakles had to bring the monstrous dog Kerberos from Hades, to show to King Eurystheus, and then return. It was the most dangerous of his Labours, and so regarded as early as Homer. In art he is shown dragging the multi-headed beast, since he was not allowed to wound it. But for a while in Athens only we see a different approach, exemplified in the scene in Fig. 34. Kerberos shows that the column at the right and the crowned woman behind it must signify the Hall of Hades and its queen, Persephone. At the left Hermes (an appropriate figure at the threshold between the two worlds) encourages Herakles, and the hero stoops, holding the chain-lead, to pat the monster on the nose. The beast will clearly go quietly and with Persephone's blessing. There are hints of this version in later literature. In the context of the vase it surely relates to Athens' new relationship with Persephone's local home, Eleusis, and the take-over of the Eleusinian Mysteries (which has also popularised Triptolemos; see above). Moreover, the new organisation involved creation of the Lesser Mysteries in Athens itself, and the *aition* invented for them involved Herakles, seeking purification before he could be initiated, and becoming naturalised as an Athenian citizen. We glean all this from various texts; to the ancient viewer it was common knowledge, and the new negotiated agreement over Kerberos can readily be seen as part of the deal, expressing in myth a politico-religious coup for Athens.

On one of his Labours overseas Herakles had to wrestle with the sea-god Nereus to learn the way, and this is shown by him fighting a man–fish who shows mutations by animals or flames springing from his body (sea-deities had this ability). By the mid-sixth century the scheme is borrowed, without the mutations, for a fight between Herakles and a figure named Triton (Fig. 35), and for the encounter with Nereus the sea-god is now given human, not fishy form. There is no known literary authority for the Triton fight and it is short-lived, confined to Athens (appearing twice in Acropolis pediments also). We have, then, no clues to its significance, but may reasonably believe that there was some topical event to promote it; some amphibious success, it may be, such as seizing Salamis from Megara, or operations in the north-east Aegean (also to Megara's detriment). Megareus, eponym of Megara, was a brother of Triton, but this does not take us far and the scene must remain a puzzle, requiring an explanation which cannot be unlike that offered here. The manner of such imagery was a commonplace of antiquity (which

35. Attic black-figure hydria, drawing of detail. Herakles and Triton. *c.* 510 B.C.

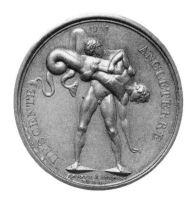

36. Bronze medal struck in Paris. A.D. 1804.

is one reason why we should not be too concerned about its appearance in Athenian art of the sixth century), and persisted through the Roman period, was picked up again by the Renaissance and dies hard. I illustrate a latter-day version on a French medal where a Herakles-like figure wrestles a fish−man (Fig. 36). It celebrated Napoleon's invasion of Britain (*Descente en Angleterre*) and was struck in occupied London (*Frappé à Londres 1804*): an excellent example of anticipatory mythologised propaganda that went wrong.

The unique problem scene is shown in Fig. 37. At the right we see a fountain house attended by a woman. Herakles, behind her, is attacking a snake which emerges from the upperworks, and below a small lion rushes out. Behind him stands Athena with a chariot team. An appeal to literature might reveal that the Hydra monster at Lerna (one of Herakles' Labours) was snake-like and lived by a spring; but the scheme for the Hydra Labour was well established in Athenian black figure, and although almost anything is possible, it would be

37. Attic black-figure hydria. Herakles at a fountain house. Attributed to the Priam Painter. *c.* 510 B.C.

quite perverse for an artist to ignore all the elements of the standard scene, which may involve Iolaos helping the hero, and an attacking crab sent by Hera, as well as the form of the multi-headed Hydra, and to offer instead a scheme containing none of the signals by which we must judge that any sixth-century viewer (or we) could recognise the scene. Herakles also killed a snake in the garden of the Hesperides to get the golden apples, and some of the Hesperides are associated with springs. This episode in the story was not shown in black figure, but if this is a unique example it is incredible that the object of the fight, the tree with the apples, guarded by the snake, should be omitted. From what we know of the story and what we know of black-figure iconography it would not have been possible to identify the story. (The story of Herakles mating with a snake-girl in Skythia has even less to recommend it.)

Forget the texts; look at the picture, which includes many signals common to other black-figure scenes even if not so assembled. We perhaps have learned by now enough of the grammar of black-figure iconography to read one of its more puzzling texts. The fountain house with its woman drawing water is surely Athenian; it appears in this form on many vases of this date, and by this painter, with the attendant women often being given Athenian, not mythical, names. Snakes are associated with fountains; this one is dangerous and Herakles has to deal with it. Lions are supernaturally dangerous (there were none in Attica at this time) and the lion here can only represent another threat posed at the fountain which has also to be met. It cannot be the Nemean Lion, whose skin Herakles is already wearing (artists are careful about this; there is one careless exception in about 800 black-figure scenes); it is at any rate too small, and reminiscent flashbacks to earlier deeds are, in this form, unparalleled. Nor is it a familiar, since familiar animals, common enough beside heroes and deities in black figure, are not belligerent. Its behaviour shows that it is another threat. The place is dangerous but Herakles will, in his expected way, see that all is well and that the customary domestic activity can proceed unhampered. We are not to suppose that the attack is happening while the woman draws water; she is, as it were, an attribute of the Athenian fountain. We need not even believe that the fountain house yet exists. The setting could be imaginary, simply displaying Herakles' concern for his adopted home, but since the many fountain scenes of this date are plausibly associated with the

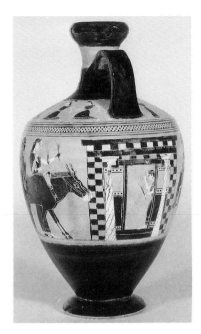

38. Three views of an Attic black-figure lekythos. Wedding procession. Attributed to the Amasis Painter. *c.* 540 B.C. Ht 17.3 cm.

also are the few scenes of commerce and craft (from fishmonger to potter's studio). These reflect surely on the preoccupations of the customer and many may be bespoke. Religious scenes in black figure are few, sometimes dramatic like the bull raised for sacrifice (Fig. 40), and not shape-specific. The richness of these reflections on everyday life is better appreciated in the following century. We may become complacent about what the scenes offer, without allowing for the way in which they too are subject to formulae of depiction, and that they too are the subject of choice. What, for instance, are we *not* shown in black figure? – not the details of domestic scenes or the life of women, children or slaves; none of the private or 'mystery' religious acts, only the public or generalised ones; no civic life; no direct and explicit references to contemporary events or figures (except for mottoes praising handsome youths, unrelated to the scenes in which they appear). There are exceptions to these restrictions, but very few indeed – enough to point the lack. There may be taboos operating here but there is more than a hint that the iconic imagery of Archaic Athens

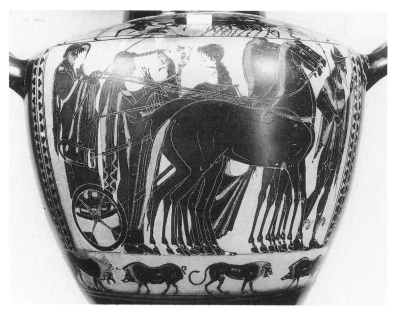

39. Attic black-figure hydria. Wedding procession. Attributed to the Antimenes Painter. *c.* 520 B.C.

was severely circumscribed, and that definition of its limits might prove as illuminating as the proper elucidation of what *is* shown, which is the preoccupation of most scholars.

Much of this chapter has been devoted to the questions posed by the scenes on Athens' black-figure vases, because they are the first major corpus of ancient Greek iconography which may be related to a reasonably well-known society and on which our skills of interpretation may usefully be exercised. The study of vase iconography cannot be divorced from study of the iconography of other media; nor can it be divorced from other vase studies, of shapes and hands. This may have become apparent from what has been said already, but I give instances to bring home the point. Our view of the appearance of Dionysos on Athenian vases of around the mid-century, and especially interpretation of the way he may be shown with, apparently, mortals, could indicate a profoundly unusual approach to

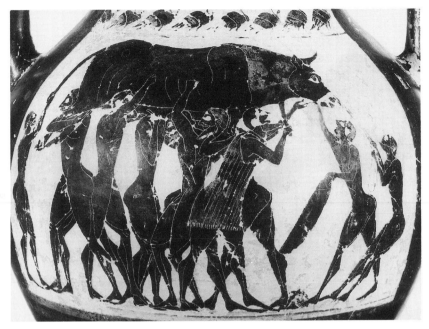

40. Attic black-figure amphora. Sacrifice of a bull. *c.* 550 B.C.

the function and worship of the Olympian in Athens of the day, until it is realised that this image is the creation of one painter and his pupil, ignored by others until a new, more traditionally Olympian image of the god is popularised in later years. Some late black-figure vases show a man fighting a lion, sometimes observed by commoners and without any indication of being Herakles. They have been explained as some sort of heroised human activity or aspiration, even as heroised ephebic hunting. But we should observe that they are never the subject of major painters, but always, and for a very limited period, of the second- or third-rate, who are given to rather mindless repetition and trivialisation of major themes, an activity common enough in the arts of many places and periods and to which it would be foolish to attach too much importance. Or, to dip into early fifth-century red figure, the flood of new Trojan scenes on vases might give rise to views about new epic editions or performances, until it is observed

that the innovations may virtually all be the product of the imagination of one influential painter, and tell us as much or more about him than about the receptivity to epic themes of his fellow Athenians (which was certainly heightened at this time, the age of Aeschylus). Recall remarks above about the gesture of the thumb and forefinger joined in a circle and its modern meaning. The gesture appears on a few black-figure vases and we might imagine it to have been current in Athens, but our view of it is profoundly affected by knowing that it appears only in the work of one artist (the Affecter), who gives other indications of an unusual background or training and who cannot be taken as arbiter of ordinary Athenian behaviour. The study of the iconographical preferences of a single artist is in itself valuable since it brings us to grips with the responses to the world of images of an individual who is also a creator of images.

So much in the iconography of vase-painting, and especially of black figure, is repetitive, that it poses the question of how the formulaic treatment of figures and themes was transmitted. There was more than one potters' quarter in Athens, but the Kerameikos was the major concentration of workshops, it seems, and the example of the work of neighbours must have counted for much. The vases were readily portable and not expensive; they were made in their hundreds and, though the turnover in the market could have been brisk, they themselves provided a corpus of models for the painter. He would, at any rate, have learned in his apprenticeship (I imagine nothing formal, but often father encouraging son in his profession) the basic schemes for well-known subjects, and as a member of the comparatively small community he served he would have been as well aware as his customer of the conventions, which he would have applied instinctively. It has been suggested that there were something like pattern books for series of iconographical themes, but pattern books breed a stereotyping of detail which is less apparent on the vases than the general agreement on figure and action schemes, which did not require such formulation. In Athens the third-rate painters were merely sloppy, not mechanical copyists. That individual studios had their own sketches for reference, perhaps for special commissions, is likely enough.

It may have been uncommon for a vase-painter to have behaved with any notable originality, but the passage of fashions in various themes and treatments must have been promoted by someone in the

potters' quarter, and we can readily distinguish those painters whose approach is uncommon, never stereotyped, and, it must be judged, therefore deliberate and thoughtful. If other media were a source of inspiration we can seldom judge how close the copying might have been, and when, in later periods, we *can* judge, it seems minimal. The variants which good painters offer on single themes suggest that they are not copied but are the product of their own imaginations, recomposing familiar themes. Just as a current vogue, for Herakles, for example, could elicit a response in vase scenes, so a new style in major painting or relief sculpture might prove enough to promote changes in painting styles, by no more than observation with or without some ancient equivalent of a sketch book. If there had been regular use of 'sketch books' we would have expected far closer versions of major works of sculpture or relief, and these are lacking. Occasionally we may be sure that artists skilled in other media turned to vase-painting, moonlighting, it may be, and especially if they relied on the exercise of their craft for a living (of which we cannot ever be sure). This must have been perhaps the only craft with a constant demand for skills in draughtsmanship, unless we undervalue demand for painting on wood or wall, which is not much mentioned in our sources for periods earlier than the Late Archaic though we know that it was practised for major projects.

Studies in Greek vase iconography have a long and honourable history. The material evidence is vast and in constant need of re-ordering, while attempts at interpretation in terms of the artists' intentions and the viewers' response will remain more subjective and controversial. In all historical studies it is generally recognised that each generation or school is influenced by its other social or academic preoccupations in the way it approaches its subject and what it finds of importance or significance in it. In the past such studies of vase scenes have been coloured by various interests: Biblical (on the famous Exekias cup in Munich, Dionysos in his ship could be taken for Noah), Marxist, jingo-imperialist. All these approaches can be seen to be seriously flawed. Latter-day ones can be seen to be inspired by anthropological (Structuralist), psychological, racial (study of ethnic groups), feminist, or more broadly social (minority groups) consider-ations. These too must be judged to be flawed if they proceed from and are dominated by an ideology which may predict results. They need rather to be inspired by what have proved to be the main sources

of lasting progress in our studies: by new evidence, by the application of new methods of analysis to the whole corpus of evidence – mechanical, if need be. Especially they need the inspiration of other disciplines, scientific and humanistic, themselves no more immune than ours to ephemeral dogmas; but they must always remain dependent on painstaking observation and imaginative breadth of experience in the study. The vase scenes give us a richer view of the visual imagery of Greece than is vouchsafed for any other ancient society, and all the indications are that this imagery in Greece was unusually well disseminated through all strata of society. The challenge to attempt to read their messages is irresistible.

5

Vase-painting in fifth-century Athens

I DYFRI WILLIAMS II LUCILLA BURN

I THE INVENTION OF THE RED-FIGURE TECHNIQUE AND THE RACE BETWEEN VASE-PAINTING AND FREE PAINTING

The invention of the red-figure technique, that is the inversion of the old black-figure scheme so that the figures are reserved in the red clay against a black slipped background, seems to have occurred in about 530–520 B.C. This was a great turning-point in the history of Athenian vases, and indeed of the fabrics of other Greek cities, although none of them was to follow suit immediately. Red figure was, in fact, just one of many experiments that were made at this time of artistic ferment in the potters' quarter at Athens – the others were the use of a white ground and the use of superposed colour with incision (the so-called Six technique). Nevertheless, red figure proved by far the most successful, although the white-ground technique did outlive it, at least on the fringes of the Greek world.

It is easy enough to assume that the red-figure technique must have been invented by one man at one moment, for it required the deliberate decision to reverse the normal colour scheme of black figures on a red ground. It is much more difficult to put a name to that man. He must have been a vase-painter, but he may have been instructed to make the change by a potter, or a complete outsider such as a customer. The possible role of a customer or the like cannot reasonably be assessed, but it should not be forgotten. If a potter had a hand in the beginnings of red figure, then there are three possible candidates: Nikosthenes, Amasis and Andokides. The name of Amasis has recently been revived, for parts of what are possibly

signatures of Amasis as potter occur on fragments of two early red-figured cups. Andokides has left his name on six very early red-figured pieces (four amphorae, a calyx-krater and a cup); Nikosthenes his on five (three cups, a *kyathos* and a kantharos). Numerical superiority might give the prize, therefore, to Andokides. Nevertheless, there is a strong case for believing that the potter Nikosthenes was the inventor of the white-ground technique and of the Six technique, and a relatively large number of pieces that display the most primitive red-figure technique take the form of unusual shapes (lip-cup decorated inside the lip, stemmed dish, chalice, *mastos* and Nikosthenic amphora) which may be linked rather with the potter Nikosthenes than Andokides. It is perhaps more likely, therefore, that, if the invention of the red-figure technique occurred in the ambit of one particular potter, then that potter was Nikosthenes.

When we think of a vase-painter who might have invented the technique or at least been the first to employ it, the artist most frequently put forward is the Andokides Painter. This painter has left us fourteen or more vases in primitive red-figure technique. He seems to have worked only for the potter Andokides (hence his name), but there are among the more problematic pieces that Beazley described as recalling the Andokides Painter more or less vividly vases which, by reason of their shape, might rather be associated with Nikosthenes. One alternative to the Andokides Painter as the inventor would be a lesser artist in Nikosthenes' shop, perhaps the painter who produced the pieces listed by Beazley under the sobriquets of the Painter of Oxford 1949 and the Painter of the Vatican Horseman (cf. Fig. 41). A third possibility would be the red-figure artist who worked for Amasis – not, of course, the artist whom we call the Amasis Painter. For it has been argued that the Amasis Painter's outline work presages the red-figure style, while one scholar has recently gone further and suggested that among the major black-figure artists of the third quarter of the sixth century, the Amasis Painter is the one who comes closest to the threshold of red figure. Finally, there is Psiax, who seems to have worked with a number of potters and was equally at home in the black-figure, red-figure, white-ground and Six techniques. Here, however, there are problems in isolating the earliest red-figure work of this artist, and his facility with all techniques does not necessarily make him the inventor of any of them.

Let us examine now what external influences may have prompted the idea of the new technique, especially other media that employed

light-on-dark schemes. These are sculpture, metal-working and textiles. Over the years scholars have built much on possible stylistic and colouristic connections between the works of the Andokides Painter and the sculptural frieze of the Siphnian Treasury at Delphi. Some have even gone so far as to suggest that the Andokides Painter might have worked as a painter of the frieze of the Siphnian Treasury before moving to Athens and inventing the red-figure technique. This idea allows for a painter working on architectural sculpture, and hence using a blue background for the figures (most funerary reliefs had red backgrounds), to move across into the world of vases and, from a state of innocence, create the red-figure technique by continuing to use the light-on-dark scheme he has learnt from sculpture. Yet, surely it is inherently unlikely that a painter of relief sculpture, who was skilled enough to be employed on a new and elaborate building at Delphi, would have moved to Athens and immediately gone to work in a potter's shop and equally suddenly invented the red-figure technique? The skills of potting and vase-painting required years of experience, so much so that they were most probably passed, then as now, from generation to generation within the same family.

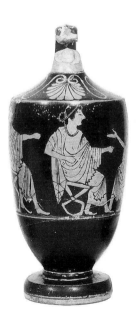

41. Attic red-figure lekythos. Two men and woman seated on stools. Attributed to the Painter of Oxford 1949. *c*. 530–520 B.C. Ht 16.8 cm.

Another origin for the idea of inverting the colour scheme on vases has recently been put forward, namely influence from metalwork and a putative change from silver-figured bronze vessels to gold-figured silver ones. In the first place, however, there are no examples of silver-figured bronze vessels and, secondly, although there clearly were gold-figured silver vases, none of the preserved examples is earlier than the late fifth century and even these are perhaps best understood as imitations of ceramic vases. Ingenious though the proposal is, it fails, I feel, to take account of the long tradition of vase-painting, overlooks the clear development of the styles of individual vase-painters which can be observed by careful analysis, and surely exaggerates the amount of precious metal owned by or available to Athenian citizens.

The third medium to be considered as a possible influence on vase-painters is that of textiles. Most elaborately decorated textiles on red-figured vases are in the 'black-figure' technique (Fig. 42), like the vessels that vase-painters painted on their vases, no doubt as a result of scale and technical difficulties. Nevertheless, on a number of sixth-century black-figured vases, including Kleitias' masterpiece, the François vase in Florence, we see figured light-on-dark decoration and on two exceptional fifth-century white-ground cups we see light-on-dark florals. Thus, as with relief sculpture, dark-on-light and light-on-dark schemes occur in both the sixth and fifth centuries and there is no moment of obvious change in the late sixth century from the former to the latter.

Although relief sculpture and textiles, therefore, may have offered examples of light figures on a dark ground, there is no clear indication that any of these possible outside sources proved to be the impetus for the invention of the red-figure technique. It is surely much more plausible to view the invention in the context of developments within the sphere of pottery-making itself, namely those in the black-figure technique, pioneered by the Amasis Painter, combined with the search for new ideas, driven by the potter Nikosthenes, which also led to the invention of white ground and the Six technique. The first red-figured piece may well have been on a small scale, such as a cup, and the work of a minor artist. It was probably only later that the technique was transferred onto the large format of the amphora and so given particular and deliberate prominence, especially through the work of the Andokides Painter.

The painter Psiax, who was mentioned earlier in connection with

42. Attic red-figure skyphos (detail). Demeter.
Attributed to Makron. *c.* 490–480 B.C. Ht 21.2 cm.

the invention of the red-figure technique, is of further importance
since it is on his works that we first begin to see a stirring of interest in
the drawing of the human figure in unusual poses. He seems, in fact,
to have been the teacher of Euphronios, the greatest of the 'Pioneers',
as Beazley dubbed them, the group of artists who displayed a
heightened interest in representing the human frame and human
movement. These Pioneers learnt to foreshorten the limbs of their
figures. They attempted new and more complex poses. They
experimented with various ways of giving their figures the illusion of
three dimensions. Alongside these developments there was also an
awakening of interest in more elaborate scenic settings, more it would
seem, however, among artists outside the group of the Pioneers. One

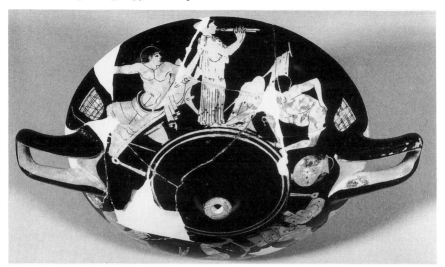

43. Attic red-figure cup. Symposium. Attributed to the Brygos Painter. *c.* 490–480 B.C. Diam. 23.7 cm.

thinks particularly of such representations as a boy fishing off a rock, a city under siege and the walls of Troy rising above the slaughter of Troilos. These scenes all require the painter to widen the scope of his vision, beyond the human figure itself.

After about 500 B.C., the pupils of the Pioneers, such as the Kleophrades Painter and the Berlin Painter, both pot-painters, and the cup-painters Onesimos and Douris, together with their younger associates, the Brygos Painter and the Antiphon Painter, perfected many of the inventions of their teachers. Some of these artists produced real *tours de force*, employing an immense degree of foreshortening, such as the lewd dancer on one side of a cup attributed to the Brygos Painter (Fig. 43). There were some new experiments, including shading, although this was used with any regularity only for inanimate objects, especially vessels and shields. Some of their predecessors' ideas were not followed up: for instance, Euphronios' use of a wash of dilute glaze for pools of shadow in the stomach muscles and the Sosias Painter's depiction of a fully profile eye. With the end of the Leagros Group of black-figure vase-painters, painters

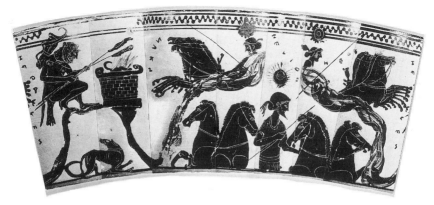

44. Attic black-figure lekythos. Helios, Herakles, Nyx and Eos. Attributed to the Sappho Painter. *c.* 500–490 B.C. Ht 17.5 cm.

still using the black-figure technique gave up almost all attempt to compete with the younger technique, at least in the realm of the drawing of the human figure. There was, however, still one avenue left for creative development, one apparently eschewed by the red-figure painters, and this was the depiction of scenic space.

On a black-figured lekythos in the Metropolitan Museum in New York, a work of the Sappho Painter and normally dated 500–490 B.C., we find just such developments (Fig. 44). On the front of the vase we see Helios and his four-horse team rise frontally from the sea – he is named and there is a sun-disc atop his head. Above him and moving away, to left and right respectively, are Nyx and Eos – Night and Dawn – both named. Upon a stylised rock under the lekythos' handle crouches the figure of Herakles, roasting two spits over an altar flame, while below is a dog. Scenes involving Herakles and Helios seem to gain particular popularity in the early decades of the fifth century B.C. Sometimes Herakles shoots at Helios with his bow, at others he simply threatens him with his club. His wish was, it would appear, to be told the way to reach Geryon and his famous herd of cattle that dwelt on the Red Island in the midst of Ocean.

The New York vase betrays a number of new approaches to space. Firstly, Herakles is on top of a rock, perhaps to be thought of as a mountain, while a dog is shown below. The dog, it might be argued,

is nothing more than a filling ornament for the awkward empty space, although the rock could have been made solid or given some other inanimate decoration. But what are we to make of the representation of Night and Dawn? They seem to disappear into a thin smoke-like

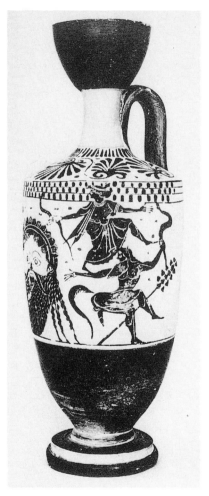

45. Attic black-figure lekythos. Satyrs and maenads dance around mask of Dionysos. Attributed to the Gela Painter. *c.* 500–490 B.C. Ht 31.0 cm.

column of mist that rises up, around and behind Helios. It is just as if the artist were trying to represent how the sun's rays begin to obscure the night's stars. This sort of scenic, properly atmospheric, touch is particularly remarkable and, on the whole, it seems foreign to the normal scheme of vase-decoration.

On another black-figured lekythos, this time in Palermo and attributed to the Gela Painter, satyrs and maenads flank a colossal mask of Dionysos (Fig. 45). The subject is represented on a number of other lekythoi of the period, but this is the only one on which the maenads are placed above the satyrs in a fashion which suggests an attempt to depict space and distance, as the celebrants dance around the totem of their god.

These, and other black-figured lekythoi, all dating before 480 B.C., reveal new developments in the representation of both the environment and pictorial space. There is no counterpart on red-figured vases, which makes one suspect that the artists of these pieces are in some way trying to rival red figure by enlivening their scenes as much as possible. But is it likely that they made these experiments for themselves? Or were they rather transferring onto vases ideas being formulated or already formulated in a medium such as free painting?

Such developments in pictorial space are normally linked with the free painter Polygnotos of Thasos and, by extension, his contemporary Mikon of Athens, and the Niobid Painter's famous red-figured calyx-krater in the Louvre held up as the first reflection of these new ventures (Fig. 46). But Polygnotos' or Mikon's work on the new Theseion at Athens probably dates from the late 470s and Polygnotos' paintings in the *Lesche* of the Knidians at Delphi, where Pausanias' description first suggests the painter's use of a multiple ground-line approach to pictorial space, to the 460s. The lekythoi discussed above, however, indicate that experiments were already being made before 480 B.C. and so perhaps before even Polygnotos himself. That this might have been the case need not surprise us, for nowhere do the ancient sources credit Polygnotos with such an invention. That such experiments should be first reflected on works in the less popular black-figure technique need not trouble us either – red-figure artists may well have felt them unsuitable to vases, a possibility that no doubt evokes some sympathy from a modern eye.

In a study of the group of vases that may show reflections of the Theseion at Athens one scholar has noted an unusual detail of anatomy

and used it to suggest that all the vases imitated a common source. This is the delineation of the stomach with three horizontal divisions above the navel (e.g. Fig. 46). It was admitted that this anatomically incorrect representation of the stomach had been rectified by about 520–510 B.C., but the problem of why Polygnotos or Mikon should have made it part of their style in the 470s and 460s was not addressed. Surely it is unlikely that leading artists of the Early Classical period should still employ an anatomical error nearly fifty years after it had been corrected? One can only reasonably conclude, therefore, that some late sixth-century paintings survived the sack of Athens by the Persians in 480/479 B.C. to be seen and studied by artists of the second quarter of the fifth century. Did the painter or painters of the Theseion, then, deliberately adopt an archaic trait to suit the heroic past being evoked by Kimon's recovery of the supposed bones of Theseus from Skyros? Such a conclusion might well be surprising, but it does appear to be the most likely solution to the problem.

It thus seems that such ideas as complex views of the human figure and split ground-levels are not inventions of the Early Classical period. They had begun earlier and were the result of artistic imagination and experimentation from the late sixth century onwards. It is eminently likely that experimentation with varied ground-lines and scenic effects was chiefly carried out on the unrestricted surface of free painting and not on the tightly delimited and awkwardly curved planes of vases. New poses and foreshortenings, as well as experimentation with how the human figure was drawn may also have occurred first in the realm of free painting, but there is such a sense of personal discovery about some works of the Pioneers and their pupils that we cannot give priority to wall-painting with any degree of confidence.

There is, however, a further development in drawing on vases in about 480 B.C. that may well have been the result of influence from free painting on a neutral background. This is the change in the use of contour lines, a change that can be most clearly seen on cups. There, on the mature works of the Pistoxenos Painter and the works of the Penthesilea Painter and his companions, we see the high relief-line contour being replaced by a flatter contour line. This change has little artistic effect in red figure, except perhaps to soften slightly the contours of the figures. It certainly does not go so far as to break those

46. Attic red-figure calyx-krater. Uncertain scene with Herakles and Athena. Attributed to the Niobid Painter. *c.* 460 B.C. Ht 53 cm.

47. Attic white-ground cup. Aphrodite on a goose. Attributed to the Pistoxenos painter. *c.* 460 B.C. Diam. 24 cm.

contours and suggest that the light that plays on the figure emanates from the darkness around it.

At the most pragmatic level, it could be argued that the change on red-figured cups was nothing more than mere labour saving. This does not, however, take account of a similar development on white-ground vases. There the black, high relief-line gives way to the soft brown, dilute glaze line both for contours and for interior details, such as drapery folds (Fig. 47). At about the same time more colourful washes begin to appear for areas of drapery. These two developments, which occur around 480 B.C., or perhaps slightly before, may well point to influence from free painting on a neutral ground. In turn, they probably indicate the real reason for the change from high relief-line contour to a flatter, softer one in the red-figure technique.

There are further changes that occur during the early part of our period. In the last decades of the sixth century an increase in the popularity of the hero Theseus on vases has been observed, an increase which may reflect that hero's association with the new democracy, but from around 490 B.C., there is a general tendency towards fewer representations of myths and more scenes taken from everyday life. The reason for this is probably complex, involving both the artists and their customers. After the battle of Marathon and the virtually single-handed defeat of the Persians by the Athenians there was no doubt a surge of self-confidence, one that may well have manifested itself in a certain decline in the liking for scenes involving the heroes of the past and a greater desire to see themselves portrayed in activities which occupied them in their normal lives. On the part of the artists, after the great burst of inventiveness and artistic questioning of the late sixth century and the first decade of the fifth, which took with it a degree of ambition and imagination in iconography, a reaction against scenes of elaborate myth and action would be quite understandable.

One of the results of this change in subject matter, of course, is that scenes tended to become more static. It is interesting to note here a remark by Martin Robertson when discussing the new approach to pictorial space in free painting. He suggests that the new taste for stillness may have played a part in encouraging the abandonment of the single base-line, for multiple base-lines allowed more interesting groupings of static figures. This seems to make admirable sense, but the situation was probably more complex, for, as we have seen from

our consideration of two black-figured lekythoi, moments of action could also encourage new experiments in the treatment of space and no doubt some free-painters enjoyed depicting scenes of great drama and action.

In the realm of shapes, the standard repertoire had been established before the end of the sixth century. It was dominated to a high degree by shapes made for the symposium, the pastime of the rich. Modifications were, of course, made in the early fifth century to

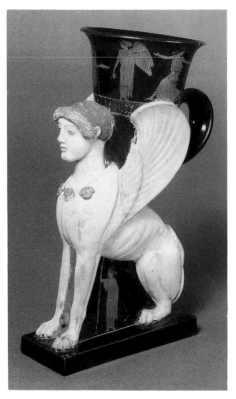

48. Attic sphinx rhyton. The potting attributed to Sotades and the painting to the Sotades Painter. *c.* 470–460 B.C. Ht 29.2 cm.

well-known shapes, such as the cup and neck-amphora, but the additions are almost all in the sphere of plastic shapes and are probably the result of particular potters' interests and capabilities in the use of moulds. The earliest are special drinking-vessels (*rhyta*) in the form of animal heads, but later more complex forms are added, especially by the potter Sotades, which include the negro and crocodile, the sphinx (Fig. 48), the mounted Persian and the knucklebone. To these might be added the lobster-claw *askos*, which begins about 480 B.C. It is strange that at this time the products of the ordinary Athenian coroplasts were neither of such fine quality nor so imaginative in subject. Could this mean that potters such as Sotades had more contact with metal workers and their products, whether vessels or statuettes, and with the makers of large-scale terracotta groups than with the more humble coroplasts?

As for the artists themselves, in the earliest stage of red figure relatively few names are known, but there is a dramatic increase at the time of the Pioneers. During the time of the pupils of the Pioneers there seems to be a drop in the number of signatures of pot-painters, although cup-painters are rather more free with theirs. When it comes to the Early Classical painters there are far fewer signatures both of potters and painters. This may indicate a gradual drop in the artistic pride, perhaps even status, of vase-painters and potters, although this sort of conclusion must be treated with a good deal of caution. Nevertheless, one cannot help feeling that the quality of their products was on the decline both in painting and potting. As Beazley put it, just over 70 years ago,

from this period onwards, the vase degenerates, both absolutely and relatively to other works of art: beauty we shall find, but not so often and not so pure as before. Relatively; for in the archaic time, the vase-painter often does work which will stand comparison with the best done by workers in other mediums, and which cannot have come short of contemporary painting on wall, or wood, or marble; but in the age of Polygnotos, the *artist* begins to disengage himself from his fellow *craftsmen*; until now, the team ran abreast, but now the first string forges ahead and distances the pace-makers. As long as painting meant line-drawing coloured in, so long the vase-painter felt himself the painter's brother: when painting ceased to be that, the man who draws outlines on pots becomes a humbler, more mechanical person. And absolutely; for something irreplaceable is perishing out of Greek art: the fire and freshness of youth.

Beazley's image of a race is particularly evocative. What we have observed above suggests that the painters of vases were at the forefront of developments in drawing at the end of the sixth century and the beginning of the fifth, but that this position had begun to be lost by the time of the Persian Wars. The lead had surely been taken by free painters and once there, they took the inside track and could not be overhauled. This is not to say, as Beazley himself emphasised, that there are no more vases of great beauty, for we need think no further than the white-ground work of the Achilles and Phiale Painters or the white-ground lekythoi of the end of the fifth century, which are discussed below, but the fact that we do think of white-ground works rather than red-figured pieces is surely itself symptomatic of the dominating presence of free painting.

II RED FIGURE AND WHITE GROUND OF THE LATER FIFTH CENTURY

As we move into the later part of the fifth century, in which Athenian vase-painting displays rather fewer technical innovations yet still produces noteworthy achievements, we may change the method of approach a little. The later fifth century witnessed the production of vases of very various types in Athens; rather than discussing their variety and significance in the abstract, an attempt will be made to extract such common characteristics as they may possess from a detailed examination of specific examples. The aim here is not merely to provide an introduction to later fifth-century vase-painting, but also to suggest a system of critical appreciation which may be applied to any painted vase.

The first vase under consideration here (Fig. 49) is a substantial red-figured hydria, made in Athens towards the end of the fifth century. It bears two figure scenes – above, the Judgement of Paris, below, Dionysos with an entourage of satyrs and maenads. The vase was attributed by Beazley to the Painter of the Carlsruhe Paris, named from this vase, an associate of the more famous Meidias Painter.

The Carlsruhe Paris hydria is, first, typically late fifth century in

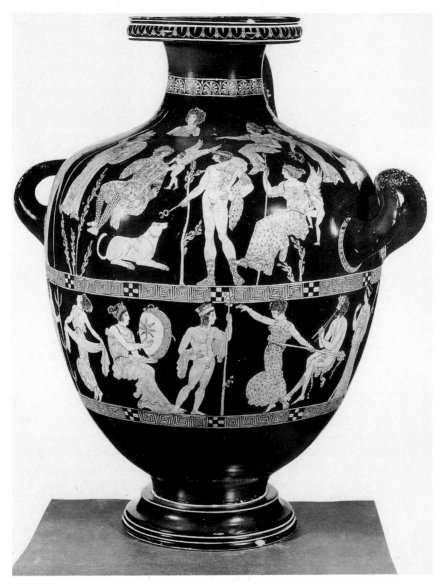

49. Attic red-figure hydria. *Above*: Judgement of Paris; *below*: Dionysos with satyrs and maenads. Name-vase of the Painter of the Carlsruhe Paris. *c.* 420–400 B.C. Ht 50 cm.

shape. It is generally true that vases get smaller as the century progresses, owing to a shift in the emphasis of their use and function. Whereas the majority of fine sixth- and earlier fifth-century painted vases are 'symposium' wares, cups and kraters designed for use at male drinking-parties, in the later fifth century production of these sorts of pots declines, at least in red figure, at the expense of smaller 'female' vases, the squat lekythoi (Fig. 50), pyxides and *lekanides* used by women to store their cosmetic oils and perfumes. However, some 'male' vases did continue in production. Cups are rare, but bell-kraters and pelikai were popular into the fourth century, as was the finest of the larger late fifth-century shapes, the hydria or *kalpis*, which attained an extreme degree of elegance at this time. The beautiful profile of the Carlsruhe vase is immediately obvious, with its flaring rim, its narrow neck swelling down into the sloping shoulder, gently continuing to the widest point at the horizontal handles, then drawing in again, first gradually and then more steeply, to the gracefully stepped and articulated foot. Fine hydriai like this were produced in several late fifth-century workshops.

The shape of the vase and the elements of its construction are brought out clearly by its pattern decoration. The rounded, overhanging rim is painted with a rounded, overhanging egg-and-dart border, while the narrow point of the neck is wreathed with a band of circumscribed palmettes, perhaps an echo of the wreaths of living flowers hung around vases at symposia. The two meander-and-chequer bands which encircle the vase at its widest circumference and just above the foot emphasise the taut roundness of the shape, like lines of latitude described on a globe. Out of sight round the back, the area around the vertical handle is decorated with an elaborate complex of circumscribed palmettes and lotus buds, the curved and springing design complementing the rounded surface of the pot and the rising form of the handle.

When we turn to look at the style of the painting, it is scarcely necessary to look back at one of the sober and restrained masterpieces of the earlier fifth century to be immediately struck by the rich, positively overcrowded nature of the figure scenes. Where a Late Archaic painter would have contented himself with one, or at most two cleverly intertwined red figures standing out against the glossy black surface, here the proportions of light and dark seem roughly equal, an effect due in no small part to the provision of not one but

two separate figure scenes. A second readily observable characteristic of the upper scene, where the painter has had more room to indulge himself, is the way figures are spread around all over the available surface, sitting and standing at various levels, in an attempt to represent depth of field. In the centre is a female figure shown only as far as the breast, as though emerging from behind a hillock; on the far right the sun-god Helios, also only partly visible, drives his four-horse chariot vertically up into the sky. Not merely space but also landscape setting is of interest to this painter, as is demonstrated by the white lines which represent rocks or humps in the ground, and the small, leafy trees and shrubs scattered liberally around. Both the multi-level composition and these indications of landscape are doubtless due in part to the influence of wall- and panel-painters, and are observable in the works of many vase-painters of the later fifth century from the Niobid Painter on. They may also give the impression that the painter is rather straining at the limits of his medium, trying to achieve more than the curving, two-dimensional surface of the pot will allow.

Turning to the actual figures, here too no one could fail to be struck by their richness and elaboration. Drapery is minutely pleated and folded, often finely patterned with stars, and, where appropriate, stripes, zigzags, checks and floral sprays. Hair is elaborately curled and waved, and there is plentiful use of raised and gilded clay, not merely for jewellery, which is lavishly displayed, but also for the fruit on the trees and for larger areas such as Erotes' wings. Poses are varied and sometimes complex; Paris, for example, sits in an almost frontal position, and there are both frontal and three-quarter faces. With all this virtuosity, it must be said, goes an element of mannerism.

The subject of the principal scene is an old one, the Judgement of Paris, the incident which legend made the origin of the Trojan War. The Judgement of Paris had been popular with vase-painters from the sixth century B.C., along with other episodes from the Trojan cycle such as the combat between Hector and Achilles, or the sack of Troy. But in the second half of the fifth century, scenes of combat became less fashionable, and the Judgement of Paris was by now the painters' favourite episode from the entire Trojan cycle.

The style of the iconography has changed, too. Earlier black-figure Judgement scenes show more concern with narrative, representing the goddesses led in procession (Fig. 24) to visit the herdsman Paris on

Mount Ida. But later red-figure painters preferred to show the goddesses arrived at their destination and awaiting the verdict; and whereas earlier scenes had left the outcome uncertain, with Paris wavering and undetermined, in the late fifth century it is very clear who the winner will be. All this is very much in keeping with the ethos of later fifth-century art, its distaste not merely for violence but also for narrative, and its preference for peaceful 'heavenly garden' scenes. While some late fifth-century painters chose to show the outcome by putting Aphrodite in the centre, often relegating Paris to a distant corner of the scene, here, a little more subtly, Paris retains the centre of the stage, and Aphrodite remains at a discreet distance; but Paris turns towards her, the Eros leaning confidentially on his shoulder must have come from her, and to judge from the critical, appraising gesture of Paris' hand, his decision is made. The extra characters who appear amongst the protagonists must partly result from the painter's late fifth-century *horror vacui*, but some of them have independent functions. We have already noted the attempt to show space, perspective and landscape; there is also an effort to show time, in the person of Helios, the sun-god, whose rising chariot suggests the scene is set at dawn. (On a contemporary Judgement scene on a krater in Vienna, Helios and his team on one side are balanced by the figure of Selene on the other, riding her horse down into the ocean: as the moon sinks below the horizon, the sun rises above it.) A sense of historical time is implicit in the looming figure of Eris; her presence looks back to the past, for it was she, the wicked fairy not invited to the wedding of Peleus and Thetis, who threw amongst the goddesses the golden apple inscribed 'for the fairest' which caused the quarrel now to be resolved by Paris, and at the same time she looks forward to the strife and bloodshed that will ensue from Paris' decision.

The representation of personifications such as Eris is very typical of late fifth-century iconography. On the whole, the personifications are of pleasant concepts, such as Eutychia (Good Fortune), the name of one of the women shown above Aphrodite on this same vase. On a small squat lekythos in London (Fig. 50), for example, Aphrodite is shown seated in a pleasant garden among trees and flowers in the company of Kleopatra (Of Noble Parentage), Eunomia (Good Order), Paidia (Games or Playfulness), Peitho (Persuasion) and Eudaimonia (Happiness). This vase, like the Carlsruhe hydria, is

extremely characteristic of late fifth-century trends in shape, style and iconography. The Aphrodite seated in a garden may possibly reflect the fact that there were at least two Athenian sanctuaries of Aphrodite with the cult-title 'In the Gardens' (*en Kepois*) at this time, and it has been suggested that variations of the seated pose in which the goddess appears here may even reflect one of the actual cult-statues. Aphrodite is one of the two most popular gods or goddesses to appear in the vase-paintings of later fifth-century Athens. This may result in part from the fact that many of the vases now being produced were containers for cosmetics, the use of which might hopefully transform an Athenian housewife into an Aphrodite; at the same time it should be pointed out that Aphrodite was a goddess of universal appeal at this time, worshipped by everyone from hetairai to magistrates.

To return briefly to the Carlsruhe hydria: the lower frieze shows the male deity who appears about as frequently as Aphrodite on the vases of the period, Dionysos, the god of wine, with a troop of satyrs and maenads. The swirling drapery of the pirouetting maenads is very characteristic of the style of the period; at the same time they and similar maenads in other vase-paintings may well owe their poses to the lost late fifth-century work of sculpture, possibly part of the decoration of the temple of Dionysos, from which the Neo-Attic maenad reliefs derive. Interesting too is the figure of Dionysos. He stands directly below the Hermes of the upper scene, and it is noticeable not merely that their poses are virtually mirror-images of each other, but also that they are represented as equally youthful: this Dionysos forms a striking contrast to the venerable, bearded Dionysos of the black-figured vases. Most gods and heroes became younger as the fifth century grew older; and an interest in their birth and early childhood was perhaps a logical outcome of this retrogressive sort of development. Erichthonios, for example, the hero whose birth from the earth was the source of the Athenians' claim to autochthony, appears on a substantial number of late fifth-century vases, where he is represented as a small child handed up from Gaia, the earth, into the care of the city-goddess Athena. Several other heroes appear now as children, including the hunter Kephalos and the musician Eumolpos; the god Asklepios, introduced to Athens in 421, also appears as a child in the arms of his nurse, the nymph Epidauros.

So far we have looked only at red-figure vases, but at the same time a very different technique of vase-painting with a very different

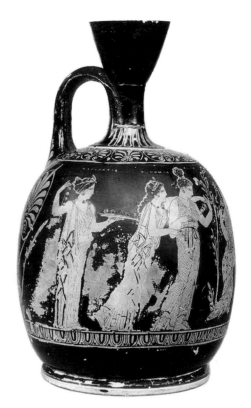

50. Attic red-figure squat
lekythos. Aphrodite and
associates. *c.* 420–400 B.C. Ht
19.4 cm.

end-result was being practised in later fifth-century Athens. The
technique was white ground, and its most characteristic products were
the tall, slender lekythoi designed to hold the perfumed oil offered as a
gift to the dead. As described above, the white-ground technique had
been evolving since the late sixth century. At first it was used simply
as a variant of black figure: the white-ground area of the vase would
be covered with the white slip, the figures painted on top in black
silhouette and, as in ordinary black figure details were incised
through. Alternatively, figures could be drawn either partially or
totally in outline on the white ground. With the development of the
red-figure technique, several advances were made in white ground.
All figures were now drawn in outline, the lines drawn first in glaze
and later in matt colour, usually black or red. A range of colours came
to be employed for hair, drapery and other accessories; at first these
were strong pigments which could withstand the heat of the kiln,

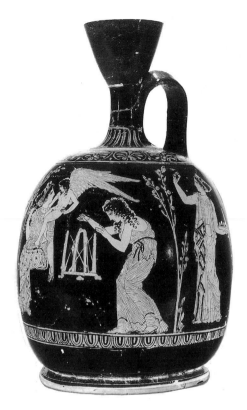

notably red, purplish-brown and yellow-ochre; but in the second half
of the fifth century other, more fugitive colours were added after
firing, a whole range of greens, blues and mauves. Many of these
colours do not survive today, but where they do, they offer a vivid
and unique glimpse of the sort of polychromy which must have been
an important element of the decoration of Athenian homes and public
buildings, in the wall- and panel-paintings which no longer exist.

The iconography of white-ground lekythoi is rather different from
that of contemporary red figure, largely because of the very specific
function of lekythoi: these by the second half of the fifth century were
made only for the tomb and for the local markets of Athens and
neighbouring Eretria. It has in fact recently been suggested that
virtually all painted vases were made for the tomb, as cheap replicas of
the metal vases actually used in daily life. It is indeed important not to
overlook the existence of gold and silver plate in later fifth-century

Athens just because it no longer survives, and it is clear that some vase shapes do imitate those of metal and that the glossy black-glaze drinking cups and other vases popular in the second half of the fifth century may well have been intended to imitate their shiny silver counterparts. However, it is equally important not to exaggerate the extent of the use of gold and silver, or to devalue all fine painted wares by writing them off as coarse imitations of truly artistic luxury items. It is probably true that the majority of red-figured vases have been found in tombs, both in Athens and Etruria. Some of them were undoubtedly made specifically for this purpose, as is shown, for example, by the excavation in tombs of sets of pots apparently in mint condition, often made in the same workshop and with related iconography. However, if all the vases found in tombs were made for that purpose, how can we explain the fact that some of them show clear traces of having been used, even broken and mended with bronze rivets, before they were laid in the tomb? The obvious explanation for this phenomenon, as for tomb-groups consisting of vases made at widely varying times, is that some vases were laid in the tomb because they were the prized possessions either of the dead person or of his surviving family, objects used and valued in daily life. Moreover, it is to some degree the accident of excavation that vases are mostly found in tombs: until relatively recently tombs were the favoured objectives of excavators, as they still are of clandestine treasure-hunters, and even today it is in tombs that vases are most likely to be found intact. However, to suggest that all vases were made for the tomb is to overlook the fact that thousands, often fragmentary, have also been found in sanctuary sites, where they were used in ritual or offered in dedication. And in the few cases where excavation of houses has proved possible, as for example in the fourth-century city of Olynthos in northern Greece, many red-figure vases were found in a domestic context, often in a condition which suggested they had been put to regular use.

It therefore seems reasonable to suggest that while many red-figured vases did eventually end up in the grave, they were not produced exclusively for this purpose, and their iconography reflects their multifarious uses. White-ground lekythoi, on the other hand, were apparently used almost exclusively for funerary purposes from the mid-fifth century onwards, and this is very strongly reflected in their iconography.

This is interesting both because of the concrete evidence it seems to offer for funerary practices, and for the less tangible glimpses it

suggests of people's thoughts about death and the dead. We gather, for example, information on what the grave monuments looked like, mostly the tall stelai which served as markers until restrictions on funerary expenditure were relaxed in the last decades of the fifth century, and the fashion developed for more elaborate monuments in stone. We are given visual representations of the practice known to us from the literary sources, of friends and relatives of the dead person visiting the tomb and bringing offerings. We see how the tombs were decked with fillets and how vases, mainly lekythoi and loutrophoroi, were placed on their steps; sometimes musical instruments are hung above. Occasionally, we catch a glimpse of the landscape of a graveyard, with tall reeds between the closely set monuments; on one lekythos we see boys pursuing a hare between the tombs. But as these vase-paintings are both less and more than photographs, we should and need not read them on a purely superficial level; rather we may allow them also to suggest to us something of the way in which the dead were regarded. There are a few vases on which the souls of the dead are represented as tiny stick-men hovering around the tomb. But on the whole, when the dead are shown at all, they are represented exactly like the living, as though they were themselves alive, albeit in another world. Sometimes we see the mythological characters with whom the world of the dead is populated, as when the dead person steps into the boat of the ferryman Charon, or when Sleep and Death carry away a body. But more subtle and perhaps more interesting is the way the dead appear alongside the living. As on the sculptured grave stelai, it can be difficult at times to distinguish the dead person from his living mourners. The youths who lean on long staffs by a tomb, for example, while a woman brings offerings, could be either the mourner or the person mourned. However, the men or women who sit in front of their monuments like people seated at the doors of houses to receive their guests are surely the owners of the tombs. Although the dead are live in appearance, there is no contact between them and the living. Attention is lavished on the monuments; the dead themselves are either disregarded, or else observed with a melancholy stillness; there is a clear absence of direct communication between the worlds of the living and the dead.

The scene on the very typical white-ground lekythos represented in Fig. 51 shows a woman seated in front of her tomb, visited by two mourners. The tomb is shown as an unusually broad monument, hung about with sashes. On its steps stands a lekythos, and on the top are three more vases, two alabastra and a black vase, probably a pelike.

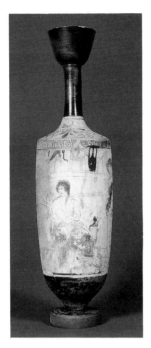

51. Attic white-ground lekythos. Woman seated at tomb. *c.* 410–400 B.C. Ht 50.8 cm.

The woman, who is almost certainly to be thought of as the dead person herself, sits on the steps beside the lekythos, her arms folded in a gesture of resignation, her feet propped up on rocks. Her body is strongly foreshortened and shown in three-quarter view to the right, while her face, framed by a mass of curly hair and ringlets, is turned in three-quarter view to the left. Two women approach from left and right; the one on the left holds out on her finger a small bird of the type which appears on sculptured stelai or red-figured scenes of women, but the dead woman takes no notice. The woman on the right brings to the tomb a shallow basket with fillets and other offerings.

That the scenes on lekythoi may be taken as evidence for the way the lost large-scale paintings of the time would have looked is not merely probable, but actually suggested by what little concrete evidence for such paintings exists, in the form of the occasional painted tombstone, or apparent Roman copies of Greek originals. The literary sources, too – principally Pliny – when they describe the characteristic traits of such famous artists as Parrhasios, could at times be referring to the lekythos paintings themselves. Parrhasios' style

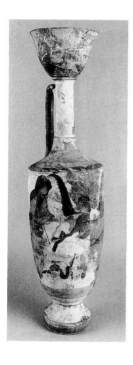

52. Attic Huge
Lekythos. Youth
seated at tomb,
two mourners. *c.*
410–400 B.C. Ht
95 cm.

53. Detail of
lekythos of Fig.
52.

was apparently considered rather 'linear': eschewing such techniques as shading, he achieved an impression of depth of field and three-dimensionality through his clever use of line. Something of the same effect may at times be detected on such lekythoi as those of the Reed Painter shown here, where the strongly foreshortened figure of the seated woman is immediately legible without any need for shading or chiaroscuro, purely through the skilful use of line.

In another, smaller group of later fifth-century lekythoi, an extraordinarily rich approximation to the appearance of contemporary painting may be obtained. The Group is that of the Huge Lekythoi, five enormous vessels which range in height from 68 to 110 cm (the average normal lekythos is little more than 30 cm high). As vases, these lekythoi are anomalous in the extreme: they were not designed to hold liquid, for they are open underneath, a fact which suggests either that they were purely decorative or else that they were designed to receive libations poured through them into the ground. Perhaps because of their huge size, their mouths were made separately, slotting into the necks like funnels. They also differ from normal-sized lekythoi in having no areas of black glaze, being entirely coated in

white slip. Like their open bases, this rather goes to suggest that they were designed as cheap substitutes for the large marble lekythoi which were a fashionable alternative to stelai in the late fifth century. Some of these marble lekythoi bear scenes in relief, while others are plain, but it is highly probable that like the rest of classical sculpture, all were originally brightly painted; so the Huge Lekythoi, garish as they may seem to modern taste, may provide us with some idea of what their stone counterparts once looked like. At the same time, because of their larger scale, they convey a much better impression of what major painting must have looked like than can their smaller counterparts.

The scenes on the Huge Lekythoi are on very much the same subjects as those on the smaller vases: four show visitors to a tomb, the fifth a *prothesis* scene. Their painter (or painters), however, is perhaps less interested in depicting form and mass through line, than in tackling the problem of rendering light and dark through the use of colour and shading. One remarkable feature of their colour schemes is that all male flesh is shown as shaded brown; garments are also shaded, while women's flesh is left white. Skill in rendering perspective is shown in the treatment of objects such as footstools and caskets. But beyond such individual details as these, the Huge Lekythoi seem to be more generally important because of the overall impression they contrive to offer of monumental painting. They may carry as many as four figures, rather than the standard two or three of the smaller vases, and in most cases their colours are comparatively well-preserved, great expanses of blue, violet and brownish-purple.

On the Huge Lekythos in Madrid shown in Figs. 52 and 53 a youth sits in front of his tomb. His brown, carefully shaded flesh contrasts with the almost dazzling whiteness of the mantle wrapped around his lower limbs. His hair is long and finely waved. The tomb behind him is shown as a tall, bright blue shaft, details of its bead-and-reel moulding, its palmette acroterion and its acanthus leaf finials all picked out in coloured paint: the blue seems to be laid over a mauve base, and sometimes only the mauve remains. To the left is a youth leaning on a knotty staff, and to the right two more figures, a man and a faintly preserved woman who brings a basket of offerings. Even in its fragmentary state, this vase and the other four Huge Lekythoi offer a remarkable glimpse of the paintings and painted sculpture that we have lost.

6

Greek vases in Etruria

NIGEL SPIVEY

A case of mistaken identity

Search any good atlas or gazetteer and you find 'Etruria'. Not the land
of the ancient Etruscans, this, but a small pocket of Staffordshire in
England: a factory site at a junction of canals, not far from
Stoke-on-Trent. English Etruria dates from A.D. 1769. It was created
by Josiah Wedgwood (1730–95), who himself occupied a stately home
christened 'Etruria Hall'. Properly landscaped according to the
superior standards of the eighteenth century, Wedgwood's Etruria is
still a pleasant place to visit. But the name enshrines a fallacy: the
fallacy of assuming that the many vases recovered from the tombs of
ancient Etruria were Etruscan vases. When (again in 1769) Wedgwood
and his partner Bentley produced a clutch of black vases decorated
with red enamel figures, the legend was 'ARTES ETRURIAE
RENASCUNTUR' – and there lay the mistake, for these were not
the arts of Etruria reborn but the arts of Athens, transplanted in
antiquity to the tombs of Etruria.

Wedgwood was not conspicuously foolish in baptising his pottery
as born-again Etruscan. Italian, particularly Tuscan, 'Etruscomania' in
the eighteenth century had persuaded the early collectors of Classical
vases that the Etruscans were responsible for not only all the vases
found in Etruscan tombs, but also those recovered from South Italian
cemeteries. This hypothesis, however, was beginning to crumble in
Wedgwood's time. Sir William Hamilton, British envoy to the court
of Naples, tolerant husband of Lady Emma and proto-benefactor of
the British Museum, had been amassing a collection of vases from the
graves of Campania, Lucania and Apulia (see Frontispiece), and

publishing his finds. The first publication, done for Hamilton by P. d'Hancarville, comprised four volumes: *Collection of Etruscan, Greek and Roman Antiquities . . .* (1766–7); the second publication – again in several volumes, beginning in 1791, this time done by W. Tischbein – was entitled *Collection of Engravings from Ancient Vases mostly of Pure Greek Workmanship . . .* In his introduction, Hamilton confesses that he once believed such vases to be Etruscan, but had since changed his mind: 'there now seems to be little doubt of such monuments of Antiquity being truly Grecian'. Hence the title, emphasising the 'pure Greek workmanship'.

For Wedgwood, an entrepreneur, this was all academic. And it was not entirely settled. In the years 1828–9 the cemeteries of Vulci came to light, and thousands of the painted vases were disgorged from the tombs of that hermetic Etruscan site. The Vulci vases outnumbered so impressively the quantity of similar pieces so far found in Athens that scholars were forced to reconsider. Were the old Etruscomaniacs right after all?

In the years of the *rapporto volcente*, as the Rome-based German antiquarian Eduard Gerhard and his colleagues struggled with the deluge of vases from Vulci, the problem of provenance bulked large amidst the excitement caused by all the new scenes and subjects. Most of the vases were demonstrably the work of Greek craftsmen, and plenty could be related specifically to the Athenian ambience – by their *kalos* inscriptions, for example (see p. 216). But how was it that so many of these were being yielded by the tombs of Vulci? Gerhard and others found it hard to believe that the vases had travelled all the way from Athens, and so postulated workshops of Attic vase-painters in Etruria, or else intermediate establishments in South Italy.

It is not impossible that new evidence will surface; but there is now a general consensus amongst ancient historians, archaeologists and even Etruscologists that most of the vases in Etruscan tombs were produced in the Athenian Kerameikos. Etruscan vases do exist: but they are not the Classical models of Wedgwood, any more than the 'Etruscan rooms' created by Robert Adam at Osterley Park and Audley End and other eighteenth-century mansions are based on Etruscan wall-painting. The case of mistaken identity has been resolved. But the problem of provenance deserves fresh attention. The briefest of browses through J. D. Beazley's catalogues of Athenian vase-painters will reveal that Vulci is still our main source of pots. After Vulci, other Etruscan sites: Tarquinia, Cerveteri, Orvieto and

Chiusi. As long as studies of vases were concerned with the individuation of painters, the significance of the legend 'from Vulci' was minimal. But as work on the iconography of Athenian vases becomes increasingly sophisticated, it seems as well to reconsider the ancient owners of these vases. An Etruscan at Vulci may have heard of the Athenian autocrat Peisistratos, but is unlikely to have known that Peisistratos encouraged fountain construction, surprised the Athenians with a coup when they were at their dice-boards, or launched an attack on Megara. Such localised and precisely historical factors in the iconography of Athenian vases will present obvious difficulties for a vicarious Etruscan 'reading' of Greek images; and broader cultural issues may be no less difficult. If vases were painted for an Athenian aristocracy, how were they understood by an Etruscan aristocracy? Should we suppose (as Herbert Hoffmann has suggested) that there was a common pool of myth and ideology to which both Athenian and Etruscan aristocrats were drawn – or that the Athenians 'exported' such aristocratic codes as 'beautiful death' (*thanatos kalos* – to quote Hoffmann's example) to their Etruscan neighbours? Etruria was a profoundly Hellenised country, but the Etruscans were nevertheless *barbaroi*: they did not speak Greek. We can make no easy assumptions about their reception of Greek images. An Etruscan at Vulci customarily dined with his wife: what might he make of the image of the all-male symposium, or the symposium attended by professional hostesses (hetairai)? Again: Athenian vases have been used as a primary source for historical information about Greek homosexuality, and the definition of a 'homosexual ethos' at Athens. But homosexual practices were not equally fashionable or acceptable throughout the Greek world, and there is no evidence for a predilection for them in Etruria: so what did our viewer in Vulci make of the many scenes of pederasty, and sometimes mass sodomy, that came his – or her – way?

These are questions that are easier to ask than to answer. But it is time that some attempt was made to define the significance of Greek vases in an Etruscan context, and the aim of this chapter is to do so. It will be tentative, as most enterprises of iconology are: the 'old commonsense view that a work means what its author intended it to mean', which E. H. Gombrich applauds, has somehow to be reconciled with the precept that 'we cannot write the history of art without taking account of the changing functions assigned to the visual image in different societies and different cultures' (Gombrich again). The immediate problems appear to be firstly, how far were

Athenian painters catering for a market for their vases in Etruria? – and secondly, can we estimate just how extraordinary is the survival rate of Athenian vases in Etruscan tombs? But these are problems for those who begin with Athens. We shall try beginning with Etruria – with the fact that vases are found in Etruria, and then the significance of vases being found *in tombs* in Etruria.

The Etruscan value of Greek vases

We overvalue Greek vases; consequently we overvalue Greek vases in Etruria. The first (and so far the only) Greek vase to fetch a million dollars was the krater by Euphronios now in the New York Metropolitan Museum of Art. It is probable that it was illegally excavated from a tomb at Cerveteri. The price is absurd, as the art market is absurd, but such absurdities do influence proper studies and aesthetics. Once we stake a million dollars upon a 'masterpiece' by Euphronios, we encourage a fetishism for pottery that inflates its ancient importance. Gasping over the skill of the New York krater, we want to believe that an Etruscan in Cerveteri at the end of the sixth century B.C. would, if offered the vase, have sold his own grandmother to buy it.

The case against a high premium for Athenian vases in Etruria has been made by Michael Vickers, as an extension of his argument for generally downgrading the status of painted pottery in ancient society and in ancient trade. Much of his case is based upon common sense, and few would dispute the claim that the ancient value of Greek vases has been exaggerated. It is not entirely due to the grotesque manoeuvres of the art world, but also to the fact that in the archaeological record, pottery we have always with us, whilst oil, grain, timber, metals and slaves pass away. But Vickers has over-stated the case. He wants us to treat painted pottery travelling from Athens to Etruria as 'saleable ballast': saleable in Etruria because it offered 'smart tableware' for the Etruscan poor (the extent of their poverty is not delineated by Vickers), and substitute silver for the rich, who could then keep their precious metal services above ground, and leave the painted pottery for the use of the dead.

Vickers gives us a picture of the Etruscan aristocracy from a first-century B.C. source, Diodorus Siculus. It is a well-known passage (5.40), mentioning the twice-daily banquets and excess of everything

– including silver drinking vessels. Vickers does not consider the passage as a historical cliché (*topos*), the usual condemnation of love of luxury (*tryphe*) in an enervated rival (Diodorus is, after all, 'Siculus': writing with the built-in bias of Sicilian historical tradition, and the tyrants of Sicily were assiduous enemies of Etruria). But even allowing some credibility to Diodorus, it remains impossible to demonstrate that painted vases were imported by the Etruscans as a cheaper alternative to vessels of precious metal. No one can say what quantity of gold and silver was deposited with the Etruscan dead: there are very few perfectly intact Etruscan tombs, and most were raided many centuries ago with the intent of clearing out metal objects and jewellery (whilst ceramic vases became worth snatching only when they became collectable items, i.e. around the time of Hamilton *et al.*). One of the rare intact tombs is the Regolini–Galassi burial at Cerveteri: when it was discovered in 1836 it yielded a mass of gold- and silver-work – over two hundred items – now on display in the Gregorian Museum in the Vatican. This dates to the mid-seventh century B.C.; it might be argued that anti-sumptuary legislation, or other sociopolitical pressure, later made the deposition of silver and gold with the dead less feasible. But equally one might allow vessels of precious metal a greater availability in the 'Orientalising' period than in the sixth/fifth centuries – i.e. when the most conspicuous importation of painted pottery takes place.

One type of evidence is not considered by Vickers, but it is important. Etruscan tomb-paintings often depict symposia, and as such they sometimes show *kylikeia*, i.e. the cabinets of vases required for making merry. Reviewing the depictions of Etruscan kylikeia, one is bound to ascribe some justification to Vickers – metal vases *do* feature at an Etruscan banquet – but at the same time recognise that Vickers is wrong to relegate pottery as low as he does. Iconographical exegesis may be partly complicated by the notion that black-glazed pottery sets out to imitate tarnished silver: so it is difficult to say whether the symposiasts in the Tomba della Fustigazione, for example, are proffering metal or ceramic cups. But in certain representations, ceramic and metal vases are juxtaposed in such a way as to suggest virtual parity of value. In the Tomba dei Vasi Dipinti (Fig. 54), *c.* 500 B.C., the artist wants us to see two black-figure amphorae either side of a metal volute krater; and underneath, a pair of upturned ceramic kylikes. And the paintings of the Tomba della Nave (datable to around the mid-fifth century B.C.) may make a more

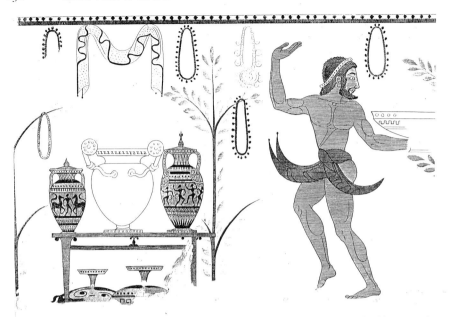

54. Etruscan tomb-painting from the Tomba dei Vasi Dipinti ('Tomb of the Painted Vases'), Tarquinia. Drawing of detail. *c.* 500 B.C.

55. Etruscan tomb-painting from the Tomba della Nave ('Tomb of the Ship'), Tarquinia. Drawing of detail. Mid-fifth century B.C.

explicit link between the importation of Attic vases and the conduct of a banquet. As one enters the tomb, the iconography seems more or less conventional: on the far wall, the participants at the banquet reclining on their couches (*klinai*); on the right-hand wall, servants busy with supplying the feast, and then dancers. But it is the left-hand wall (Fig. 55) which gives the denomination of the tomb: depicting a merchant vessel (on which a number of mariners are just visible), and a figure (whose scale relates him to the banquet scenario) seeming to wave off or salute the reduced-scale (intended as far-off?) ship. Another figure stands by a kylikeion, which has a variety of vases on and around it, but mainly featuring a large red-figure column krater decorated with a centauromachy of some plausibly mid–fifth century sort. Beyond the kylikeion is a lyre-player, so if the frieze were laid out and read sequentially, it would begin with the arrival of the ship, proceed to the vases, then the musician, then the banqueters and their servants, then the dancers. I think we are supposed to take the dancing as happening after the meal: should we than presume the ship to be part of the sequence: it brings the vases, which supply the feast, and the feast yields to dancing?

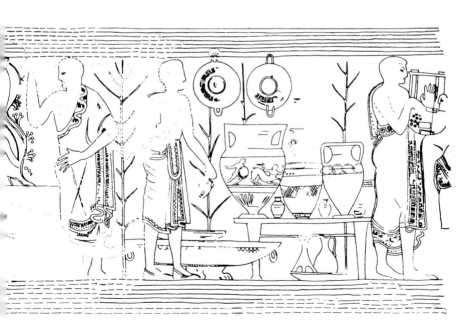

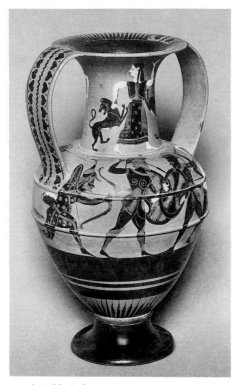

56. Attic black-figure Nikosthenic amphora, from
Cerveteri. Battle scene. *c.* 530–510 B.C. Ht 32.1 cm.

Whether that sequence is intended by the artist, it remains the case
that ceramic vases are prominent. If such items were merely ballast,
their prominence seems odd. It is also odd that their owners went to
such trouble to repair them when they broke, with fiddly (and to our
eyes, unsightly) rivets (see below, p. 254); and odd that the wells and
midden-areas of Etruscan settlements, which generally contain masses
of the coarse 'impasto' pottery used in domestic situations, rarely
include any fragments of painted Attic vases – odd, that is, if
(following Vickers) *hoi polloi* had such vases on their tables.

The Etruscans had no dollars to pay for their vases: they were not
operating a monetary economy before the fourth century B.C. But we
do not need money to estimate value. Value is 'worth, desirability,
utility'. The actual economic value of pottery was probably low – it
may be readily perceived as a 'non-essential item', whose trade might

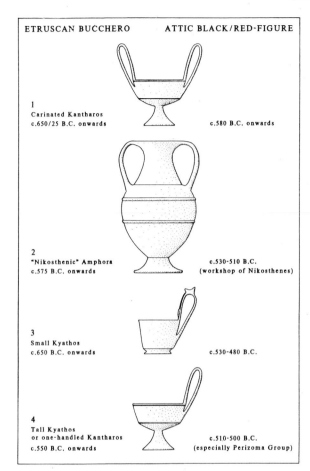

ETRUSCAN BUCCHERO ATTIC BLACK/RED-FIGURE

1
Carinated Kantharos
c.650/25 B.C. onwards c.580 B.C. onwards

2
"Nikosthenic" Amphora c.530-510 B.C.
c.575 B.C. onwards (workshop of Nikosthenes)

3
Small Kyathos
c.650 B.C. onwards c.530-480 B.C.

4
Tall Kyathos
or one-handled Kantharos c.510-500 B.C.
c.550 B.C. onwards (especially Perizoma Group)

57. Attic borrowings from Etruscan bucchero shapes (with dates of initial production in bucchero and Attic).

continue in time of war (as it did between Athens and Corinth throughout the late fifth century B.C.). The scratched or painted trademarks that are found on Attic vases bound for the Etruscan market (discussed in more detail by Alan Johnston, pp. 219–24) give no substantial indication of what those vases were worth in Etruria. Indirect evidence, however, can be mustered: by registering what effect the Etruscan demand for vases had upon the potters and painters based in Athens.

There is a distinctive shape in late sixth-century B.C. Attic black figure known as the 'Nikosthenic' amphora, which features flat

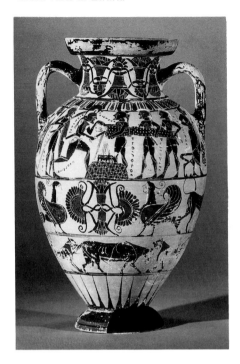

58. Attic black-figure Tyrrhenian amphora. Sacrifice of Polyxena. *c.* 560–530 B.C. Ht 38.1 cm.

handles (like curved bands of metal), a conical mouth, and a body with horizontal ridges (Fig. 56). The angular design of this type immediately puts one in mind of metal; and metal prototypes may well have been in circulation, but there are surviving ceramic models – not in Attic but Etruscan pottery, i.e. the metal-imitating 'bucchero' fabric taken to be native to Etruria. The amphora produced by the Athenian potter Nikosthenes appears to reproduce a shape established within the repertoire of Etruscan bucchero, and in particular a shape popular at Cerveteri: so it is not surprising to find that Nikosthenic amphorae turn up almost exclusively in Etruria, and that the provenance in Etruria is usually Cerveteri. Nor is the Nikosthenic amphora the only borrowing from Etruscan bucchero (or metallic) vase-shapes: the carinated kantharos, the small or squat *kyathos*, and the high-footed kyathos (or, as it might be called, the one-handled kantharos), are further types whose creation in bucchero precedes their appearance in Athens (Fig. 57) – and, of course, their export, as Attic vases, to Etruria. Some considerable pains were being taken to satisfy Etruscan taste: e.g. the two hemicylindrical red-figure 'stands', perhaps by the Euergides Painter, which ought to be singled out as the

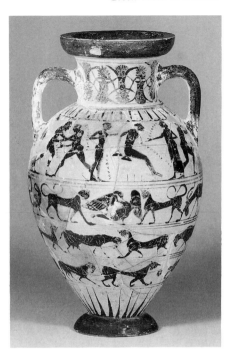

59. Attic black-figure Tyrrhenian amphora. Athletes. *c.* 560–530 B.C.

most extraordinary Attic imitations of Etruscan shapes; and it is hard to see why Attic potters should have pandered to Etruscan tastes (and localised Etruscan tastes at that) if their wares were being loaded as ballast. Whatever the pecuniary value of Athenian vases in Etruria was, it was evidently sufficiently high to make special marketing strategies for Etruscan demand worthwhile.

If Nikosthenes and others were accommodating Etruscan morphological predilections at their workshops (and it should be incidentally mentioned that Nikosthenes borrowed other shapes from abroad – not only Etruscan), might some concessions have also been made regarding iconographical content?

This is a fair question, but has rarely been given a fair answer. Scholars of Greek art are understandably reluctant to allow an Etruscan appropriation of the images on Athenian vases, yet they have in the past allowed some iconographical gratification of the market by Attic painters. There is a class of black-figure amphorae known as 'Tyrrhenian', because nearly all of them (87 per cent of the 250 that survive) have been found at Etruscan sites along the Tyrrhenian coast. In fact, they were once thought to have been made in Etruria: a

surmise recently revived, but unlikely to hold, for the Tyrrhenians belong to a sequence in the development of Attic black figure. As a sub-group, however, they have been re-dated – to *c.* 560–530 B.C., as compared with a previous range of *c.* 565–550 B.C. If this re-dating is right, it makes the Tyrrhenians a more cynically commercial exercise than formerly supposed. As mid-sixth century B.C. Attic production, they stand out as sedulously sensational, specialising in gaudy violence and sexual excess. Fig. 58 is typical: above the bands of a Corinthianising menagerie we find a gruesome sacrifice of Polyxena. The girl is held over a pyre by three warriors: Neoptolemos grabs her by the hair and plunges his sword into her throat. Blood gushes out generously, as it does on some scenes of Etruscan tomb-painting. The viewer of this vase is supposed to be impressed by the explicitness of the scene, and presumably also by the names labelling the protagonists. Not all Tyrrhenian amphorae presume such erudition, however. Some are notorious for their 'nonsense' inscriptions: e.g. Fig. 59. It looks to depict a generic scene – wrestlers, trainers, and jumpers. As on the Polyxena amphora, the labelling is copious: only in this case the labels are meaningless, mere strings of letters.

Several reasons may be given for the nonsense on this and other Tyrrhenian vases. The painter may have been pretty well illiterate (unlikely, since he was not unlettered); the inscriptions are jokes at the expense of a barbarian customer – who in the Etruscan case would recognise the letters, but not the language – rather perverse jokes, these; or the inscriptions add a veneer of extra value to the vase, whatever they mean (or do not mean) – i.e. they make part of the picture, part of the overall effect, like splashes of colour. They might appear to heroise a perfectly ordinary scene. Athenians of the well-educated class would have sneered at the superficiality of this device; but it is more readily understood if considered as a trading dodge, a means of enhancing value – not for the home market, but for those customers in the West who had, so it seemed, more money than sense.

The Etruscan meaning of Greek vases

In its way, pottery speaks. Ethnoarchaeologists attempt to listen to the 'silent discourse' operated by pottery. Decorated vases travel and speak to those who accommodate them. When we look at an image on a Greek vase, what it says to us may not be what its artist intended it

to say – but the discourse goes on, regardless. The functions to which Athenian vases were put determine to some extent the nature of their imagery. Some were funerary; some held the drink at drinking-parties or symposia; some served as prizes at athletic competitions; and so on. But once disembarked in Etruria, these vases may work differently; the messages and meanings they carry can change.

The Panathenaic prize amphorae provide a good example to begin with (Fig. 100). They were made specifically for the Panathenaic games, and their worth as prizes must have been as much for the oil that they contained as for their decoration. They were obviously prone to be kept for sentimental reasons (many bear the name of the *archon* or official presiding over the games in a given year), as souvenirs of victory to show to one's grandchildren when all the oil had gone: one Panathenaic amphora in New York, decorated by the Antimenes Painter, is riddled with no less than fifty-eight repair holes. And one of the best-known examples of the Panathenaic type, the 'Burgon amphora' in the British Museum, was taken by a mid-sixth-century B.C. Athenian to his grave – in fact, in so far as it served as an ossuary, it *was* his grave. However, other winners of these vases – perhaps, like characters one can remember from school, the sort of athletes who won everything at every competition – dispensed with their prizes, or cashed them in. Either that, or else surplus stocks got taken aboard Etruria-bound merchantmen. Consequently, vases made as prizes for Greek athletic contests, with images of a suitably aggressive Athena and the various sporting disciplines, turn up in Etruscan tombs.

The Etruscans were barbarians, of course: they may have collected strigils, and known how to throw a discus, but they were barred from attending the Panathenaic games. What did they make of the images on these vases – and why does one Panathenaic found in Etruria carry an Etruscan legend, *suthina*: 'belonging to the grave'?

The answer is simple. Panathenaic amphorae depict games: boxing, wrestling, discus-throwing, running, chariot-racing. These are the games that are depicted on many Etruscan tomb-walls. Why are games depicted on Etruscan tomb-walls? Because games were really or ideally part of the funerary rite of passage in Etruria. Those Etruscans buried with scenes of wrestling about them need not have been champions themselves. Such competitions were staged above ground when the deceased had been laid to rest – or else the deceased might have aspired to the status of a Patroklos, or an Anchises, to have such games staged in his honour. Or he may have envisaged that

Pindaric bliss of non-stop sport in Elysium – which Virgil was to incorporate in his presentation of the ideal Roman afterlife: 'their airy limbs in sport they exercise,/And, on the green, contend the wrestler's prize' (*Aeneid* 6.642–3, trans. Dryden).

There is no need to suppose that the Athenian producers of these vases altered their intentions to allow for Etruscan funerary customs. The point is that a funerary gloss can be put on the Panathenaics: Panathenaics may be perceived outside Athens as *suthina*, as things suitable for grave decoration.

The painters of the Panathenaics made no concessions to Etruscan taste, but the painters of the late sixth-century B.C. Perizoma Group evidently did. Beazley's christening of this group comes from an item of dress worn by the athletes who figure on the pot: a white-painted loincloth. In itself this prompts suspicion of barbarian influence. After all, it was a cultural condition that a Greek athlete in the *gymnasion* went there *gymnos*: naked, unclad. Early Romans (e.g. Ennius) regarded this as the onset of vice (*flagiti principium*); and since the athletes depicted on the walls of the Tomba delle Olimpiadi at Tarquinia (*c.* 510 B.C.) are clad in the *perizoma*, it may be supposed that the Etruscans shared Roman censoriousness.

A favoured shape of the Perizoma Group potters is the stamnos, and it is worth noting that the stamnos as a shape belongs to Etruscan funerary tradition: impasto versions of a very similar shape – often described as 'jars' or *olle biansate* – are well attested in seventh-century B.C. Etrusco-Italic tomb-groups. Equally worth noting is the association made by Perizoma Group painters between games and symposium scenes. Stamnoi with these scenes associated have been recovered from tombs at Populonia, Tarquinia, Vulci and Cerveteri. What was a symposium for Athens becomes a funerary banquet for Etruria, and the Perizoma Group seems to exploit this ambiguity.

More generally, it is clear that the images produced for the aristocratic fraternities of Athens more or less matched the expectations of Etruscans in search of ostentatious burials. Sporting and military prowess; horsy pursuits; patronage of strummers, flautists and bards. Etruscan viewers may have mistaken Athenian courtesans for wives, and the objects of Athenian pederastic desire for slave-boys. But much of the imagery is consonant with their own art. Such a consonance is not confined to Athenian vases: the iconography of sixth-century B.C. Corinthian column kraters can be matched with coeval Etruscan architectural terracottas. The 'Eurytios krater' in the

60. Attic black-figure one-handled kantharos. Drawing of *ekphora* scene. *c.* 510–500 B.C.

ekphora (Fig. 60): within the production of the Perizoma Group, these kantharoi all come from Etruscan sites (and, as we have noted, the shape is Etruscan-inspired). Such as they are, these may constitute instances of an Athenian workshop actually creating 'vases for the Etruscan dead'. But of course funerary iconography does not have to be directly related to funerary rites of passage. The painters of the Clazomenian sarcophagi do not depict the funerary process, and the painters of Etruscan tombs only rarely show the *prothesis*. And yet a funerary decorum prevails in the iconography of both Clazomenian sarcophagi and Etruscan tomb-paintings.

The presence of Greek vases in Etruscan tombs requires some archaeological definition. In the first place, it ought to be noted that the Etruscans deposited vases with their dead more generously than the Greeks. Greek cemeteries such as Delos are modestly endowed compared with any of the main Etruscan *necropoleis*. In Athens, it may be that anti-sumptuary laws limited the custom. And as it stands in qualitative terms, the only site in Greece that can match Vulci or Cerveteri is not a cemetery but the sanctuary of the Athenian Acropolis.

Secondly, we need to take account of the local variations within Etruria. These have been charted according to numerical statistics, and some historical factors invoked for the pattern that emerges: what is important is to realise that funerary traditions vary from site to site. Vulci is not very far from Tarquinia, but in the period when the

Tarquinians (or about 2 per cent of them: the richer Tarquinians) were having tombs decorated with wall-paintings, their coevals at Vulci were purchasing more Athenian black- and red-figure vases instead. The reckless nature of the Napoleonic excavation of Vulci makes it now impossible to judge whether vases came to Vulci in batches, and were purchased with immediate funerary use in mind: but David Gill has spotted what he takes to be a 'trading batch' in a tomb-group from Cerveteri, and if we only had the chance to re-excavate properly we might find many more examples of such batches.

Vases were put in tombs as part of the tomb's decoration, and can be expected to some extent to match other types of tomb decoration (painted walls, sculpture). But vases also bear a function in the afterlife: as food and drink were left with the dead, so the dead should have crockery from which to feast in decent style. The ultimate end to which a vase could be put was as a container of cremated remains. There is no knowing just how many of the Greek vases in our museums once held the ashes of their Etruscan owners, but some excavators were scrupulous enough to declare what was found inside a vase. So we know that the vase which figures on the cover of John Boardman's *Athenian Black Figure Vases*, with its spectacular Diony-sos-face, once occupied a squared-off hole in the ground of the Ripagretta area by Tarquinia: a *tomba a buco,* covered by a plain boulder. It had a lid made out of local bucchero: inside were the cremated remains, along with five silver fibulae and a couple of gold studs. For scholars in the tradition of Beazley, the significance of this vase is in its attribution to the Antimenes Painter; for scholars such as Claude Bérard, the significance will lie in the image of Dionysos and the nature of Dionysiac cult in Greece. But the fact of the finding is that the vase was an Etruscan ossuary: and that fact deserves more attention.

We may use that vase to focus upon some residual difficulties created by Greek vases in Etruria. It is an amphora (now in the Tarquinia Museum, inv. RC 1804) painted in Athens: on both sides it has a large frontal mask of Dionysos (cf. Fig. 45 for a similar mask). Assume it was painted for an Athenian symposium, and there are no problems. Dionysos and his votaries, however unruly their behaviour, are utterly appropriate on vases *qua* vessels: as god of the vintage, Dionysos should be the toast of every good symposiast. Assume it painted for its eventual usage, as a cinerary urn, and again there are no

problems: on vases *qua* funerary furniture, Dionysos is appropriate; he is the god who promises immortality to those who join his train or *thiasos*. So the British Museum 'Blacas tomb' from Nola in Campania was furnished, in the mid-fourth century B.C., with two Attic and three Campanian vases, all painted with Dionysiac themes – as if they had been selected on iconographical grounds for the funerary purpose. And so at Spina, the north Etruscan site which succeeds Vulci in the fifth century B.C. as the most fertile yielder of Greek vases, Dionysiac images are predominant.

The ambiguity of Dionysos matches the ambiguities we have already encountered in athletic scenes (athletes/celebrants of funerary games/blessed sportsmen in the afterlife), and also in banqueting scenes (symposium of Athenian party set, complete with *kalos* names, in-jokes and caricatures/funerary meal/ideal of plenty in the next world). In effect, we have to admit that Greek vases in Etruria have two readings: and who is to judge which is absolutely 'right'?

The vase belonged, we presume, to an Etruscan at Tarquinia. But there is no telling how he came to be buried with it. As it was a neck amphora, its shape may have been decisive – it resembled the biconical cinerary urns of local impasto tradition. Or it may have been a favourite possession. Or its eventual 'occupant' had been a devotee of Dionysos (whose cult is known to have reached Etruria). Or it was the only vase his relatives could get hold of when he died.

To dwell upon the funerary value of Greek vases in Etruria can never tell the whole story, of course. Nor should the funerary emphasis preclude other destinations of fine pottery. Vases were also dedicated in sanctuary areas, as they were in Greece: the clearance of a large cistern adjacent to a temple building within the urban precincts of Cerveteri has yielded many fragments of the sort of pottery we would expect of find in tombs – including pieces of a cup in the manner of Douris or Onesimos, showing the usual symposium scenes. The finds from the sanctuary at Pyrgi nearby are also demonstrating an important non-funerary place for Greek vases in Etruria.

Such finds, though important, are unlikely to alter statistics significantly. The statistics amount to 80 per cent of Greek vases anywhere being recovered from tombs. The figure was advanced by Ernst Langlotz, who used it as a basis for trying to determine the *Sinngehalt* or 'sense-import' of Attic vase-paintings. The obvious objection was voiced by T. B. L. Webster: 'the fact that 80 per cent

were found in graves does not mean that 80 per cent were designed for graves'. As a logical objection that stands good; as an archaeological objection it is less powerful, in so far as we are hard-pushed to find where else these vases were used: excavations of Attic houses reveal that the Athenians used coarse and black-glazed pottery at home. But Langlotz was simply running against the general attitude of scholars towards these vases. For classical archaeologists, they are works of art; for ancient historians, surrogate documents (and useful for book jackets). I suppose that if we were chronicling the Greek-vases-in-Etruria phenomenon in purely art-historical terms, it might turn out to be a freak, or a vogue. One thinks of Japanese prints – used in the nineteenth century for lining tea-chests, or packing china: how they became collectable, and then an enormous influence on the French Impressionists. But the partisans of Etruscan archaeology are few: and as one of the few, I feel bound to try to see Greek vases – and that means most of the Greek vases in our museums – as their ancient owners saw them; that is, as the Etruscans saw them.

7

Farce and tragedy in South Italian vase-painting

A. D. TRENDALL

Introduction

One of the ways in which vase-painters in South Italy and Sicily during the fourth century B.C. most clearly diverge from their Athenian contemporaries is to be seen in the frequency with which they depict scenes associated with the theatre and with Dionysos as god of drama. His is a triple godhead – he is god of wine, and hence of the symposium; he is god of the drama and of the choral ode or dithyramb; he is also god of the mysteries, whose initiates may hope for a better life in the hereafter. A vase, therefore, which represents one or other of these aspects of his divinity is appropriate for a symposium or as an offering to the dead, and almost all of the vases here discussed were used for funerary purposes.

Dionysos first appears in Athenian vase-painting around 580 B.C. on a vase by Sophilos, and, in the period immediately following, we see him and his followers, the satyrs, as 'light-hearted symbols of the pleasures of wine'.[1] Later, a more complex personality begins to emerge, maenads join with the satyrs in the revels, and cult scenes begin to make an appearance. Tragedy, which is myth enacted in honour of Dionysos, began with Thespis in 534 B.C. and, during the fifth century, many Athenian red-figured vases depict those myths which provided the basis for the plots of Greek dramas. Although there is little evidence for any direct connection between the stage presentation and the vase-paintings, it is not improbable that a theme brought to popular notice by a performance in the theatre might have subsequently been taken up by vase-painters.[2] Such subjects, however, begin to die out in Athenian vase-painting early in the fourth century

B.C., perhaps as a result of the changed export market in the aftermath of the Peloponnesian War, but became increasingly popular with the western Greeks in South Italy and Sicily, and especially with the Tarentines in Apulia, where the rule of Archytas in the 360s had greatly encouraged the arts.

Before turning to look in greater detail at the local products, we might take brief note of three vases of Athenian origin which must have made their way into Apulia around 400 B.C. and could have had some influence upon them. Two are fragmentary kraters, both found in Taranto and now in Würzburg – one[3] showing Dionysos with a female figure (Aphrodite or Ariadne) seated above members of a tragic chorus, holding their masks in their hands, together with a flute-player, the other[4] a symposium with Dionysos, half-draped in a richly-patterned garment, reclining on a couch with a second symposiast (Hephaistos) to left, and to right a bearded satyr playing the cithara, while, below, a youthful satyr (MIMOS) plays the flute. The third is a well-preserved volute-krater found in Ruvo,[5] which shows Dionysos and Ariadne with the cast of a satyr-play, in which Herakles was the hero, together with the musicians Pronomos (flute) and Charinos (cithara) and the poet Demetrios, all of whom have identifying inscriptions beside them.

All three are vases of comparatively large size, painted by Athenian artists at the end of the fifth century B.C., and all have connections with what we may call the 'theatrical' Dionysos. It is very interesting to note that they were all found in Apulia, two at Taranto and one at Ruvo, and this raises the problem of how and why they got there. Webster (*IGD*, 8) suggested that the Pronomos krater might have been a special order for use at a party after the satyr-play (perhaps the *Omphale* of Demetrios), which subsequently found its way to Ruvo via the second-hand market. This theory is not entirely convincing and, in the light of recent discoveries of vases of native Apulian shape decorated by Athenian painters,[6] one wonders whether it might not have been a specific commission by a wealthy resident of Apulia, who saw, and was impressed by, the actual performance. That the western Greeks showed a deep interest in Greek drama, from which, as the Peloponnesian War dragged on, they must have become increasingly isolated, would probably come as no surprise to anyone brought up in the first two decades of this century in the more distant British dominions, where the arrival of a touring company with a repertory of comparatively recent plays was regarded as a most important

cultural event. It is, therefore, not difficult to understand why the Syracusans were prepared, as recorded in Plutarch's *Nikias*, to set free such of the Athenian prisoners as were able to recite substantial passages from recent Euripidean dramas. The import of vases such as these, and others like the Talos Painter's name-vase (Ruvo 1501) or the Dionysos krater by the Kadmos Painter (Ruvo 1093), probably had a considerable impact upon the local Apulian vase-painters and it is significant that volute-kraters of large dimensions became increasingly popular there, long after they had ceased to be produced in Athens.

The Dionysiac connection

The greater emphasis placed in South Italian vase-painting on the role of Dionysos as god of drama is clearly to be seen on the substantial number of vases painted during the first seventy years or so of the fourth century B.C. in which the god appears in some sort of theatrical context. We may see him, as on a Sicilian calyx-krater from Lipari (Fig. 61), in the company of a satyr and two maenads as fluteplayers, one of whom carries a *thyrsus* (fennel-rod tipped with ivy leaves) from which a *phlyax* (comic) mask is suspended, while a second mask, that of a young woman or *kore*, with long, black hair and face painted white, is suspended above. A somewhat similar scene will be found on the bell-krater Louvre K240,[7] where Dionysos is shown riding on a panther between an old satyr, with white hair and beard, and a maenad playing the flute with a small satyr-boy behind her. Both Dionysos and the old satyr are holding thyrsi from which hang comic female masks similar to the one on the Lipari vase. The two vases form part of a group, mostly of Sicilian provenance, which are the immediate forerunners of Paestan, and which includes other vases showing Dionysos with actors in phlyax plays, like the well-known calyx-krater from Lipari[8] on which he is seated on a stage watching the performance of a female tumbler, while two phlyakes look on agape, and two women, wearing the white-faced masks of the hetaira (courtesan) and the *kore*, look down from windows above. Another vase from the same group[9] shows Dionysos with a cithara moving to left at the head of a small procession consisting of a phlyax with two torches and a flute-playing satyr carrying a small Eros on his shoulders in the 'flying angel' position. Such vases clearly illustrate the

connection between Dionysos, his followers, the satyrs and maenads, and the comic stage. They lead directly on to the Paestan style proper as exemplified, in particular, by the numerous vases from the workshop of Asteas and Python, the two chief vase-painters of that fabric, known to us by name from the signatures on some of their vases. They flourished between *c.* 360 and 330 B.C. and between them painted a large number of vases, mostly bell-kraters, showing Dionysos in the company of phlyax actors, maenads, satyrs and papposilens (older satyrs with shaggy goatskin tights), often with a comic mask somewhere in the picture. A typical early example may be seen on a bell-krater in Melbourne (Fig. 62) which shows him standing beside a maenad, who holds a white-haired phlyax mask in her hand. Many more vases showing Dionysos with a phlyax actor

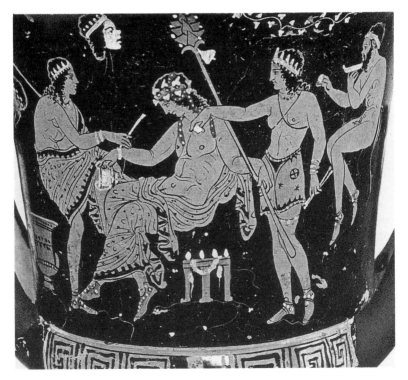

61. Sicilian red-figure calyx-krater. Dionysos, maenads, mask. Second quarter of fourth century B.C.

appear in the more developed phase of Asteas's work, sometimes also with a suspended mask.

Python uses a formula similar to that of his colleague Asteas for his standard compositions showing Dionysos with a phlyax or an actor dressed as a papposilen.[10] One of these shows a more interesting picture – Dionysos is seated beside a flute-playing maenad in a two-wheeled cart, drawn by a papposilen – reminiscent of the earlier black-figure vases showing Dionysiac processions.[11] Also significant is his well-known bell-krater in the Vatican,[12] which shows three actors playing kottabos (see above, p. 26) at a symposium, held perhaps to

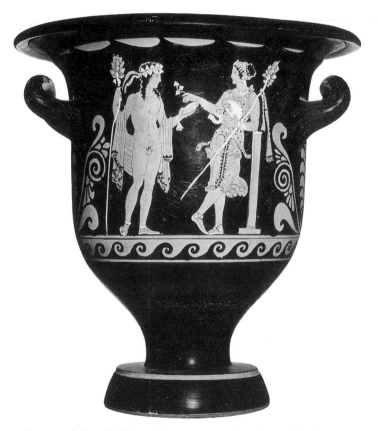

62. Paestan red-figure bell-krater. Dionysos, maenad, mask. Attributed to Asteas. *c.* 360–350 B.C. Ht 35.5 cm.

celebrate a successful performance, since suspended above are three different comic masks – youth, *kore* and old man – which may well represent the characters they played. A Dionysiac element is introduced by the presence of a papposilen, fast asleep beside the banqueting couch, the two reeds of a flute still clutched in his hand, and of a young satyr-boy with a ladle, whose task it must have been to replenish the cups of the banqueters. To left, a girl in a long orange-coloured robe plays a musical accompaniment on a flute.

Early Sicilian and Paestan give us perhaps the best illustrations of the 'theatrical' Dionysos, but Apulian is not far behind. During the first seventy years of the fourth century, from the Tarporley to the Darius Painters, a long series of vases illustrates the close connection between Dionysos and the stage in its various aspects. Among the earliest of the vases which may be attributed to the Tarporley Painter and which must have been painted not long after 400 B.C. is a bell-krater, at present on loan to the Metropolitan Museum of Art in New York,[13] which shows a youthful Dionysos, with a thyrsus in his right hand, contemplating a long-haired female mask which he holds in his left; beside him, a young satyr draws up an oinochoe from a bell-krater. A second, and slightly later, vase by the same painter[14] shows a youthful actor, with an exactly similar mask in his left hand, about to be crowned by Nike (Victory) in the presence of a young Pan-satyr, who represents the Dionysiac connection, since, in the absence of any identifying attribute, it is difficult to see the youth as the god himself. Of particular importance in this context is a volute-krater in Naples[15] by the Painter of the Birth of Dionysos, early in the fourth century B.C., which shows on the lower register a sacrifice in progress at an altar beside a bearded image of the god, while, above, the god himself in more youthful guise looks down upon the scene in the company of maenads and satyrs, with a long-haired female mask suspended above. It illustrates in one scene the three main aspects of the divinity of Dionysos – his cult, as god of the mysteries, his role as god of wine, with the ecstatic maenads and the half-drunken satyr clutching his wine-skin, and his association with drama in the mask suspended above. Also of interest are several vases showing symposia, with masks of various types hanging down from above, and others, with a more direct association with the stage, depicting Dionysos holding a mask, or in one unique instance (Fig. 63) a young actor considering which of two masks he will choose for his performances.

Perhaps the finest of all these vases, as a work of art, is the superb

calyx-krater in Basel (Fig. 64), representing Dionysos embracing Ariadne in the presence of a maenad and a satyr, who pours wine into a bell-krater, while a small Eros above flies to crown the couple; below them on the ground lies the mask of a bearded satyr. Again the scene brings together various aspects of the cult of Dionysos. We should, however, be cautious in reading too much symbolic content into the many Dionysiac scenes which regularly appear on Apulian vases.

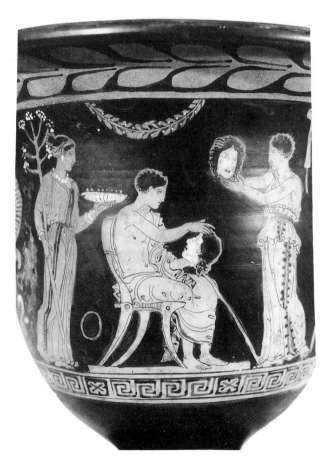

63. Apulian red-figure bell-krater. Actor and two masks. Second quarter of fourth century B.C.

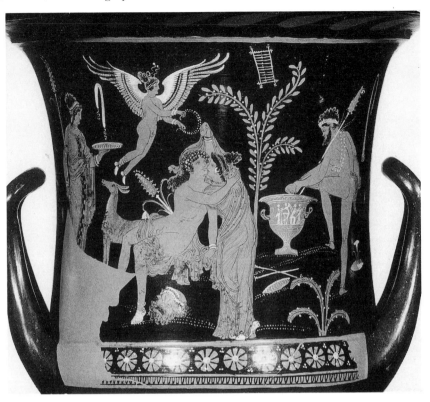

64. Apulian red-figure calyx-krater. Dionysos, Ariadne, mask. *c.* 350–340 B.C.

Satyr-plays

Satyric drama may look back for its origins to the dithyrambs of Arion around 600 B.C., but it does not seem to have assumed a serious literary form until the time of Pratinas, a century or so later, of whose 50 plays 32 are recorded as being satyric. His influence may perhaps be seen in the way in which Attic vase-painting from the last quarter of the sixth century onwards begins to show satyrs in scenes that look to be connected with drama. To the classical Greek tragic trilogy the satyr-play was intended to provide a light-hearted conclusion, calculated to relieve the tension caused by the preceding tragedies, and several red-figured Athenian vases, from 470 onwards, provide us with scenes inspired by such plays. Of particular interest in this context is a hydria by an early mannerist,[16] which represents five white-haired satyrs seated in front of a Sphinx – almost certainly the chorus from the *Satyric Sphinx* of Aeschylus, performed in 467 B.C. Other vases may well illustrate his *Diktyoulkoi* (Net-pullers) and *Prometheus the Fire-bringer*, and the *Sphyrokopoi* (Hammerers) of Sophocles probably inspired a number of vases showing satyrs hammering the ground to assist in the release of an earth-goddess or Pandora.[17]

Fragments of a bell-krater in Bonn[18] by the Painter of the Athens Dinos show a flute-player with actors in a satyr-play wearing loincloths and masks, and these reappear in South Italy in the early fourth century on a bell-krater by the Tarporley Painter which shows three actors dressing up as chorus-members of a satyr-play (Fig. 65). All wear phallic loincloths, two hold their satyr-masks in their hands, the third has already put his on and has begun to caper as if for the actual performance. Our fullest evidence is, however, provided by the famous Pronomos Krater found at Ruvo and now in the Naples Museum (see above), dating to *c.* 400 B.C., since it gives us the entire cast of the play, together with the poet and the musicians, in the presence of Dionysos and Ariadne.

It is interesting to note that the first appearance of a satyr-play on a South Italian vase is on an Early Lucanian bell-krater by the Pisticci Painter (*c.* 430 B.C.), which depicts a scene associated with the *Sphyrokopoi*.[19] It shows a satyr, holding up a large hammer beside a tree, and a goddess (Pandora?) almost completely emerged from the ground. A little later comes a calyx-krater,[20] the name-vase of the

65. Apulian red-figure bell-krater. Actors dressing for satyr-play. Attributed to the Tarporley Painter. First quarter of fourth century B.C. Ht 32.5 cm.

Cyclops Painter, who follows on from the Pisticci Painter, with a scene that it is difficult to divorce from our one surviving satyr-play, the *Cyclops* of Euripides. It shows the sleeping Polyphemos, drunk from the wine he has consumed from the now nearly empty wine-skin beside him, about to be attacked by three of the companions of Odysseus, who hold the sharpened tree-trunk between them, while Odysseus himself directs the operation. To the left are two more of Odysseus' men, while from the right come up two satyrs, members of the chorus of the play. The prelude to this scene is depicted on a Sicilian calyx-krater showing Maron giving Odysseus the skin of

wine[21] which he later used to intoxicate the Cyclops; this may well have been inspired by a play, since the figures appear to be standing on a stage-platform, and the two principals are flanked by Opora and Ampelis, who might well have delivered the prologue and epilogue. The date of the *Cyclops* has been considerably disputed, but it now seems probable that it was performed *c.* 408–407 B.C., in which case it raises problems for the dating of the Cyclops Painter's vase, which can hardly be later than, if as late as, that date and this would not allow for the normal time-lag. Other scenes which may be connected with lost satyr-plays show Perseus terrifying satyrs with the Gorgon's head,[22] and satyrs running off with the weapons of Herakles, or stealing his food after a feast. The former of these is best seen on the reverse of a bell-krater in Milan,[23] on the obverse of which is a scene from a phlyax play, and it is interesting and unusual to see both varieties of comic performance on the same vase. Thereafter, phlyax plays continue in popularity for another half-century, but satyr-plays are hardly to be seen again in vase-painting, and presumably their production had now come to an end.

Comedy and phlyax plays

It is in the extensive series (*c.* 250) of the so-called 'Phlyax' vases that Magna Graecia makes its most useful contribution to our study of comedy and theatre-production in the fourth century. The word *phlyax* seems to have been used to designate both the actors in a certain type of comedy, as well as the performances themselves, which were regarded as being the South Italian equivalent of what the *deikelistai* performed in Sparta. It may be derived from *phlyarein* ('to talk nonsense'), but it is more probably to be connected with *phleo* ('swell'), and this would be very appropriate as applied to the actors in their well-padded costumes, which look back to those of the padded dancers who appeared so frequently upon Corinthian vases;[24] *phleos* or *phleon* ('tumid') is also used as an epithet of Dionysos, in whose honour such performances were given and who, as has already been noted, is frequently to be seen in the company of phlyax actors.

Comparatively few Attic vases depict scenes which can be specifically associated with the performance of comedy. Of these the most important is the small bell-krater in the J. Paul Getty Museum, recently published by J. R. Green,[25] which represents a frontal piper

between two dancing men dressed as birds. Green plausibly associates it with the *Birds* of Aristophanes, produced in 414 B.C., and there can be little doubt that the scene is closely connected with comedy. A red-figured oinochoe of *c.* 420 B.C.[26] represents a comic actor, who appears to be a dwarf, on a simple stage approached by a flight of steps, playing the part of Perseus (with the *harpe* and the bag for the Gorgon's head). Below, watching the performance, are two spectators, one a bearded man, the other younger, who Webster has suggested may be the *choregos* (producer) and the poet. Another, in the Louvre,[27] gives a comic version of the apotheosis of Herakles; and a third in Leningrad[28] shows five children, with various types of comic masks. More remarkable is a set of *choes* (small jugs), one in the British Museum and four from the Athenian Agora,[29] decorated in the polychrome technique, with scenes that seem to be connected with comedy and certainly have affinities with those on some of the South Italian phlyax vases. They are unique and were probably a special dedication. There is also a Corinthian bell-krater,[30] which shows two comic actors beside a mortar, assailed by geese, as well as several fragments from the excavations at Corinth also depicting comic actors. The total, which includes a few other Athenian items, is very slight by comparison with the extensive range of such vases from South Italy and Sicily, from which we can learn a great deal more about the staging, costumes and production of local comedy.

Comedy has quite a long history in Magna Graecia and at any rate goes back to Epicharmus, who was active under Hieron, tyrant of Syracuse in the second quarter of the fifth century B.C. His plays included characters like the country bumpkin, the parasite, the braggart, and the sharp-tongued woman, all of whom feature in Middle Greek comedy and again in the representations of the phlyakes, which were current in Magna Graecia throughout the fourth century, and achieved literary status in the work of Rhinthon of Syracuse. He flourished at the end of that century and gave a more permanent form to the sort of farce which we see represented in the vase-paintings.

The various types of stage shown upon the vases suggest an outdoor performance, not necessarily in a theatre, for which light, movable sets could be used to provide the requisite background. A phlyax vase in Bari, dating to *c.* 370–360 B.C., gives a good illustration of an improvised stage (Fig. 66). It seems to have been set up beside a living tree, to which the curtain in front of the stage has

been actually pinned and which provides the necessary cover to conceal the flute-player who plays the real tunes which the two phlyax actors simulate as they dance around an altar. The stage itself here consists of a platform supported by four Ionic columns and approached near the centre by a flight of steps; between the columns hangs the swastika-patterned curtain, pinned to the floor of the stage, except for the occasion when it is fastened to the trunk of the tree. Other vases illustrate the wide range of stage design, from a simple platform of logs or planks, through a rather more elaborate form in which a low stage is supported, first by posts, then by columns, sometimes (as in Fig. 66) with curtains between them, to the final development in which the stage has much taller supports and is approached by one or two flights of steps. A door may be provided at either or both ends of the stage to allow for exits and entrances. Many vases, however, give no indication of a stage, though a door or window may be present.

66. Apulian red-figure calyx-krater. Phlyakes and flute-player.
c. 360–350 B.C.

The standard costume of the phlyax actor (cf. Figs. 66 and 67) consists of close-fitting tights (which represent nudity), with padding in front and behind, and a large phallus attached to it. Over this basic costume may be worn other garments, such as a tunic or a cloak, which are sometimes shown in added colours (red, white, orange-yellow) to enliven the picture. With this costume male figures wear the appropriate masks, as do the actors playing female roles, although they wear normal dress, and their masks are often painted white.

The subjects represented on the phlyax vases cover a wide range, from a simple mask to an elaborate scene from a play, sometimes with inscriptions to identify the characters and in one case what appear to be actual quotations from the play. These are to be found on one of the earliest of the phlyax vases, a calyx-krater in New York[31] showing the Punishment of the Thief, in which a youth inscribed TRAGOIDOS looks on while while a policeman is about to give a beating to the thief, whose hands have been bound above his head; to right, on a platform leading to a door, stands the old woman he has robbed, gesticulating and crying out that she will produce witnesses. The inscriptions are in Attic not Doric, which suggests that we may have here a scene from an Athenian comedy.

A bell-krater, only recently come to light, represents a most unusual scene, which takes place upon a low stage, approached by a short flight of steps in the centre, with a half-open door to the left (Fig. 67). Through the door has entered a man, dressed in tragic costume with a *pilos* (conical cap) on his head, which he touches with his right hand, while he grasps two spears in his left. He wears no mask and is inscribed AIGISTHOS. Greeting him is a white-haired comic inscribed CHOREGOS whose younger colleague, similarly inscribed, looks on from the right as he leans upon a stick. Between the two choregoi a phlyax, dressed in a short tunic over his tights, stands on an upturned basket and raises his right hand in a declamatory gesture. He is inscribed PYRRHIA[S], a common slave name, particularly for Thracians because of their red hair. The subject is so far without parallel – either for the appearance in a phlyax scene of a character who should be part of a tragedy, or for the presence of the two choregoi, who presumably are the leaders of the two semi-choruses, and not the producers of the play. Close to this vase in style and probably by the same hand is the bell-krater in Milan, to which reference has already been made for the scene from a satyr-play on its reverse.[32] The obverse gives us a typical scene from a

67. Apulian red-figure bell-krater. Aigisthos and phlyakes. First quarter of fourth century B.C.

phlyax comedy, taking place on a low stage, supported by Doric columns, with a half-open door to left. Three slaves, Philotimides, Charis and Xanthias (again a name based on the fair or yellow colour of his hair), have stolen a tray of goodies from their master's house and are about to deal with them, Xanthias moving off to right as he inserts a cake into the fold of his tunic – 'take-away' food. These two kraters belong to the early years of the fourth century B.C. and are associated in style with the work of the followers of the Sisyphus Painter and the Painter of the Birth of Dionysos. It is, therefore, clear that this type of comic representation was well established by the early years of the fourth century B.C. The connection with Old and Middle Comedy in Athens is further strengthened by the scene on a bell-krater in Würzburg, by the Schiller Painter (*c*. 370 B.C.), which depicts a parody of the story of Telephos, in which a wine-skin is substituted for the infant Orestes (Fig. 68), and a priestess comes

68. Apulian red-figure bell-krater. Parody of *Telephus*. Attributed to the Schiller Painter. Second quarter of fourth century B.C.

running up with a bowl to catch the wine when the skin is stabbed, much in the manner of the scene described in lines 733ff. of the *Thesmophoriazousae* of Aristophanes.

Other followers of the Tarporley Painter, especially in the period *c.* 380–360 B.C., also decorate a large number of vases with phlyax scenes, covering a wide range of topics, including comic versions of familiar legends (Oedipus and the Sphinx, the birth of Helen of Troy, Chiron's cure), of the adventures of Herakles (robbing Zeus at Olympia, mocking Eurystheus, at the feast), of scenes from everyday life (husband and wife, master and servant, the reluctant soldier), as well as a number with single figures of phlyakes or even just phlyax masks. After *c.* 360–350, phlyax scenes disappear almost completely in Apulian, and all that remains is the occasional mask at a symposium or in the hand of Dionysos.

Passing reference should perhaps here be made to the comic dwarfs who figure on several vases by the Felton Painter, sometimes to lend a humorous touch to a mythological scene, or to enliven a symposium, more often by themselves. They are achondroplasiacs, with large heads, spindly legs, pot-bellies and huge genitals. They were often employed as entertainers and dancers, their slightly ridiculous appearance providing a source of rather cruel amusement. Something of this may also be seen on a Gnathian vase[33] of *c.* 350 B.C., representing Prometheus as such a dwarf, bound onto the rock, as he looks down upon a bird, which contemplates him with a knowing eye.

Lucanian vase-painting offers few examples of comic scenes – a vase by the Amykos Painter represents the punishment of the slave,[34] a popular theme in Old Comedy, and the Dolon Painter decorated a few skyphoi with phlyax actors,[35] but once the centre of production moved from Metaponto to the hinterland (*c.* 375 B.C.), they are rarely seen again, as the artists can no longer have been in touch with the theatrical performances in the larger cities like Taranto and the local population probably had little taste for such subjects.

In Sicily and at Paestum, the story is quite different and some of the finest phlyax vases come from those areas. We have already noted some of the early phlyax vases from Sicily and their influence upon the art of Asteas and Python. In the later period more elaborate phlyax vases appear, characterised by a special form of stage, which looks rather like a hollow box, approached by a flight of steps;[36] a calyx-krater in Lentini shows Herakles carrying off Auge from a temple; a skyphos in Milan shows him again with a woman and Hermes, another in Gela the typical master-and-servant theme.

As we have already seen, many of the Paestan vases merely show Dionysos in the company of a phlyax actor, but several others represent scenes from plays, often with the stage, and in these Dionysos himself has no place. An early bell-krater by Asteas[37] depicts the lyre-player Phrynis dragged along against his will by Pyronides. The former was a celebrated musician of the later fifth century, and the vase may depict a comic version of his quarrel with the Spartan ephor over his musical innovations. Asteas signed two phlyax vases, one in Berlin[38] showing two robbers attacking an old man on his treasure-chest while his paralysed servant looks on powerless to assist his master, and another,[39] of which only a fragment of the obverse remains, representing a parody of the Rape of Cassandra in which the tables have been turned and it is now

Cassandra who is about to smite a terrified Ajax, who clutches the Palladion for protection, while the temple-priestess raises her hand in surprise. Two other phlyax vases attributed to Asteas show the god who would a-wooing go[40] – Zeus on a bell-krater in the Vatican, his tinsel-crowned head peering out between the rungs of a ladder, which he is going to climb up in pursuit of a woman (perhaps Alkmene) whose bust is framed in the window above, while Hermes lights him on his way with a pocket-lantern; on the other vase, slightly earlier in date, the lover, in this instance perhaps an ordinary mortal, is half-way up the ladder and reaches out towards his inamorata, while his servant stands by with a lighted torch. These vases well illustrate the lively sense of humour which Asteas can show at his best.

Python also painted several phlyax vases; the best is perhaps the bell-krater in the British Museum,[41] showing master and slave returning home, on a stage with unusually tall columns, but Louvre K244[42] gives a superb portrait of a phlyax (the cunning slave) carrying home a basket of cakes on his head, as he lights his way with the aid of a blazing torch; by his feet is a small duck with a worm in its mouth, one of the typical Paestan 'early birds'. The Paestan series comes to an end about 330–320 with two bell-kraters by the Painter of Naples 1778[43] – one showing a phlyax between Dionysos and a maenad, the other two phlyakes with wicker shields, escorting a woman – Antigone perhaps, or the return of Briseis. They show all too well how by this time their 'fire had died away'.

Phlyax vases play a very small part in Campanian, and only one depicts a stage. This is a bell-krater in Melbourne,[44] which shows the country bumpkin, holding a reaping-hook, and the city slicker, who is in converse with a flute-player. Two others by the same painter show just the phlyax with a flute-player.[45] A squat lekythos in Paris[46] shows a phlyax finding an infant wrapped in swaddling-clothes, a motif very popular in later Greek comedy, and a few others show genre scenes. It is, however, clear that the Campanians had little taste for phlyax frivolities, perhaps the more surprising because of their popularity at Paestum.

In all, the phlyax vases represent some of the most attractive products of the pottery workshops in Magna Graecia. The scenes upon them are usually well presented, lively and entertaining and without the pretentiousness which often characterises the larger vases with themes associated with tragedy. They reflect in some measure contemporary Middle Comedy in Athens, but also, no doubt, local

productions, of which few traces remain, since they had probably not in their time achieved publication. Professor Dearden has pointed out the conformity of treatment in the phlyax scenes on all the vases from the different fabrics of South Italy and Sicily and argues that this militates against an impromptu type of performance. It seems more probable that these productions were put on by itinerant players, who would have their own repertory, and who would take with them the simple stages and properties that were required, together with a standard range of appropriate costumes and masks and thus could put on their performances where and as required, without the need for a formal presentation in a theatre. The texts might be adapted from Athenian comedies or local compositions, and no doubt they could be modified to suit the occasion. They had not yet become definitive and hardly did so until the time of Rhinthon, when phlyax vases were no longer being painted.

Tragedy

A forerunner of the representation of tragic themes on the vases of South Italy is probably to be seen on an Attic red-figured calyx-krater of the later fifth century B.C. which seems to reflect the production of the *Andromeda* of Euripides in 412.[47] The vase shows Andromeda, leaning against a rock to which her outstretched hands are bound, as she appeared at the opening of Euripides' play; above to left, Hermes walks away, and in the distance is a seated Aithiopian girl in oriental costume – perhaps a representative of the chorus in the play. To left, below, is Andromeda's father Cepheus, and, to right, Perseus with the *harpe* in his hand. Above him is Aphrodite, holding a victor's wreath over his head. It could not be called a representation of the drama, but it sets a pattern which is to be closely followed by South Italian vase-painters in their treatment of scenes which have theatrical associations. In the beginning their scenes are less elaborate and show fewer characters, nearer in treatment to the Andromeda krater, but from *c.* 350 onwards, and especially on the vases from the workshop of the Darius Painter and his circle, the vases increase greatly in size and are decorated with multi-figured compositions, in at least two registers. On such vases the upper level is often filled with various divinities, some of whom may have a direct connection with the drama unfolding below; this often depicts the denouement of the tragedy, which could not of course be performed on the actual stage,

but was narrated by a paidagogos (elderly retainer) or a herdsman who happened to be present when the tragic event took place. His presence on many of these vases establishes the connection with the stage, since he has no part to play in the pure myth. These vases, therefore, are 'illustrations' of Greek tragedies, rather than actual representations of them and they offer us, as it were, an artist's recollection of the play, in which he gives us the principal characters, a striking scene from the play, and perhaps a hint of what may be the aftermath. In such a context we would hardly expect to see the stage or to find the characters wearing masks, but they do wear the elaborate costumes which played such an important part in the performance.

Only two red-figured vases have so far survived to give us any indication of the stage in performances of tragedy. One is a fragmentary calyx-krater in Syracuse (Fig. 69) with the scene from the *Oedipus Tyrannus* of Sophocles, where the messenger from Corinth tells Oedipus of the death of his reputed father Polybos, and Jocasta, realising the revelation about to follow, draws her veil over her head before leaving the stage. Beside her is a female attendant, who turns her head away, and also present are the two children Antigone and Ismene, probably included by the vase-painter to heighten the emotion. All the principals wear richly patterned and, in some cases, coloured robes, typical of the 'tragic' costume in such scenes. They are here shown standing on a wide stage platform, supported by low posts; four tall Doric columns in added white rise up from it to symbolise the stage background. A much simpler form of stage appears on another Sicilian calyx-krater by the same painter,[48] which shows a woman, kneeling on the floor of a simple stage, between two other women, both dressed in embroidered tragic costumes with cloaks, one of whom turns away from the suppliant, while the other raises both hands, as if in horror, as she listens to the tale told by a white-haired and bearded man, wearing a black *pilos*, who must be playing the role of the Messenger. The scene is not easy to identify, but it might be associated with the *Hypsipyle* of Euripides, where the messenger narrates the death of Opheltes to Eurydike, and Hypsipyle's appeal for mercy is ignored by the leader of the chorus. The most important extant representation of a stage set is to be found on a fragmentary calyx-krater in Würzburg,[49] painted in added colours on a black background in the so-called Gnathia technique and dating to the middle of the fourth century B.C. It shows two projecting porches (cf. the Adrastos krater, Fig. 71), supported by

69. Sicilian red-figure calyx-krater. *Oedipus Tyrannus. c.* 340 B.C.

Ionic columns, with architrave, pediment, and coffered ceiling, one on either side of a wall, in front of which two figures are standing. In each porch is a half-open door, with a woman standing in it. The identification of the figures is problematic; perhaps, in view of the representation of Bellerophon on Pegasus as the central acroterion of the pediment, it may be connected with the *Stheneboia* of Euripides; another possibility is the arrival of Jason at the court of Pelias. A distant parallel to the stage architecture on the Würzburg fragments may be seen in the background to a representation of the *Iphigenia in Tauris* on a Campanian bell-krater in the Louvre,[50] which also shows a building with two wings, in the doorway of one of which stands a statue of the Tauric Artemis, while from the other Iphigenia emerges

to speak to Orestes and Pylades. Both vases are of interest for the treatment of perspective, especially in the drawing of the doors.

Reminiscences of a stage setting are probably to be seen on two Paestan vases signed by Asteas,[51] one showing the Madness of Herakles, the other the parting of Bellerophon from Proitos and Stheneboia, as he leaves with the fatal letter to Iobates. On both these vases there is a sort of loggia, from which various figures may look down on the scene taking place below. On the Herakles vase, the structure has an upper level supported by two Ionic columns, and this is provided with a ceiling supported by four shorter Doric columns, between which appear busts of Mania, Iolaos and Alkmene; on the other, the upper element is supported by two columns, between which appears the bust of Aphrodite, flanked by those of two Furies.

The range of tragic themes depicted on South Italian vases is extensive; all three of the great Greek tragedians are well represented, Euripides in particular, since his popularity seems greatly to have increased in the fourth century, when his plays seem to have been frequently revived. The works of other tragedians, like Astydamas or Chaeremon, probably also provided the inspiration for various scenes, but as they have survived in only small fragments or as little beyond the titles of their plays this is not easy to determine, and there are many scenes depicted upon vases, like the Medeas on the volute-kraters in Princeton and Munich by the Darius and Underworld Painters,[52] which are almost certainly of dramatic inspiration but which cannot be directly associated with any known play.

An excellent example of the way in which a vase-painting can serve as an 'illustration' of a known play is provided by a Sicilian calyx-krater from Lipari, early in the second half of the fourth century B.C. (Fig. 70), the scene on which would make an admirable poster for the *Trachiniae* of Sophocles. The figures on it are almost all inscribed, so there is no doubt about their identities. To left sits Deianeira and beside her is a woman, an attendant or perhaps a representative of the chorus; above is a seated Nike (Victory) holding a crown in her hand. The central figure is the youthful Herakles, with club and lion-skin, who looks down at the seated white-haired Oineus, father of Deianeira, above whom sits the horned river-god Acheloös, Deianeira's suitor. The scene provides an admirable illustration of the lines (6–21) spoken by Deianeira at the opening of the play: 'I, who in the house of my father Oineus . . . had such fear of bridals as never vexed any other maiden of Aetolia. For my wooer was the river-god

70. Sicilian red-figure calyx-krater. *Trachiniae. c.* 340 B.C. Ht 49 cm.

Acheloös, who was ever asking for me from my father . . . but, at last, to my joy came the glorious son of Zeus and Alkmene, who closed with him in combat and delivered me . . . '

The chief characters are all shown, and the presence of Nike with a crown in her hand points to a victory for Herakles; the painter does not intend to give us a representation of an actual performance of the play, but rather to tell us what it is all about, as if, having seen it, he gives us the *dramatis personae* and an indication of how the plot will develop. The reverse of this vase shows the muse of comedy, Thalia, playing the flute, to the accompaniment of which an actor dressed as a papposilen is dancing, while to the right a satyr turns his head round to watch the spectacle. The combination of tragedy with comedy on the same vase is remarkable.

Another instance of the influence of drama on vase-painting may be seen on a second calyx-krater by the same painter, which shows

71. Sicilian red-figure calyx-krater. Adrastos. *c.* 340 B.C. Ht 39.8 cm.

Adrastos intervening in the quarrel between Tydeus and Polynices (Fig. 71), which took place outside his palace in Argos, on the porch of which are standing his two daughters, later to marry the combatants. The palace is shown as a most elaborate structure (slightly reminiscent of that on the Würzburg fragment mentioned above) with columns, coffered ceiling and half-open doors and it must surely owe something to stage architecture. The episode depicted on the vase is described by Euripides in both his *Phoenissae* and his *Suppliants*, and we know from a passage in Antiphanes (fr. 191) that Adrastos figured in several tragedies. Further evidence for this may be seen on the calyx-krater in Boston (Fig. 72), by the Darius Painter, which shows Adrastos, as King of Sicyon, insisting that Thyestes expose his infant son Aigisthos, born of an incestuous relationship

72. Apulian red-figure calyx-krater. Adrastos, Thyestes, Aigisthos.
Attributed to the Darius Painter. *c.* 340–330 B.C. Ht 63.5 cm.

with his daughter Pelopeia, in order to fulfil the oracle which said that
only through such an offspring could he achieve revenge upon his
brother Atreus. The Boston vase provides a good example of the
more elaborate type of illustration which is regularly to be found on
Apulian vases, especially from the workshops of the Darius, Under-
world and Baltimore Painters, in the period between *c.* 340 and 310
B.C. In the upper register are Artemis and Apollo with a small figure
of Pan between them, then a Fury, and finally a personification of

73. Apulian red-figure loutrophoros. *Niobe.* Attributed to the Darius Painter. *c.* 330 B.C.

Sicyon (inscribed) to give the location of the action; below are the principal figures of the drama – in the centre Adrastos, directing Thyestes to hand over the baby Aigisthos to the herdsman for exposure, and to right Pelopeia being comforted by Amphithea, the wife of Adrastos. Sophocles is known to have written a tragedy entitled *Thyestes in Sicyon,* and this vase may well look back to it.

Although few South Italian vases show the actual stage, and the characters do not wear masks, the influence of the stage is almost certainly to be seen in the elaborate and richly decorated costumes worn by the principal characters, and also in certain features which are repeated in various scenes and which are probably stage 'props'.

Typical of these is an object which may serve as a rock (to which Andromeda or Prometheus may be bound), as the mouth of a cave or grotto (Philoktetes, Dirke), and the lopped trees which provide a sort of landscape background or again may serve as the posts to which Andromeda is bound in scenes where the rock is not used. Such features tend to look more artificial than natural, and would be just the sort of thing that an artist might bring away in his mind's eye from a stage production.

Many of the tragic themes illustrated on South Italian vases are concerned with extant plays, but up to the end of the first quarter of the fourth century B.C. they are more usually to be associated with the legends that provided the plots of the dramas rather than with a

stage production. We see this in the numerous early representations of the story of Orestes – his meeting with Elektra at the tomb of Agamemnon, his pursuit by the Furies, his purification at Delphi – mostly on vases by the Tarporley Painter and his followers; these have no direct connection with the stage, and the same may be said of the early vases depicting Alkmene, Hippolytos, Medea, Dirke and others. It is not long, however, before the influence of the stage makes itself apparent, especially during the second half of the century, when the greatly increased size of vases like volute-kraters, amphorae and loutrophoroi gave far greater scope to vase-painters for multi-figured compositions at different levels, in which both the gods, the principal characters of the drama, and the paidagogos (or the herdsman) are all present. What is quite fascinating is the large number of vases, especially from the workshops of the Darius, Underworld and Baltimore Painters, which provide illustrations of lost tragedies and thus can sometimes contribute to their reconstruction. Among these may be noted in particular the following.

(1) A series of vases shows Niobe at the tomb of her slain children, resisting the entreaties of her father Tantalos or her brother Pelops to desist from her mourning; on several of these vases the lower part of her body is painted white to symbolise her forthcoming petrification, and on one there is even a personification of Mt Sipylos in Lydia where she finally comes to rest (Fig. 73). These may look back to the *Niobe* of Aeschylus, but are more likely to reflect some later play on the same theme.

(2) Several vases illustrate the story of Andromeda,[53] some showing her bound to posts (Sophocles), others to a rock (Euripides). Three different episodes are shown – the pact between Cepheus and Perseus, the liberation of Andromeda by Perseus, and her final triumph, where she is shown seated on the throne of Cassiopeia (Fig. 74), who kneels before her entreating forgiveness; behind Andromeda is the personification of Concord (Homonoia) and above is Kypris (Aphrodite); one wonders whether either or both of these might have spoken prologue or epilogue in a late drama on the Andromeda theme.

(3) Two vases, both by the Darius Painter, perhaps illustrate the *Kreousa* of Sophocles.[54] Both show the Pythia at Delphi standing in front of or on an altar which bears the painted inscription KREOUSA, with a bearded king and a young man (Xuthus and Ion) to left and two women (Kreousa and attendant) to right. The

74. Apulian red-figure pelike. *Andromeda*. Attributed to the Darius Painter. *c.* 340–330 B.C. Ht 61 cm.

inscription is here probably a title (as on the painter's Persians and Patroklos kraters), since the figure at the altar cannot be Kreousa herself, and may therefore refer to the lost drama by Sophocles.

(4) Several vases may be associated with the *Antiope* of Euripides; these begin with the early and simpler versions of the story on the vases of the Dirke and Policoro Painters[55] and culminate with the huge calyx-krater by the Underworld Painter,[56] which gives the full story in elaborate detail. Above, Amphion and Zethos attack Lykos, but are restrained by Hermes; below, the dead body of Dirke lies beneath the bull, beside her is the thyrsus she had been carrying while celebrating the Dionysiac rites during which she was caught by Amphion and Zethos, and sent to her death on the back of the raging bull; a Fury and Oistros represent the passions unleashed in the drama, and the old herdsman witnesses the denouement, which he can later relate. Little doubt that this scene is inspired by the Euripidean drama, in the light of the presence of the thyrsus and the herdsman.

Perhaps the best of all the representations of lost plays is the volute-krater in Geneva, also by the Underworld Painter (Fig. 75), showing the story of Melanippe, the subject of two dramas by Euripides. In the upper register is the typical row of divinities – Artemis, Apollo, Athena, Eros with Aphrodite, and Poseidon, of whom only the last two have any close association with the plot; below, the story of Melanippe unfolds – first her brother Kretheus crowning a mare, which may represent her mother Hippe, then Aiolos, her husband, the herdsman holding the twin children, Hellas the father of Aiolos, and Melanippe with the white-haired nurse. The costume of the herdsman follows the standard pattern for the paidagogos or messenger in such representations, and again the picture almost certainly looks back to one of the lost plays.

Many other examples could be cited, but the selection given above clearly shows what a vital contribution the fourth-century vases of South Italy and Sicily make to our better understanding of the relation between art and literature and to the bridging of the gap between the two worlds of myth and of the theatre. The vase-painter may have been more concerned with an evocation of the myth itself, especially in its significance for the after-life, since so many vases were destined for the tomb, but he draws on his visual experience at the theatre, where emphasis was placed on the cathartic quality of tragedy and this is to be seen in many of the vase-paintings. In the representation

75. Apulian red-figure volute-krater. *Melanippe*. Attributed to the Underworld Painter. *c.* 330–320 B.C. Ht 80.5 cm.

of comedy or phlyax farces greater emphasis is placed on the funny side of things; humans are no longer godlike and gods come down to a very human level. Our vases touch upon both the lighter and the darker sides of life and the fact that they were destined for the tomb brings home to us the force of Ernest Dowson's poem:

> They are not long, the weeping and the laughter.

8

Fine wares in the Hellenistic world

J. W. HAYES

General comments

The Hellenistic period, in political historical terms, is considered to run from 323 B.C. (the death of Alexander the Great) to 31 or 27 B.C. (the ascendancy of Augustus). While those art-forms directly dependent on royal patronage may show an abrupt change of direction at such historical turning-points, the less 'political' products of the potter, made for everyday use, have their own rhythm of change: a momentous political event may affect popular taste not at all, or its effects may filter down slowly. Hence those archaeologists who would put cultural tags on pottery are well advised to stick to round figures: 'third to first century B.C.' (with occasional wanderings beyond these limits) will suffice for our present discussion.

What primarily distinguishes the study of Hellenistic pottery from that of Classical Greek is that the 'vase-painting' approach (that of Beazley) becomes inapplicable, since in most cases the surface of a pot no longer occupies the attention of the 'artist' (in the modern sense), but is left merely to the 'decorator'. The linear drawing and restricted palette of earlier Greek painting were relatively easy to apply to the surface of a pot, but the full polychromy and effects of light and shade preferred in Hellenistic times (and seen in, e.g., Macedonian painted tombs from the late fourth century onwards) were harder to match. Since most of the new colouring substances required could not withstand high-temperature firing, the only solution was application to the pot *after* firing, which meant that they were not durable. Such 'temporary' painting was acceptable for funerary use, where the pot would be displayed to view only briefly (it had already been used for

the Attic white-ground funerary lekythoi, see above, p. 124), but was not suitable for everyday purposes. Hence, after a few short-lived experiments in the late fourth and third centuries B.C., the picture-painters directed their attentions elsewhere, leaving even the funerary vases to the 'decorators' (who might be the potters themselves). As it happens, the 323 B.C. date closely approximates to the end of the 'vase-painting' tradition – i.e. when the art of free *composition* of figured scenes lapsed. Though the red-figure medium survived in places for a good half-century more, the impersonal decorators, with their symmetrical patterns (less and less figural) had more or less taken it over. The Classical Greek approach to pottery decoration fizzled out, while its manufacturing techniques were retained. Alexander the Great (or his successors) cannot be held personally responsible.

If a major artistic change signals the beginning of Hellenistic pottery, its end is to be defined in different terms: new trading patterns rather than innovations in technique or decoration. The classic 'Roman' ware – 'Arretine' ware (*alias* Italian *terra sigillata*) – with a fine red-gloss surface, crisp, angular shapes, potters' stamps and, on occasion, figured decoration in relief (cast from moulds), comes into the limelight soon after the 27 B.C. date cited above. None of its features are novelties – all, individually, have Hellenistic antecedents. The ornamentation of the decorated vessels, which here concerns us most, harks back to an earlier age: as Marabini Moevs has demonstrated, it revives figured motifs created in the third century B.C. – perhaps in some cases through direct casting off the highly prized surviving metalwork of that period, which also strongly in-fluenced Roman metalware (as evidenced at Pompeii and Hercul-aneum). Arretine ware and other Italian products of the period set a pattern for the years to come, not only in those northern regions previously untouched by Mediterranean artistic traditions, but also, in lesser degree, in the Hellenistic East, where a cycle of mixing of styles and periodic revivals of earlier styles was *already* in progress in the other arts.

The foregoing remarks serve to warn us that Hellenistic pottery is multi-faceted, and lacks the sort of single focus provided by Athens in the fifth century B.C. This lack of a single model, combined with the geographical extension of Hellenistic culture, embracing the whole Mediterranean littoral and Alexander's extensive eastern conquests, means that a given new style was not necessarily employed everywhere – in fact, the distinctive series almost all stem from the Mediterranean area. Similarly, distinctive production techniques are

not universal – in part owing to the availability of suitable raw materials, though in part owing to tradition. Hence the black 'gloss' or 'glaze' treatment (a sintered slip) inherited from Classical wares is fairly universal in Greece and the Aegean region, and all over Italy. From there it spreads over most of the western Mediterranean, but, with rare exceptions, is absent from Near Eastern and Egyptian products. To take another example, the relief-decorated ('Megarian') bowls (described below), so common on Aegean sites, are scarcely seen – except as imports – in Italy and further west; a Syrian production of such bowls is offset by their near-absence in neighbouring Cyprus, Palestine and Egypt.

The Hellenistic world was politically dominated by a number of great powers, with their capital cities – Antioch, Alexandria, Pergamon, and so on, and latterly Rome. One might expect certain differences in emphasis among the pottery styles of these empires, within the broader context of a trading system embracing all of them. But given that artistic *styles* were less and less the preserve of the potters, and that there is scant evidence that the capital cities themselves were major producers of fine wares (except for Pergamon), broad terms such as 'Alexandrian' or 'Pergamene' come here to mean very little. Rather, the pots *reflect*, spasmodically, what the silversmiths and goldsmiths and sculptors in the major centres were doing. Thus, the appearance of 'Megarian' bowls (below, Fig. 78) in Athens, it is now suggested, may reflect diplomatic gifts of fine silverware to Athens by the Ptolemies of Egypt; a similar process may be postulated elsewhere.

To search for the hands of individual artists among these predominantly 'faceless' products is, as indicated above, largely futile, though it has been attempted for some of the smaller painted categories (e.g. the Hadra vases found at Alexandria). We must limit ourselves, generally, to distinguishing workshop traditions or 'styles'. Where mechanical means of reproduction are used (as with the mould-made vessels), we may trace the history of individual motifs – a form of study well established for Roman decorated *sigillata* wares, and equally applicable here. In fact, Hellenistic pottery decoration, having abandoned the 'vase-painting' tradition, expresses itself as a series of clichés – generally single motifs borrowed from the stock artistic repertoire, combined in random arrangements which are usually governed by a desire for simple symmetry. The particular clichés favoured may vary from generation to generation, serving as a rough guide to the dating of individual pots.

Dating

A general lack of interest in post-Classical Greek-style pottery by the then dominant art-historical school, along with the diversity of styles involved, contributed in the past to a lack of precision in dating. In Greece, Thompson's classic article of 1934, presenting a sequence of closed deposits from the first years of the Athenian Agora excavations, has been heavily used as a point of reference; other sites, such as Olynthos, Alexandria and Delos, with 'historical' links, have been taken as fixed points. Meanwhile, two more-or-less independent chronologies have been constructed for the Italian finds. That for Magna Graecia, based on Trendall's work on red figure, and that of his followers for Gnathia and related wares, remains essentially art-historical, becoming increasingly vague as the vase-painting tradition declines during the third century. That for Rome and central Italy is more archaeological–historical, with its own series of fixed points based on Roman colonial foundations; here stamped black-gloss wares are the prime material. The cross-linking of the three 'systems' remains fluid, particularly in the third century, when the respective coinages pose dating problems (resolved only by the rise of the Roman denarius system and its contemporaries). Morel, among others, has pointed to a 'great divide' between eastern and western scholarly traditions, only now being bridged. Recent work in the fringe regions – e.g. the Campania–Lucania divide, the eastern Adriatic, and Cyrenaica, offers hope of solutions in this area.

A general tendency towards later dating of early and mid-Hellenistic pottery has emerged in recent years, in Greece, spurred by the finds from Koroni in eastern Attica and material from the Kerameikos. This is due mainly to V. Grace's studies of amphora stamps, which can now frequently be assigned very precise dates. Morel has brought similar precision into the dating of the later Italian ('Campana') black-gloss wares, on the basis of numerous site-contexts, notably those from new work at Carthage. The dating of the later material from South Italy and the first-century B.C. transition in the Aegean remain problem areas, while the dates of the early material from Alexandria and the latest finds from Olynthos may require revision. The revised Athenian Agora chronology being worked out by Rotroff may, like that of Thompson fifty years ago, provide a new anchor-point. However, a continuing lack of documentation from much of the eastern Aegean, where important developments were occurring in the second century, hampers further understanding.

Shapes

Whereas the potters of earlier Classical times had sometimes created their own 'potters' shapes', the fourth century B.C. saw the re-emergence of copying from metalware – a tendency that had never been totally submerged. Ribbing, contorted handles and pedestal-like bases are the signs of the age (Fig. 76), and stamped ornaments mimic engraved and punched decoration. With the Hellenistic age, the natural links between raw material and form finally break down in the face of experimentation with various media, some used for the first time. A single shape may be repeated in precious metalware (the commonest source), pottery, glass, 'faience' (i.e. glazed quartz-frit),

76. Black-gloss amphora with overpainted decoration. Late fourth century B.C. Ht 78.7 cm.

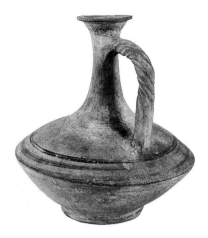

77. Lagynos, with paint banding. The twisted handle is a standard feature. *c.* 150–50 B.C. Ht 21.2 cm.

marble, alabaster and a range of semi-precious stones such as onyx and rock-crystal, sometimes at the cost of great effort. In the case of pottery, the makers struggle against the natural properties of their raw material to produce large flat platters, or cups of eggshell thinness. Colour seems less important: the range of colours exhibited by these diverse wares (especially *millefiori* glass) warns us against equating the surface colours of Hellenistic pottery too closely with a particular model. 'Black-glaze' surfaces dominate at first, but an uneven firing is very common (since the red-figure treatment, which depended on a sharp contrast, is abandoned); later, a red-gloss surface, simpler to produce, gained favour, especially in Asia Minor and the East.

Some of the basic shapes of Classical times survive long into the Hellenistic period, especially the simpler 'black-glaze' forms serving everyday needs. An example may be seen in the small shallow bowl with inturned rim (the Classical 'salt-cellar'). The rim becomes thinner, the Classical pattern of painted rings on the bottom is abandoned, the stamped decoration on the floor, where present, becomes more perfunctory. The basic type survives in the Aegean and the Levant right through the period. Meanwhile, a deeper, hemispherical counterpart, already seen in Rome around 300 B.C., is widespread in the western Mediterranean. A merging of the types is already visible in Asia Minor and the East by the mid-second century.

Amphorae undergo a greater transformation in the ornamental 'West-Slope' style: the version favoured here is rather squat and wide-necked; heavy base- and rim-mouldings (typically a double-

stepped flat-topped rim, as in Fig. 79) distinguish the late and influential series from Pergamon (after *c.* 160 B.C.). Here, and on the parallel narrow-necked jug (the *lagynos*), the debt to metalware is more pronounced. The lagynos has a broad, flattish shoulder and angular body, at first roughly biconical; early examples are mostly plain and sometimes stamped (recalling commercial amphorae). The one shown in Fig. 77 may be an Egyptian version of the shape. After *c.* 150 B.C. they acquire decoration in dark paint on the shoulder, applied over a slip of white china clay (like that used for Archaic Chian vases). The shape becomes flatter: either very acute-angled at the belly, or broad-based with a near-vertical side. Variants occur in black/red-gloss fabrics with relief ornament, or plain; the shape is repeated in moulded glassware.

Also typically Hellenistic are various bowl shapes with rounded or unstable bases, reflecting Achaemenid Persian and other metalware influences. These, designed to be cupped in the hand, may bear painted or relief patterns – sometimes both. One series is of near-conical shape (*mastoid* – i.e. breast-shaped), deep or shallow. Most common *c.* 225–150, these tend to be black-glazed with added paint bands encircling a central flower motif, or sometimes a mould-made relief medallion – a non-functional feature rarely found earlier. Some late examples bear merely a set of mouldings below the rim on the interior. A second series comprises hemispherical bowls with vertical fluting on the outside, to which may be added plain

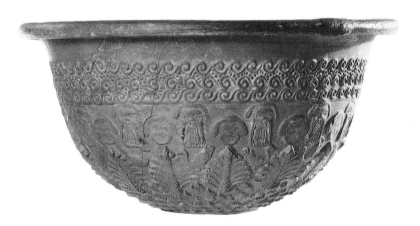

78. 'Megarian' bowl, with tragic and comic masks in relief. Perhaps *c.* 220–180 B.C. Diam. 10.5 cm.

imitations of halved ostrich-eggs; these are matched by many examples in glass and 'faïence'. Third and last, there are the rounded bowls with relief ornament on their outsides (conventionally – but erroneously – termed 'Megarian bowls'), distinguished by their technique – manufacture within moulds rotated on the potter's wheel (Fig. 78). Rotroff has recently documented in detail the series from Athens – where the pottery version may have originated, in the 220s B.C.; Siebert and Edwards do so for the matching Peloponnesian series, Laumonier for the later 'Ionian' bowls (commonly termed 'Delian' from a major findspot), and Marabini Moevs for the small central Italian class. The rich series from Thessaly and Macedonia are as yet only patchily documented. All of these display a more or less hemispherical bowl bearing the decoration, with an upright rim added by hand above the top of the enclosing mould. The series may be distinguished on the basis of ware, the choice and disposition of the reliefs, and (sometimes) the rim treatment. The later 'Ionian' series have very shallow bowls (while their Greek contemporaries retain the basic hemispherical form). Siebert has offered an overall classification based on rim-form, but this is valid only for the larger centres. As is noted above, some areas (like Cyprus) rarely produced these bowls, and the profiles of these are not standardised. An unusual early relief-ware bowl from Central Italy, possibly from an Italian workshop, is illustrated in Fig. 78. The motifs – tragic and comic masks, an Athena Parthenos medallion on the bottom – match those on early Greek relief bowls, but the smooth red ware and slip, and flaring rim-form are distinctive. The motifs are here very sharp, suggesting direct moulding from a lost metalwork original.

Cross-currents may be seen in the adoption of motifs from other (non-moulded) wares on 'Megarian bowls': incised linked pentagons and vertical fluting (the 'long-petal' motif extremely common after *c.* 160 B.C.) are the prime examples. At the same time, the addition of a pedestal base and a wheel-made neck to a moulded bowl could produce an amphora, footed krater, or jug/lagynos; a small number of these are known from Pergamon and other Asia Minor workshops, datable mostly to the later second century. These point the way to the relief-decorated Arretine wares made in Italy in Augustan times, and their counterparts in lead-glazed wares. The mechanics of this later revival(?) remain unclear – dated relief wares are at present lacking from the middle years of the first century B.C.

Painted decoration: black-gloss wares

The aftermath of the red-figure tradition may be seen in a number of small Italian classes spanning the third century, with simple figured motifs in added paint – typified by the simple bowls (*pocula*) bearing motifs such as elephants surrounded by white and purple banding.

Contrasting with these is the 'West-Slope' style created in Athens (named after finds from west of the Acropolis). Derived from a class of fourth-century vessels with added orange clay ornaments imitating gilding, this rejects figured compositions, and concentrates on floral arrangements. These – vine-tendrils, ivy and myrtle-wreaths – retain certain sculptural qualities during the third century. Orange 'barbotine' and thinner white paint, supplemented by incision, are the Attic norm, while the florals on the parallel Gnathia style of Apulia are rendered in a flat white (washed brownish-gold in parts) and dark purplish-red. Modelled ribbing of the body of the vase remains in fashion in Greece, while vertical gouging predominates on the later Gnathia products. The Attic style is rapidly copied throughout most of Greece, as far north as Macedonia; especially distinctive are chequer-patterns and groups of diminishing squares, either used to flank panels or forming bands on their own. Meanwhile, Gnathia ware serves as the model for most Italian painted wares – a late derivative from the east-central Adriatic features white birds enclosed in white 'picture-frames'. Hybrids of the two styles occur in Epirus and the eastern Adriatic.

By the late third century a second generation of West-Slope ware emerges, characterised by small silhouette dolphins, swans, garlanded *boukrania* (bulls' skulls) and the like, closely drawn ivy-scrolls, and large two-tone rosettes on the insides of bowls. At this point the centre of gravity seems to move away from Athens. The range of later West-Slope motifs is noted in the Corinth report, and recurs at Pergamon, which, under its Attalid rulers, now assumes a prominent role. By 160–150 B.C. even Attic potters were adopting the Pergamene style, as is exemplified by an amphora in Attic(?) fabric found at Corinth (Fig. 79). The latest Attic West-Slope types, such as a class of heavy conical bowls with upright rim, are markedly 'Pergamene'. Meanwhile, at Pergamon itself the style undergoes a final change, seen on red-gloss wares, typified by sketchy 'feathery' incision enlivened by spots of white and purple paint; these survive until late in the first century B.C.

In Crete, a somewhat distinctive West-Slope style emerges before 200 B.C., combining elements of both the Attic and the Pergamene style, and employing them on vessels of traditional local shapes; close links with the dark-on-light Hadra vases (see below) are to be noted. The style was rather short-lived. A few Cretan black-gloss products also experiment with polychromy added after the main firing.

Simple incised patterns (without paint additions) are seen in a small class of bowls and globular inkpots and the like (Fig. 80), current in the eastern Aegean around 150 B.C., bearing networks of incised pentagons or hexagons (see remarks above, p. 190).

79. West-Slope black-gloss neck-amphora, Pergamon style. *c.* 160–150 B.C. Ht 39 cm.

80. Black-gloss ball-vase. Mid-second century B.C.

Painted decoration: dark-on-light wares

Mostly rather simply decorated, these continue Classical Greek techniques, with fired-on gloss-paint treatment. In regions such as Messapia in southern Italy, and Etruria, vessels with Classical-type floral ornaments continued to be made for some decades into the Hellenistic period. Floral scrollwork – particularly ivy-patterns – mostly rendered with a rather thick brush, reappears intermittently on later series, paralleling these motifs on the West-Slope ware series. The Hadra vases with dark-on-light treatment (see below) constitute a distinctive survival of the Classical tradition in the later third century. Some lagynoi and other vessels found in Cyprus display Hadra-like florals (on the same fabric?) in the late second century – though these perhaps belong more to the wider lagynos phenomenon – vessels with painted bands and, sometimes, simple encircling wreaths. The 'classic' Asia Minor lagynoi of this period, more delicately painted, show further treatments: mottled swag-patterns produced by sponging the paint, or a row of symbols and ornaments (such as lyres) arbitrarily thrown together.

81. Egyptian red-ware jar. *Shoulder*: phallus-groups and hares; *interior*: 'favoured youth'. Perhaps second or first century B.C. Present ht 14.4 cm.

A late class of Iberian wares, from south-east Spain, reverts to massed circle or semicircle patterns and various other motifs reminiscent of Greek (Proto-) Geometric styles; the dull paint and vessel-shapes (cylindrical flat-rimmed vessels, biconical jars) are however distinctive. Such vessels were widely traded in the second and early first centuries B.C., along with unpainted grey ware jugs ('Ampuritan grey ware') decorated with horizontal ribs after the Gaulish manner. Other Iberian painted classes were scarcely exported.

A small Egyptian (Delta region) red-ware series, of uncertain date, presents erotic motifs in purple and white. The drinking vessel (?) illustrated (Fig. 81) comes from Nubia, but the type is more common at Alexandria.

Stamped decoration

Small stamps, often linked by freehand incisions and enclosed by bands of 'rouletting' (small notches created by a toothed wheel or vibrating blade) are a common feature of the interiors of Classical black-gloss ware vessels. This type of ornament persisted, with some modifications, through the third and second centuries. Small impressed palmettes, arranged radially, are the Attic norm, followed elsewhere in Greece; these lose their linking incisions after *c.* 300 B.C. Italian versions, at first close to Attic, soon show increasing diversity: new motifs – in particular, rosettes – appear in the repertoire, often arranged differently. A fine-quality series from Rome or nearby, made in the early third century, aligns the stamps in a single direction, and adopts motifs standing out in relief on a sunken background, after the manner of gem-impressions. This treatment becomes fairly universal in Italian workshops, and their offshoots to the west, during the third century. Coarsened versions of these stamps persist on the *Campana A* 'utility' black-gloss wares of the Naples region (which are noted for their old-fashioned features) right through the second century. At this point similar 'Italian' stamped treatments – e.g. the 'gem-like' stamps, and large rosette stamps with 'pistils' between the petals – appear sporadically in the East. A mid-second-century revival brings back the delicate radial stamps (now with relief details) and the fine rouletting of earlier times; this occurs on both the 'Etruscan' *Campana B* wares and the red-gloss *Eastern Sigillata A* fabric made in the Levant, and is linked to the appearance of large, flat plates of

careful manufacture. The potters' stamps on the later Arretine ware may be seen as an offshoot of these.

Relief decoration

Apart from the mould-made decoration on the relief bowls (see above), moulds are sometimes used during this period to apply relief plaques to the surfaces of vessels or, in the Classical manner, to create small mask ornaments at the bases or tops of handles. In both cases, metalware provides the prototypes. Small shell ornaments or masks may be applied to the undersides of bowls to act as small feet – these are a distinctive feature of Corinthian and Metapontine relief bowls. The use of medallions on the interiors of bowls has already been noted. Late in the period (after *c.* 100 B.C.) widespread use of relief plaques occurs on the red-gloss wares of Pergamon, chiefly on the exteriors of drinking vessels (Fig. 82). Common patterns are ivy-chains formed of repeating elements, and plaques with erotic scenes,

82. Red-gloss skyphos with appliqués, Pergamon series. Mid (?)–first century B.C.

treated, as on the relief bowls and lagynoi, as unconnected ornaments.

Handmade relief additions are generally uncommon in this period (though note the snake on Fig. 80).

Glazed wares

An Eastern tradition of alkaline-glazed buff-bodied wares arose in Mesopotamia and the Seleucid domains during this period; examples of the ware in normal Hellenistic forms (such as the small bowls with incurved rims) occur at Antioch, but generally no further west. Lead-glazing came later, in Roman times.

In Egypt, at the same time, the related (and age-old) tradition of glazed glass-frit ('faience') manufacture was adapted for making vessels, some of considerable size and complexity, given the friable nature of the material. A specific class, bearing applied figures which may be recognised as Ptolemaic rulers – some inscribed – has been studied by D. B. Thompson; other creations are imitation halved ostrich-shells with friezes in low relief, and rather squat amphorae, reminiscent of West-Slope ware shapes, with impressed patterns or, later, applied 'scales' massed to form floral ornaments. The class survived into Roman times; the Hellenistic examples have a thinner glaze, tending to a light greenish tint, and a carefully prepared body. Plain dishes of this ware are quite common around the eastern Mediterranean in the second and first centuries B.C.; glassware finally ousted them.

Special functions: votive

In the Classical period, in both Greece and Magna Graecia, miniature versions of common vase-shapes had been made by the thousand as offerings in sanctuaries. Such vessels simply disappear during the third century B.C.; perhaps such minor offerings were now deemed insufficient, leaving the average worshipper out of the picture – or was cash now demanded by the priesthood? The situation with those cults whose main ceramic manifestation is the remains of drinking bouts or lamp-lighting ceremonies is perhaps different, and the offering of terracotta representations of limbs and parts of the body in healing shrines continued for a while, though this also suffered some decline.

Special functions: funerary

These may be grouped essentially under three headings: burial urns, oil/perfume containers (either for anointing or for counteracting unpleasant odours), and general tomb offerings. The terracotta figurines often found with these do not concern us here, except when (rarely) they are attached to vessels. Rather few vessels were made in the form of figurines during this period, despite the widening use of moulds for production of ceramics: some late black-ware Egyptian products – *not* funerary – form an exception.

BURIAL URNS

Cremation burial, fairly widespread during the period, on occasion gave rise to large, often ornate, pottery urns, bearing polychrome painting, in contemporary style, not designed to be permanent (compare the funerary scenes on earlier Attic white-ground lekythoi). Such vases appear in various parts of southern Italy and elsewhere (e.g. Alexandria) during the third century B.C., and in simpler versions also in Etruria. Their technique is that of fourth-century terracotta figurines – varied colours applied *after* the primary firing of the vase. The style of painting, going beyond that of red-figure vases, adds more realism, with effects of light and shadow; generally the figures are painted on a white surface-coating, contrasting with a uniform pastel-coloured background – 'shocking' pink is favoured. The Canosan series applies this treatment to vases of 'native' Apulian shapes, to which complete terracotta elements in Greek style (figurines, masks, etc.) have been attached, somewhat incongruously. More metropolitan taste, closer to metalwork, pervades a small class of spindly vases from Taranto, bearing relief friezes of Erotes (here shown as *putti*, no longer adolescents) on a coloured background, in the manner of later (Roman) stuccowork. The bodies of these presumed third-century vases, set on slender-stemmed bases, emerge from a sheath of separately modelled leaves – a feature recurring on the better-known Centuripe class from Sicily. The top-heavy forms and exaggerated lids and handles of these vases have for us a markedly 'Victorian' look about them; the scene is restricted to the front, and framed above and below by applied relief strips or florals. An alternative Centuripe type, a lidded bowl with handles (lekanis) bears

83. 'Hadra' hydria. *c.* 235–220 B.C. Ht 39.3 cm.

rather heavy applied floral motifs with painting, sometimes combined with busts in the round. While the dating of all the above classes remains fluid – their contexts are rarely known, or they come from multiple-use tombs – general opinion assigns them an early- to mid-third-century date; hence they parallel the general run-down of the Classical style on vessels for everyday use. New information on them is generally scanty. The comparable Alexandrian vases (hydriai, made locally) seem less flamboyant.

A second class found at Alexandria, the light-ground Hadra hydriai decorated in black gloss paint (with minor coloured additions), re-mains technically in the ceramic mainstream. Such vases, designed with a view to possible shipment of their contents (the remains of 'foreigners' resident in Egypt, as painted inscriptions attest) were made for more than one-time viewing. Some have been found else-where. Moreover, it is now reasonably clear that the majority were made in Crete (exactly where may be open to dispute), where the shapes and individual painters' styles seem to recur on other pottery

84. Detail of shoulder of hydria of Fig. 83.

fabrics. The one illustrated (Fig. 83) has decoration in sepia to black paint, on a light brown ground, and bears a small applied mask at the top of the handle. The palmette scrollwork (Fig. 84) is of Late Classical type (rather elaborate for this class), and the wave-pattern above occurs on other third-century products. Added inscriptions on a number of the hydriai cite regnal years (clearly Ptolemaic); current opinion, rejecting some earlier dates previously proposed, sees these as ranging from the 250s to the 190s B.C. Some spindly uninscribed vessels may carry the series some years later than this. Rather sober and old-fashioned patterns – Late Classical palmettes, leaf-sprays and wave-motifs – predominate, though the occasional use of boukrania and the like hints at late third-century fashions.

In the more remote areas of Etruria (around Chiusi), where crema-tion remained normal, some simple drum-shaped urns with lids bearing polychrome floral patterns and swags of very conventional type reflect something of Hellenistic painting; other box-like urns bear mould-made plaques with highly coloured relief friezes, while re-clining figures in high relief crown their lids. Apart from these, Roman Republican clay urns bear no more than a few paint bands and occasional frilling.

PERFUME CONTAINERS

The Hellenistic period had its counterpart to the Classical lekythos – the spindly ('fusiform') *unguentarium*, a slender vessel which, while bulbous at first, later approximates to a tube with a small bulge in the middle and a closed-off bottom. It differs from the lekythos, which had basically the same function, by the lack of a handle and of a developed base or mouth. Many unguentaria will not stand upright; presumably a crude stopper (e.g. a rag) kept the contents from spilling. In contrast to the lekythoi, decoration is minimal (a few encircling paint lines). The basic shape, introduced by 325 B.C., lasts for three centuries; occasional examples are seen in other materials (e.g. core-wound, then moulded glass). A Roman tear-shaped version continues for another century, until glass versions finally monopolise the function.

Other shapes, modelled on alabaster vases for example, are much less common.

GENERAL OFFERINGS

Other types of vessels with specific funerary functions are few. Of note is the cylindrical 'vanity-box' (pyxis) with matching lid, domed on top and bearing prominent flanges on the outside of both elements. The type develops in the later fourth century out of the Classical 'flat pyxis', acquiring a small foot; it appears commonly in other materials (silver, marble, etc.). Clay versions tend to be black-glazed, with ornamentation of West-Slope type, though some late ones are dark-on-light, comparable in ware to painted lagynoi. Perhaps most typical are those from tombs in Macedonia, where the type with West-Slope patterns persists in the second century, sometimes assuming monster dimensions. Relief masks appear on their tops, and some have decorative tripod bases.

Cooking wares

These functional vessels are normally undecorated, and subject to little change. An innovation is the introduction of large flat baking pans, the so-called 'Pompeian-Red Ware', and large domed covers for baking ('tegami'), essentially Italian types, though present in first-century B.C. contexts in the East.

A characteristic Late Hellenistic product in the East is the portable brazier with decorated supports for a cooking-vessel – an elaborated version of what had formerly been a plain piece of equipment. The cylindrical supports of these may acquire architectural features; the mould-made masks applied to the stands and forming the three pot-supports could be interpreted as 'apotropaic' (i.e. warding off evil spirits) or merely decorative. The supports, very standardised, consist of a squarish plaque rising from the upper rim, bearing a tilted mask or bull's head on the front, whose beard/snout forms an inward projection over the fire-bowl to hold the cooking-pot. Such braziers occur all over the eastern and central Mediterranean in the century after 150 B.C.; the Greek Cyclades and Alexandria may have been the major sources.

Inscriptions

Deliberate inscriptions (as against casual graffiti incised during use) occur only sporadically on most Hellenistic pottery, though rather regularly on the major series of commercial amphorae. The latter attest to a more broadly literate culture than before.

The name-tags attached to figures on black- and red-figure vases are absent on Hellenistic vases, with the exception of a class of relief bowls from northern Greece bearing scenes from Homeric legends. The stereotyped figures on other relief wares, or those appearing on medallions, would seem to have been regarded as familiar enough to require no label.

A rather specific series of inscriptions, painted or incised, naming gods and personalised abstractions (e.g. 'Health'), are worked into the design on some third-century West-Slope-style drinking vessels from Corinth and Athens. These, found mostly in buildings with a dining function, seem to attest the practice of naming successive mixings of wine after divinities.

Funerary inscriptions occur on the Hadra vases (as an added feature) and on Romano-Etruscan urns.

Some simple makers' stamps appear on Italian black-gloss wares of the second century B.C., and may arise from the rather older practice of using signet-rings to impress patterns. Monogram stamps, worked into the overall decoration (e.g. on 'Ionian' relief bowls) seem to have been the Eastern response to these; some other relief bowls bear signatures scratched into their moulds. More cryptic stamps in

'motto' form seem to be another Eastern feature (most known examples are of Roman date).

The numerous name-stamps on commercial amphora handles have a different intent: the identification of commercial products. While minor centres generally used 'decorative' seals or monograms, the stamps on Rhodian and Knidian amphorae of the late third century onwards consist of serried rows of lettering, specifying maker, controlling authority, and date of production. The analogy here is with later Roman estate production, essentially impersonal and money-based.

Conclusion

If at times this chapter may appear to have been lacking in firm direction, that is because Hellenistic pottery does not follow one even line of development; its character is eclectic – exploring some new paths, but constantly referring back to models created in other ages or in other materials, and recombining in various ways. With the wide geographical spread involved, and the multitude of producers, it could hardly be otherwise. The story continues in Roman times in much the same manner, with the addition of further outside elements to the mix. A final concise characterisation of Hellenistic pottery, within precise chronological limits, is perhaps impossible to achieve – its facets are too many.

9

Greek vases in the marketplace

ALAN JOHNSTON

Not many Greek vases have been found in the River Thames. Not many have been found in any river. So can the one dredged up near Reading in 1890 be seen as significant? The question may never have been asked before, but it does encapsulate most of the problems encountered when dealing with the topic of the Greek vase trade:

When was it decanted into the river?
How, or more pointedly, why did it get so far?
Was its loss felt?
How many more are there down below?
What happened to all the others like it?

The feeling nowadays is that the cup (Fig. 85) was thrown off a bridge in the last century, but it is a feeling that is rooted as much in the answers to such questions, asked about countless other pieces, as in the intrinsic unlikelihood that a Greek pot reached Britain in the fifth century B.C. Vases certainly reached as far north as the head of the Seine, where they have been found in properly excavated graves, and satisfy every basic archaeological requirement for us to conclude that they were interred not long after their manufacture. Yet when such finds are placed on the map, it is clear that north of the Alps they thin out considerably. A betting man might set the odds at something like ten to one against a piece being found in controlled excavations in this country.

An argument that might be used in favour of the cup having travelled so far in antiquity is its 'style'. It is by perhaps the worst painter of Attic vases, and we do note some correlation between poverty of achievement and distant (or minor) find-spots. Closer

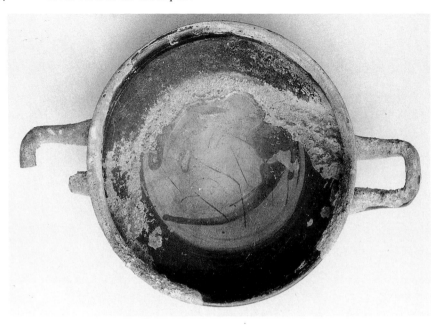

85. Attic red-figure cup, attributed to the Pithos painter. *c.* 500 B.C. Lip diam. 15 cm.

inspection, however, reveals that no piece by this particular hand has otherwise come to light north of the Alps. Indeed, almost the heaviest concentration of them is in north Syria.

There is no period during the centuries which we are treating in which pottery, both plain and decorated, is not found at good distances from its presumed place of manufacture. In the second millennium B.C. large-scale distribution of pots made in the Argolid or in Crete is well attested, with a marked decline in such trading with the fall of the Mycenaean civilisation. It would be unwise to transfer ideas about markets and mechanisms of this Bronze Age trade into the historical period, though we may note the fact that pots from historical Greece were acceptable in the Levant.

There are naturally many reasons why a pot may travel. At its simplest, it may merely accompany its owner (or owners) in any migration. At the other end of the scale we can posit potteries producing material at a high rate for immediate export to known

overseas customers, with coined silver used as a means of arranging the transactions involved. Nor is the line between these simple and complex models by any means straight; for example, gift was certainly an important aspect of artifact movement in the ancient world, though probably not directly from the potter or painter. In sum, it is not easy to outline the Greek vase trade without some clear definition(s) of 'trade' itself. Although the 'historical period' was mentioned above, we should bear in mind that for the bulk of the time we are considering there are no written records of any direct relevance to our topic, and that coined silver was something of an innovation even in the fifth century B.C. Byzantium did not coin till its end; on the other hand, we know virtually nothing about pottery production there throughout the pre-Roman period. Furthermore, while we think that we know what coined silver is used for, it has to be proved that its early producers, and users, thought the same.

No wholly agreed view on early Greek trade can be found among scholars who have examined the topic. None the less, a few fundamentals can be stated. While the basic activities of agricultural production were not (are still not) without risk, they did immediately ensure a person's livelihood. Most trading activity was by sea, where the inherent risks were as great if not greater, and the benefits – that is in the form of subsistence goods (the Athenian corn trade is the outstanding exception and of some relevance to our subject) – were not often so immediate. Generally speaking, return cargoes needed to be sold or exchanged for any usable profit to be realised. At the production end a man with potting and painting skills might, if free enough to do so, decide to concentrate on them and abandon all direct subsistence activity, primarily of course a personal smallholding. Very many factors would influence such a decision, but a key one would be thoughts about profitability, and the root of profitability would be a reasonably secure market. A would-be potter would need to obtain his livelihood, and something more, by exchange. An Athenian painter of about 500 B.C. voices what we may have suspected; beside the figure of an oil-seller which he had painted he added the words 'May I become rich!'

The shape of the vase here is a pelike, and similarly shaped vases are generally to be found in such scenes of oil-selling. Pottery and related objects made from clay fulfilled many basic functions, and any community would have required containers of various shapes and sizes. Little votive figurines of terracotta were always in use in the

86a. Attic 'SOS' amphora, from Cyprus. *c.*
600–575 B.C.

Greek world, and from about 700 B.C. onwards tiles become increasingly commonly used. Much of the demand for these objects could no doubt have been met locally by a potter working part-time, probably as a family concern. Most areas have clay beds suitable for such needs. Yet clay was also traditionally a vehicle for more elaborate work, with 'painted' decoration. Here expertise was more at a premium. While modestly decorated wares were produced at far more Greek centres than is often assumed, they rarely travel far. Almost the opposite is true of the poorer work of the major centres, such as Athens and Corinth. The main reason for this difference must be that at the latter there was already operating a network of market 'outlets', gained very largely by makers of pots of much higher quality. Inferior work, or plain ware, could be channelled through these outlets. To a large extent the 'inferiority' of such material is not technical but artistic, with the preparation of the clay and the firing of the pots being well up to standard.

We assume that in most potteries each potter would throw a full range of pieces, decorated and plain, using different clays as he saw fit. Certainly the amount of plain pottery in the Greek world is generally underestimated – storage jars, basins, cooking-pots to the fore. These

86*b*. Corinthian wine amphora, probably from Corcyra (Corfu). *c*. 500 B.C.

can also travel a long way, such as the casseroles of Aegina and in particular storage jars from a wide range of centres. Very large varieties, *pithoi*, were used in store-rooms, and may have been made by travelling potters, though even so they do not go far, if at all, beyond fairly restricted areas – Rhodes, the Cyclades, Crete were the major centres where decorated examples were made. The smaller version, often about 60 cm high, was the amphora (Figs. 86*a*–*b*), for the transport of produce; these vessels were the containers for oil, wine, fish, pitch and the like, though not in themselves wholly worthless. In some parts of the Greek world these containers were made in very large quantities; when we consider them we clearly cannot divorce considerations of pottery production and trade from trade as a whole.

Not many of these general remarks can be applied to pottery of the early Iron Age. We note that vases from a number of centres did travel in the Protogeometric period. Amounts are small, though a solid percentage of a small total production, and the mechanics of such 'trade' virtually impossible to estimate. At this period as in others we can also glimpse influence of one centre on another, even when actual objects that may have caused that influence have not been discovered

in the host centre. This pattern is first broken by the drinking vessel termed the pendent-semicircle skyphos (Fig. 87*a*), after its distinctive decoration. These skyphoi were produced in some quantity in the period *c.* 950–750, largely, it would seem, on the island of Euboea, and have a wide distribution throughout the eastern Mediterranean, just reaching Italy too. They are the first of a long line of 'mass production' cups, closely followed by the Corinthian Thapsos cups, then the Corinthian skyphos and the Attic kylix (Fig. 87*c*) in its various forms. These cups are as likely to appear in non-Greek as in Greek sites, and they tend to outnumber other imported shapes, especially in more distant regions; most were also widely imitated. Within the compass of this chapter there is little room to add many nuances to this picture; we may note for example a high number of Attic black-figure cup-skyphoi from mainland Greece, or a pre-ponderance of the heavy, black-glazed Castulo cup, Attic of the fifth century, from the Iberian Peninsula.

The pendent-semicircle skyphoi belie a picture of early Greece as an essentially aristocratic society with inter-community contact based on gift-exchange; their numbers seem to defy such a view. Here we might pause to consider the question of actual production figures, as against present survivals, since scale of manufacture is clearly a significant factor in our topic. It is unfortunate that we can only glean a few hints at what the preserved percentage might be, and they all come from Athens of the fifth or early fourth century. 'Batch numbers' will be mentioned below; they are of interest, but cannot contribute very much to the problem here. We can more fruitfully match the number of preserved prize Panathenaic amphorae (or, more often, fragments of them) with the total that we think were made for each celebration of the games, every four years. In the earlier fourth century this figure may have been between 1,400 and 1,500; there are objections to taking this figure back into the fifth century, but if we do, a preservation figure of well below 1 per cent would result. Evidence from the debris of potters' workshops in Athens has been used to argue a similarly low figure, between ¼ and ½ per cent, and we may tentatively take this to be somewhere near the truth. The amount of Attic figured fragments that continues to be found in habitation areas throughout the Mediterranean (even if most is of slight quality) makes the lower end of that range the more attractive. In general terms the figured Attic vases have been preserved rather well through being deposited in large numbers in the chambers of Etruscan and Campanian tombs. If we think of the pendent-semicircle

87. Typical, common drinking cups, distributed in numbers from their production centres: (*a*) Euboean pendent-semicircle skyphos, of the early eighth century; (*b*) East Greek 'Bird bowl', of the seventh century. Diam. 16.5 cm; (*c*) Attic kylix, 'Band cup'. *c.* 550–525 B.C. Diam. 21.5 cm.

cup, it is worth noting an almost explosive increase in numbers recovered in recent years (including a striking tally from the Phoenician 'capital' of Tyre); here ¼–½ per cent must be an even more tentative figure.

What might be termed a 'successor' to these skyphoi is the skyphos from Corinth of the so-called Thapsos style. It is found widely in the West in the new colonies, and is soon joined by the first Greek container vase to travel widely, the little Corinthian aryballos (Fig. 25). At much the same time large storage amphorae begin to be

exported, most of them carrying oil; we find a variety of fabrics, but in the earliest period, before c. 650, Attic and Corinthian jars predominate (Figs. 86a–b). It should be stressed that both drinking vases and containers, of many sizes, are involved, and that they are exported to much the same range of sites.

As yet we have no wrecks from this early period. We would however expect vessels to have been loaded with a mixed range of cargo, probably picked up at a number of production centres, and exhanged at an equal variety of ports. The poet Hesiod gives some flavour of the trade of his times, around 700 b.c., in his *Works and Days*: 'use as large a ship as possible, but do not risk too much of your total output on board, because of the dangers of the sea'. Unfortunately he does not tell us how such a ship was to be obtained, nor does he mention any likely destinations; he does, however, speak almost entirely of ship-borne trade. He implies mixed cargoes, and tries to balance the maximising of profit with the minimising of risk, a theme that rings down the generations. Additionally, he makes the point that such voyaging should be supplementary to the normal agricultural routine.

Our earliest known wreck of the Iron Age could be interpreted as illustrating these points, though it could be argued to exemplify other modes of exchange. Of *c.* 600, the Giglio wreck, found off the coast of Etruria, contained a wide variety of products, from many centres; the pottery included local bucchero vases, Corinthian aryballoi and Samian amphorae. The wreck comes from an intriguing period, near the beginning of a great upsurge of Greek imports into Etruria. They had been frequent, but not all-pervading, in the seventh century, with Corinthian ware predominating and contributions from East Greece and Attica (amphorae) noteworthy. Around 625 a number of Greek states, mainly from East Greece, set up a mart (*emporion*) at the Nile Delta, calling it Naucratis. They were no doubt encouraged by the enthusiastic reception given to the well-armed Greek mercenaries in the previous generation. It appears a clear case of trade after the swag, with each side being able to supply the other with a range of products, both essentials and 'luxuries'. We must be very cautious in our assessment of the role of individuals or corporate cities in this enterprise, but almost certainly the instigators would have been groups of individuals of fairly high status in their home city.

This was long-distance trade indeed, and we should at no time forget the perhaps less glamorous local markets. Only if we have a

good idea of what was being produced at any time, and the distribution of such material in the vicinity of the pottery, can we gain a proper impression of the range and extent of export, and so gauge the importance of distant markets to that centre of production.

Through most of the seventh century Corinth was providing pots of many types, as well as terracottas for architectural use, for many parts of the Greek world, far and near; a variety of products from East Greece, many rather plainly decorated, like the bird bowls (Fig. 87*b*) from a number of centres, such as Miletus, are also found widely distributed. There were able potters and painters in the Cyclades, but their wares travelled little. At the same time Attica, and probably the Argolid, seems economically depressed, though the Attic potteries, unlike those at Argos, were to recover as a major exporting power. The finest products of the seventh century in Attica are big amphorae and kraters, made we may suspect for display specifically at funerals; to what extent their scenes were chosen by the patron is wholly obscure. Attic plain drinking vessels and the like are poor things; none are seen much beyond the borders. Only the large oil jars and a type of krater found exclusively, and unexpectedly, at Megara Hyblaea, travel any distance.

Not surprisingly it is the work of Corinth, and to a lesser extent East Greece that tends most to influence other areas, including Etruria, where both shapes and techniques are copied. A short-stemmed semi-glazed cup ('Ionian cup') which owes its origin to East Greek models was produced locally in numerous centres, especially in Italy, by the late seventh century and throughout the sixth.

It is not immediately clear why trade expanded so much in the two generations either side of 600 B.C. A part may have been played by a need to import essentials like corn and metals (for armour and weapons), but an eye for the profits to be made from the general opening up of the Mediterranean to essentials and 'luxuries' must also have contributed. Greek society was still largely aristocratic, and conspicuous expenditure of wealth was a key factor in maintaining status, both on an individual level and as a polis (in so far as the two can be distinguished at this time). Production, and no doubt export, of oil and wine was keyed into such a system, though to what extent decorated pottery was dependent on its requirements is not so easily established. Much depends on the degree of independence potters and painters had from the ruling families, more specifically what proportion of 'sales' depended on their patronage.

We are ill-informed on the status of, or accorded to, these workers. A few vases show scenes in the pottery, where slaves seem to appear alongside perhaps free supervisors or owners. Names of painters and potters also appear painted on vases, and again seem to mix slave and free. However, Greek slaves could have a very wide range of names, including those more 'proper' ones reserved for the free; for example, Kolchos, Lydos, Syriskos are probably slaves, and Kleitias and Nikosthenes could be, though the names are also carried by free men. Amasis may have been a free man named after the Egyptian pharaoh (though before he rose to that position), or an Egyptian slave. The word '*epoiesen*' – 'made' – carries some ambiguity also: a true signature, or the 'brand-name' of the workshop owner (see below, p. 251).

Apart from three minor mentions in Pindar, Aristophanes and one later author, Attic vases do not appear in literature; their makers do not seem to have been Great Men of the Classical Period, at least to their contemporaries. Yet we do have at least three bases of now lost dedications by potters, found on the Akropolis and dating to before 480. The word *kerameus* – 'potter' – is very heavily restored on the base of a large *kore* statue dedicated by one Nearchos, and the other trio are for much smaller offerings; none the less we have preserved no such large set of dedications for any other group of Athenian artisans or producers. Much later, in the fourth century, the brothers Bakchios and Kittos were potters or shop-owners, and the sons of Bakchios migrated to Ephesus and received honours there for their pottery production, as an inscription tells us; but this is at a period when the production of figured work at Athens was much in decline and the structure of production no doubt much different from that in the sixth century.

Within such a meagre framework of knowledge of the status of ceramic workers we cannot easily judge questions such as whether the owner of a pottery had a completely free hand in seeking his markets, either locally or through shippers (other than himself?). Naturally demand would have been stimulated or depressed by many factors other than the mere taste and connections of the shop-owner. On balance, we assume that certainly by the sixth century most owners were fully independent and no doubt owned slaves to help in the establishment along with any family group. We would not have so many signatures on vases, a phenomenon rare before *c.* 580, though known from 700, had the writers not enjoyed a large degree of personal independence.

The increase in production round which we have been skirting demonstrates that markets were open for ceramic products almost throughout the Mediterranean – including the Near East, where there was no strong tradition of local figured ware. How these markets were captured, or created, and how they reacted to the influx of such imports, are big questions that cannot be attempted here; suffice it to note that the cultures of the various destinations were very disparate at the time – from Celts to Egypt. Yet we may note that the work of the vase-painter Kleitias (Figs. 88a–b), active around 570, is found in both the old 'civilised' East, and in Spain, more recently opened up by Carthaginian and Greek merchant venturers, almost certainly egged on by the search for mineral wealth.

Kleitias' masterpiece, the François vase, was found scattered in fragments in the necropolis of Chiusi in inland Etruria; and it is in Etruria that exports of decorated vases from most Greek producers concentrate in the sixth century, though it would be foolish to underestimate the broad range of other markets, now including the newly founded colonies around the Black Sea, and areas beyond.

While we do not know how the Huelva and Egypt vases were used

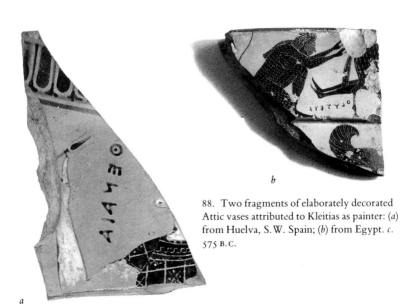

b

88. Two fragments of elaborately decorated Attic vases attributed to Kleitias as painter: (*a*) from Huelva, S.W. Spain; (*b*) from Egypt. *c.* 575 B.C.

a

at their destination, the François vase was without doubt deposited in a tomb. Etruscan tombs were generally rich in all kinds of offerings, though most were robbed of their precious materials even before they were 'excavated' in the last century. In the few instances of seemingly intact burials that have been found and published, Greek vases form a substantial, though varying, percentage of the goods. A comparative lack of excavation in contemporary Etruscan settlements means that we have a very poor picture as yet of whether these and similar vases were also used in Etruscan daily life. Until recent years excavation in all areas has tended to concentrate on sanctuaries and cemeteries rather than houses. Yet even if the balance is redressed, we should not expect a large harvest of fine decorated ware from the home. In the first place finds will be small, worn fragments, and, more importantly, we should remember that objects dedicated in a sanctuary or in a tomb could not lawfully be removed. In the very rare cases where a town has been sacked, with no opportunity for the inhabitants to remove their possessions, *and* has been subsequently excavated, the amount of fine pottery is noteworthy; Smyrna, taken by Alyattes of Lydia in about 610 B.C. is such a rare example.

In Etruria, it has been noted that in the fifth-century tombs of the northern 'colony' at Spina, the prestigious vases, especially kraters, tend to be older than their more humble companions, suggesting a period of use in the Etruscan dining-room before burial. In addition, a fair number of vases are inscribed with an Etruscan owner's name, and it is difficult to see these all as merely funereal messages. This kind of evidence certainly runs counter to the extreme position held by some that these pots were little more than cheap clay substitutes for precious metal ware, whether in the Greek or Etruscan world. Despite all this, however, there is still room to consider that Etruscan tombs may have been furnished in part 'off the peg' with Greek vases newly arrived in port.

We have raised the subject of the extent to which the pot trade depended on individual commissions for work. Were potters and painters free to choose their own shapes and decoration? Very different positions have been taken up on the question, centring on the various nuances of the phrase 'free to choose'.

With particular reference to decoration, some pots were clearly tailor-made to order. For example we have dedications painted on vases before firing, giving name of both dedicator and recipient deity. The largest such body of material is of rather plain kantharoi made on

89. Fragments of kantharoi of Chian manufacture, with dedicatory inscriptions, painted before firing, of Aristophantos and Damonidas (in local, Dorian dialect), found in the sanctuary of Aphaia on Aegina. *c.* 550 B.C.

Chios in the sixth century. A few were dedicated in local sanctuaries, but most were found at the sanctuary of Aphaia on Aegina (Fig. 89) and in particular in the sanctuaries at Naucratis; the dedicators were probably successful traders, apparently both Chian and Aeginetan.

Sporadic examples of the phenomenon are known in other fabrics. While we must remember that much Greek pottery has a sameness about it, we must not therefore assume that oddities of any kind were beyond the ken of the average potter or painter. Examples are a hydria from an East Greek workshop with a good imitation of the cartouche of the Pharaoh Apries on the neck, and a later sixth-century East Greek vase with an apparent depiction of the Persian King Cambyses; the latter comes a generation before the well-known representation of King Kroisos of Lydia on the pyre, depicted on an Attic red-figured amphora by Myson (found in Etruria).

It has been argued that many scenes on vases would only have been meaningful to a given client or clientele, and could not have been painted without their urging. It is difficult to accept this on a broad front. True, a small minority of scenes are strictly customer-oriented. Prize Panathenaic amphorae are an obvious example, though the specific owner was not of course known when the pots were made! Other types of pot too were made for a specific purpose, but rarely,

one would judge, to an individual patron's orders. Here shapes take pride of place, notably those developed for specific cult purposes. For example there are the plaques, made for suspension in sanctuaries, or attached to funeral monuments, and regularly painted with relevant scenes; or the loutrophoros, used in the marriage ceremony, or buried with the unmarried dead in Attica. Loutrophoroi too could be dedicated at sanctuaries, such as that of the Nymphs on the south slope of the Akropolis. There is a nice question of supply and demand here: did it become fashionable to make such dedications, and was that fashion in any way promoted by the potters?

While the scenes on plaques and loutrophoroi regularly refer to the area of their use the same cannot be said of many other shapes. Very varied scenes appear, even if there are some trends, e.g. to festive scenes on *psykters*. Among the range of scenes some have been taken to be particularly customer-oriented, but here too care is needed. We may find scenes of Herakles and Busiris on vases found in Cyrenaica (though not Egypt), or of Aeneas with Anchises (Fig. 90) on many pots from Etruria (though not Rome); but when overall statistics are examined, in very few cases do these apparent hot-spots turn out to be meaningful; in the latter case we have to appreciate that most figured vases are from Etruria in the first place. Not that we should not accept that interest in the myth, folklore and customs of neighbouring civilisations did influence the range of representations in Greek art. A likely exception to this rather flat conclusion is a fourth-century phenomenon, of Attic red-figured vases with simple scenes of Amazons and Arimasps; they are found in good numbers around the Black Sea, the mythological stamping-ground of those figures. A counter-example is worth noting: a number of rather abstruse scenes related to Attic myths are painted on cups by the later fifth-century Codrus Painter (Fig. 91); none were found in Attica.

An explanation is available for this discrepancy, and has indeed been proposed. The vases were made originally for an Athenian client and were then exported second-hand. It is an argument that could explain many scenes that appear to refer very much to Athens or Attica and have little pertinence for a Sicilian or Etruscan public. Two particular cases are vases with *kalos* names (praising the beauty of named youths or – rarely – girls), and those, mainly of the later fifth century, with depictions that relate to victory in contests at Athens, either musical or theatrical. Both may be combined in one white-ground calyx-krater found at Agrigento, with a scene that reflects a tragedy on the theme

90. Attic black-figure amphora, of a shape inspired by Etruscan models (cf. Figs. 56, 57), with a scene of Aeneas carrying Anchises out of Troy. *c.* 520 B.C. Ht 28.8 cm. Probably from Cerveteri.

91. Attic red-figure cup attributed to the Codrus Painter. Probably from Etruria, but with an abstruse scene, not surely interpreted, from local Attic myth. *c.* 425 B.C. Diam. 32.8 cm.

of Perseus and Andromeda, and the *kalos* name Euaion, son of the tragedian Aeschylus. Mention of white ground reminds us of a class of vessels made specifically for the Attic market after *c.* 460, the funerary lekythos (above, p. 124). It has also been argued that the number of vases found in Etruria which have been repaired argues for a period of use in Greece.

Any attempt to answer this question of a second-hand trade, and along with it that of the extent of individual commissions, must at the outset recognise that both concepts are wholly acceptable. We have already noted some types of commissioned vases, and there is no doubt that prize Panathenaic vases (above, p. 143) reached Etruria second-hand. The problem is more one of extent: what proportion of any output depended on commission, initially for a home market, and did the picture change over the years? A point that must be immediately repeated is that the vast majority of pots are either plain or plainly decorated (with figures or otherwise), and it is quite impossible to distinguish whether they were made for a home or external market. For example, the great mass of East Greek Wild Goat style vases of *c.* 650–575 have repetitive, if occasionally charming, animal friezes (Fig.

26). Just a few exceptions stand out, such as a hydria with a file of dancing women, found in the sanctuary of Hera on Samos, and the Euphorbos plate in the British Museum, from a tomb at Kamiros on Rhodes, with a scene of Homeric battle copied from some other work, probably in metal. The former served a cult purpose and could have been commissioned, the latter may have been the inspiration of either the painter or his client.

Turning to Attic vases, we first note that most figured pieces have scenes that appear on large numbers of others; they are undistinguished. As regards mended pieces, indeed many fine Attic vases are repaired, normally with lead rivets (below, p. 254); but it is a technique that appears sporadically throughout the Iron Age (and earlier), and no pattern emerges. We find fine pieces and humble, in Athens and in Etruria, in houses and in tombs. Mending seems to have depended on the wishes and no doubt means of the owner. Those fine Attic vases from Etruria could as easily have suffered en route to Cerveteri or Tarquinia, or after their arrival, as in any previous use in Athens. We must not, though, rule out the possibility of repairs made to particular large and figure-rich vases after mishaps in the pottery itself.

We must also call into play one further strand of evidence, not associated solely with Attic vases, but prominent there: the so-called trademark. On a varying proportion of vases, mostly large, we find painted or scratched under the foot, or very occasionally elsewhere, a few letters or numbers, or a 'logo' of some kind. Such marks appear first in the late seventh century, reach a peak of use around 500, and gradually fade out in the fifth and fourth centuries. One of their major contributions to our study is the prices that they sometimes cite, but let us first examine some wider aspects.

On Corinthian vases and a relatively restricted number of smaller East Greek cups and bowls, of *c.* 610–550, the marks are usually in a red paint, which is not very stable (Fig. 92); relatively few marks are cut graffito, but when they are they can be seen to have been incised after the vase was fired. Marks begin to be found on Attic vases at much the same date, and gradually the graffito becomes more common. There are also a few marks in glaze (Fig. 93), and these are very important in demonstrating that the vases concerned were marked before firing; as the same mark is occasionally found on stylistically related vases both in glaze, red paint and graffito, we can conclude that the red and graffito marks, though applied after firing, must belong to a very early stage in the pot's life. One may go further

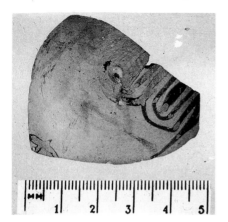

92. An untypical trademark, on a small Corinthian aryballos. Faintly preserved in red paint, added after firing, the letter N. *c.* 575 B.C. From Naucratis.

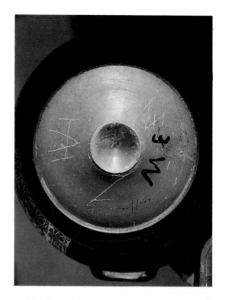

93. Trademarks in glaze (applied before firing) and graffito under the foot of an Attic hydria of the Leagros Group. The ME mark is also found in red and graffito on related vases. *c.* 510 B.C. From Vulci.

and argue that such marks could not refer to any second-hand transactions. We can also note that no such marks appear on prize Panathenaic amphorae, which would be surprising if we were to accept that a large proportion of pots was traded second-hand.

Could then these marks refer in some way to a first sale or use in Athens? There are very strong arguments against such a notion. In the first place the script of the marks on Attic vases, where we can see a difference, often displays letter forms that are not in regular use in Athens at the time. Further, no vase that has been found in mainland Greece carries a mark of such a type; the marks are virtually confined to pots going west, and among the rare marks on similar types of pot that have been found in fair numbers on Rhodes less than a handful can be closely associated with equivalents from Etruria, Campania or Sicily. It is true that no mark in glaze exhibits assuredly non-Athenian lettering, but many of these marks 'behave in the same way' as those with Ionic letters, that is they are found on groups of vases that are stylistically related, often by the same painter, and have been found in

the main in Etruria. A further point to be noted is that similar marks appear on vases of varied shape – amphora, hydria, oinochoe and krater; this strongly suggests that all were exported on a similar basis, and that none was sent full of oil, wine or any other commodity.

From these general observations we can show that the marks refer to the export of vases from the pottery. An initial categorisation of underfoot graffiti on pots is not, however, too simple, since it is very obvious that feet also bear a good number of Etruscan owners' marks (and perhaps those of one or two Etruscan traders); where the vases had a Greek destination, we should also consider the possibility of local Greek owners. The boundaries of classification are therefore somewhat fluid.

Most marks indicate the name of the exporting 'agent', except in a very few cases in abbreviated form. A number of non-alphabetic marks probably perform the same function. The lettering may be in the script of the 'agent' or of the potter. At Corinth we often find characteristic letters of the Corinthian alphabet, only once an assuredly Ionian script. At Athens there is in general terms something of a balance between Athenian and Ionian, with a modicum of other scripts, including Aeginetan. The presence of Ionian 'agents' is fully compatible with the evidence of Ionian activity around the Mediterranean in the sixth century; they predominate in the emporium at Naucratis, as also in Gravisca, the port of Tarquinia; and they also colonised parts of the western Mediterranean at this period – Alalia, Massalia, Emporion. Both at Naucratis and Gravisca there is evidence also of Aeginetans, although Corinthians are hard to find and Athenians well-nigh invisible. The fact that some marks are in the script of the producers of the vases does not of course necessarily indicate that the 'agents' denoted were from the same place; a Corinthian or Athenian potter would be likely to note an Ionian's name in his own script.

A wide range of abbreviations and signs is found. Between two and one hundred vases can be attributed to individual 'agents'. If we use the survival statistic of ¼ per cent suggested earlier, this points to between 800 and 40,000 pots so marked originally. But we should note that a varying proportion of vases were never marked, but were presumably exported by the same agents. Here statistics are more difficult to estimate; during the period *c.* 575–450 the proportion of unmarked large vases from given workshops varies from 5 per cent to 95 per cent, while marks on small vases, especially open ones, are very

much the exception. Additionally let us remember that any mark is an exception on vases going to destinations other than Italy.

The term 'agent' disguises a certain amount of ignorance. We return to the question of the precise status of the entrepreneurs of the archaic period – whether they were aristocrats who controlled ships or ship-owners who were accumulating wealth, not of course exclusive categories.

Trademarks can scarcely provide an answer to this question; we have, rather, to look at Herodotus, writing a century after the period, and at snatches of contemporary verse. By the fifth century we can be confident that a legal and social structure of trade had developed in which ship-owners were largely distinct from merchants, who were responsible for the cargo. Herodotus, however, tends to give the impression that in the sixth century a single person may have played both roles, thus echoing Hesiod. A notable (though not necessarily typical) example is Sostratos from Aegina, renowned in Herodotus' day for the wealth which he accumulated from trade. It is quite possible that he dealt, *inter alia*, in Attic pottery, since there are aspects of the trademark SO that point to an Aeginetan 'agent', and a stone anchor (Fig. 94) dedicated by one Sostratos (not a rare Greek name, unfortunately) has been found at Gravisca, dedicated to Apollo of Aegina. Dates of both anchor and the black-figure vases with the trademark chime in well enough for the anchor to belong to a late period in a trading career of *c.* 535–500. Two further notes on these vases: they include a fair number of amphorae of two types which seem to have been made specifically for the Etruscan market, the rather metallic forms painted by the so-called Affecter and the directly Etruscan-inspired confections of Nikosthenes and Painter N (Fig. 56; cf. Fig. 90). Also a number of SO marks are in glaze; this means that they were 'ear-marked' in Athens before firing, therefore somewhat on trust, before the final effect could be judged; here there is at least a suggestion that the potteries at Athens did indeed have a sellers' market.

Pursuing the topic of vases with marks and those without, we may note a number of marks that include numerals (and marks are a prime source for the early history of Greek numeral systems). They begin around 550 B.C. and become increasingly common in the fifth century. In many cases these numerals quite clearly denote sets or batches of vases, since they are prefaced by the name of a type of vase, either in full or in abbreviated form (Fig. 95). It seems likely that these batches

94. Half-preserved stone anchor, found in the sanctuary of Gravisca, the port of Tarquinia. The inscription tells that it was dedicated to Aeginetan Apollo by Sostratos. Late sixth century B.C.

95. Complex graffito trademark incised under the foot of an Attic black-figure hydria of the Leagros Group from Vulci. An individual tally of strokes is summed up in the formula 'leky(thia): 30'. c. 510 B.C.

were reserved for a given trader, perhaps to facilitate transport to the Peiraeus or on and off ship. It is further likely, though unprovable, that the rest of the batch may not have been marked at all. In the fifth century we sometimes find the word *enesti* or the like, 'included in the batch', referring to the batch; perhaps the vases were literally packed inside the marked 'master' vase, though this cannot always have been the case. It is therefore feasible that a good proportion of vases without marks once belonged to such batches, a conclusion which would lead us to shift significantly upwards the figures suggested above for the number of pieces exported through the agency of an individual trader.

The names of vases found in such trademarks are of considerable interest, and give us a good idea of the range of terminology in use in the sixth and fifth centuries. It is even more useful if we can tie a name to a particular shape, and trebly so if a price accompanies the designation. We are not well supplied by our assembled sources with prices for 'everyday' commodities in this period, and it is striking how much of our evidence is for vases, and nearly all that evidence is gleaned from trademarks.

We noted that for much of the period in question transactions must have been carried out on a non-monetary basis. Coined metal makes its appearance in Ionia in the late seventh century, but it is not till the later sixth that we find minting at mainland states, including Aegina and Corinth, and western colonies such as Selinus, near the Spanish source of silver. Clear-cut evidence to show for what such currency was used is thin for the early years. Payment of fines and taxes, as well as for mercenaries, are almost certain uses. It is a trademark that gives us our earliest assured use of small change in the Greek world, cut under a handsome red-figure calyx-krater of the early fifth century, found in Italy (Fig. 96). Written probably in the Attic script, the mark has a 'core', ON, of uncertain meaning, flanked by batch marks, 90 le— (e.g. lekythia) and 17 sky(phoi), then TI 12¾. Later marks encourage us to interpret TI as *time*, 'price', and we note that 12¾ divided by 17 is ¾. It seems that this batch of skyphoi (whether decorated or not we cannot say) was priced at a unit cost of ¾; the reference must be, by all analogy, to the obol, and the mark is then testimony to the use of the ¼-obol fractional coin in Athens at the time. In the late fifth century a skilled workman could expect to earn 6 obols (1 drachma) per day.

This is our earliest price mark among graffiti on Attic vases, and

96. Graffito under the foot of a red-figure calyx-krater attributed to the Troilos Painter. Note that the letter after SKV is. ∧ (a numeral), though the light makes it appear to be ∧ *c.* 500–490 B.C.

there are none on other wares. It raises a range of questions that can be asked of most others. Who was expected to pay how much to whom, and for precisely what? In this case it is clear that the price cited is *not* for the marked vase, a point which makes it something of an exception in the preserved corpus of material. No price is given either for the other part of the accompanying batch, the many le(kythia), though we may note that vases cited as lekythia or lekythides often come in large batches such as these. It is unlikely that we will ever be able to reconstruct the precise circumstances of the noting of this batch and price, but at least we know that it is not isolated, since the TI mark, plus a presumed price, occurs elsewhere in company with ON. This suggests that the price was being asked 'in the trade' at Athens, not casually at a 'retailer's'. Since some of the vases were found in Etruria we can confidently assume that the prices do not apply to the

end of the export trail, even if the Attic script had not demonstrated the point already.

After this earliest price we have a steady trickle, hardly a stream, of them until near the end of the fifth century, after which they are extremely rare. It is important to note the spread (about a century) and not to compare prices from different periods too closely. There are reasons, such as those just cited for the TI marks, to assume that virtually all these price notations were cut at Athens; two assured exceptions are unfortunately not easy to interpret, but potentially important, on a small pelike of *c.* 425 from Vassallaggi, near Agrigento, and in Cypriot script on a mid-century krater in New York. Uncertainty of interpretation of these two precludes any reasonable comparison between prices asked at Athens and those made in the export markets. This is regrettable since we thereby lack any clear evidence for the profitability of the trade to the exporting agents.

A few price marks are found on vases, all small, which remained in Athens, although they cannot be closely associated with any such group as the TI set of exported vases. The destination of other pieces with price marks varies, most being found in Sicily and Campania, others in Cyrenaica, Etruria, Al Mina.

There can be no doubt that the prices are quoted in Attic currency; its use was required on Attic soil, and any foreign silver would have to have been exchanged. Alternatively, a trader could take out a loan at Athens on surety of the cargo, or ship, to be paid off from the profits of the voyage; this is a process, known in English law as bottomry, which we know well from the fourth century, and there is no reason to assume that it was not in operation substantially earlier, with surety possibly in pre-monetary form. As the loan was not repayable if the cargo, or ship, were lost at sea interest rates were naturally very high.

The prices, then, vary according to date and are for a wide range of shapes of vases, not all of which we can identify. As yet there is little we can do to compare prices for the same type of vase at different times during the century. A further complication is that we can rarely tell whether the vases mentioned are decorated or plain black. It goes without saying that one should not automatically refer Attic fifth-century prices to those of other wares at other periods; it would be extremely interesting to know how Attic compared with South Italian in Italy itself, but the evidence does not exist. What seems likely though is that there was a general lowering of prices asked at Athens

in the later fifth century from previous levels; this may have had any number of causes, such as difficulty of transport during the Peloponnesian War, perceived falling-off of general quality, saturation of the market, etc.

The material that we can use to make good comparisons of prices is wretchedly limited, not much more than a dozen examples, while educated guesswork can rescue a further twenty or so prices from the obscurity of graffiti, most referring to pots of uncertain shape or size. We assume that YΔTPIΔPAXΠOI (*hyd(ria) tridrach(mos) poi(kile)* – 3-drachma painted hydria) cut under the foot of a mid-century red-figured hydria refers (*a*) to the inscribed vase and (*b*) to its price at Athens. It takes a small cluster of mid-century pieces with it. Earlier we have the TI group, whose interpretation is not quite so clear, though boosted by the nice equation which we found on the Copenhagen calyx-krater. Far more specific are a late fifth-century set, exemplified in Fig. 97, where we find between two and five batches cited on a single vase; prices are included, among them those for the marked vase and others similar. In the illustrated example the marked vase is termed a stamnos, our 'pelike', and the term *ti(me)* – 'price' – removes any doubts of interpretation. We can identify the other types of pot with varying degrees of confidence: *lekythoi dik(aioi?)*, 'proper' ones, and *lekythia mik(ra)*, 'small', probably distinguish the cylinder lekythos from the squat lekythos, and the prices seem to reflect that difference. *Oxides* and *oxybapha* appear elsewhere among this set of marks and very likely refer to black-gloss bowls of varying size.

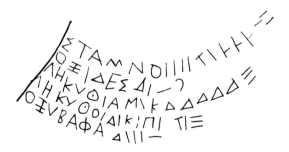

97. Graffito under the foot of a red-figure pelike attributed to the Nikias Painter, from Naples. The price list of the batch includes a mention of three 'stamnoi' – as the inscribed vase – at one drachma and one obol each. *c.* 420–410 B.C.

In sum, we see prices in the range 4–6 obols for large vases in the early fifth century, rising to 12–18 around 440 and dropping back (for pieces of not quite so high quality or complexity) to 3½–7 later.

The price of smaller vases is generally correlated with these. One further point is well worth noting: among the mid-century prices are two for black, not figured vases, and we see that they are 25 per cent and 50 per cent less than for contemporary figured counterparts. Here we have a mere inkling of the extra reward for decorating vases (though in truth the figured parts remain *un*decorated, reserved on the clay surface); in very crude terms a 33 per cent mark-up, which would represent added time expended on the piece, since cost of materials does not enter into the question.

The matter of overheads does however crop up if we attempt to assess the profitability of running a pottery as a whole. Here the proportion of free to slave labour would be a significant factor. Clay would probably have cost little, brushwood and the like for the kiln rather more. But no specific figures are available. In sum, we are left with no clear notion of *production costs* of plain vases, a very rough idea of the *mark-up for decoration* and the merest glimmer of evidence for the cost of Attic vases at the *receiving end*. We would wish more, but do not as yet have it; 'as yet' expresses a real hope that further evidence may yet come to light, at least for prices asked in Sicily and Campania, if the vases are found in archaeological excavations.

Attic pottery, especially slighter figured ware and black vases, was sent in very large quantities to sites throughout the Mediterranean in the period *c.* 540–350, with peaks in the Late Archaic period and the years after 450 (when black ware was to the fore). We have also noted that lacking prices we cannot fully judge how important this trade may have been to the carriers. There can be little doubt, though, that at this period demand was high; and in such a market the producers at least, being mainly, as far as we can tell, free men, would have considerable control over prices. There is evidence of a depressed market in the period of the Peloponnesian War, and production of red figure at Athens is sluggish in the first quarter of the fourth century; as far as we can tell, however, black ware was produced throughout in good quantities. Certainly an illustration of the marketability of the poorest material is the large cache of impoverished red-figure cups of *c.* 370–350 found in a wreck off the south coast of Majorca at El Sec (Fig. 98), as ever along with other items of cargo.

98. Attic red-figure cup of *c*. 350 B.C., from a large group found on board a wreck off the south coast of Majorca. Diam. 14.7 cm.

A further sign of a healthy market for figured wares is the fact that a number of workshops sprang up outside Athens, imitating Attic figured vases. To the best of our knowledge these pots were used for precisely the same purposes as imported Athenian ware; they are found in tombs, as dedications and in habitation areas. Their dependency on Attic models is marked by among other things their confinement to the area of production; only in the fourth century do the red-figured vases of Apulia begin to appear in any number in a wider area, though never so frequently as earlier, or even contemporary Attic pieces. It is moreover clear that in some cases, at Corinth and in South Italy, the local schools were established by emigré Athenians – and at Corinth the pioneer appears to have returned to Athens (Fig. 99*a*–*b*). It is very likely that local production of black ware followed a similar course, though here isolation of local as distinct from imported Attic material has not been as fully documented.

Here we must remember that local kilns normally supplied plain and semi-decorated pottery in most areas of the Greek world, while Athens commanded the finer end of the market. Finds from any site of the sixth or fifth century will include a majority of local ceramics, and one naturally assumes that this was because they were cheaper than any equivalent that might be imported, though loyalty to local producers is an element that should never be forgotten, even if it is wholly unquantifiable. One area of production that was very much a

99. Two red-figure vases imitative of Attic work: (*a*) calyx-krater made in South Italy, in close imitation of the school of Polygnotos. *c.* 425 B.C. Ht 29.4 cm.

mainstay of local potters was kitchen equipment (though casseroles from Aegina had a wide market) and jars for the storage or transport of wine, oil and other commodities. Where such products were a staple of the local export trade potters naturally rode piggy-back on them; this applies particularly to Chios in the sixth and fifth centuries, Thasos and Mende in the Classical period, Rhodes, Knidos and other areas later; the contemporary potters in those areas were producing the equivalent of the tin cans and plastic bottles of today.

(*b*) bell–krater attributed to the Athenian Suessula Painter, *c.* 410 B.C., emigrant for a period at Corinth. Ht 28 cm.

100. Panathenaic amphora. Runners. Attributed to the Euphiletos Painter. *c.* 510 B.C. Ht 60 cm.

10

A closer look at the potter

J. M. HEMELRIJK

Principles of shape

Greek pottery is like no other fine pottery in the world. In some respects it is unrivalled, but this supremacy is achieved only in the best Attic black- and red-figure ware. The other fine Greek fabrics, Ionian and Laconian cups for example, lead up to this Attic climax in several respects but never quite reach the level of the best Attic work of the sixth and fifth centuries.

On the other hand, Attic pottery has one great disadvantage compared with nearly all other schools of pottery in history: its sombre and monotonous red–black colouring. This is no doubt the reason for its lack of popularity with enthusiasts of, for example, Chinese porcelain and Delft ware. However, we should remember that no one in antiquity, not even Greek merchants, ever saw such large quantities of Attic pottery in one place as we find in our museums; nor encountered such a variety of material. Moreover, it makes all the difference whether we are handling a cup by the potter Brygos in the strong light of Attica or looking at it through thick glass on a museum shelf. Greek pots were made to be handled: the solid smoothness of the intricate shapes should be felt, and the volumes and ornaments enjoyed by weighing and turning the vase in one's hands.

The exceptional quality of Attic vases is to be found mainly in the potting: in the delicacy, structure and harmony of the parts, in the tension between extreme daring and severe discipline in any amphora by the potter Exekias or any cup by the potter Brygos. That the standing of the potter was actually higher than that of the painter is revealed by the signatures on the vases: twice as many potter-names

are recorded as those of painters, though the signatures were presumably written by the painters.

As regards their structure Attic pots are distinct from other pottery in one remarkable respect: the feet on which they stand. The delicate way in which feet are shaped and constructed is unique and typically Greek (Figs. 105, 106); in fact, it is by their feet that fakes usually betray themselves.

As regards shape, all pottery may be divided roughly into three types which we may call 'abstract', 'muscular' and 'yielding'. The abstract, stereometric form has contours that are, so to speak, unconscious of the weight of the contents of the vase; they seem indifferent to the pressure from within (as, for example, a pot shaped like a cylinder). The opposite principle is embodied in the muscular type, in which the tension of the contours of the belly emphatically 'resists' the pressure from within, pushing the centre of gravity upwards (Fig. 100). In the yielding shape the contours of the body 'give way to' the pressure from within, dragging the centre of gravity downwards and producing bag-like shapes (Fig. 74).

The 'unresponsive' abstract kind of shape seems to have been alien to the artistic sense of the Greeks (much modern pottery belongs to this category); yet vases of this type do occasionally occur in Greek pottery. We find it, for instance, in early Orientalising Attic ware, in some of the very slender Protoattic vases decorated by the Analatos Painter. The Greeks preferred tense, muscular shapes (Figs. 100, 101), at least in the Archaic and Classical periods, when the same taste led to the elements of the Doric temple contracting and swelling, as it were, in a muscular way. The yielding, bag-like shape is less common but is not at variance with Greek principles, since the contours of the belly of the pot reveal its function as a container of heavy liquids; the pelike (Fig. 74), the squat lekythos (Fig. 50) and the alabastron (Fig. 27) are of this kind.

Pottery shapes may also be divided into two structural types, the simple and the complex: pots shaped as a single whole, or nearly so (globular, ovoid, etc., like many Chinese vases), and pots built up from distinct members. The latter method is that practised by the Greeks. They conceived of a pot in the likeness of a human being, standing on a sturdy foot, and in possession of a belly, shoulders, neck, mouth, lip and also 'ears' (handles).

Here too we can make subdivisions: this articulated kind of pottery falls into two types – either the different members are set off from each

other by sharply marked transitions, or these transitions are smoothed over as much as possible so that the contours form a continuous undulating outline from foot to lip. Both kinds of profile can occur in different versions of the same shape; for example among lekythoi we find the cylindrical (Fig. 51) as opposed to the Deianeira (Fig. 29) and squat (Fig. 50) types; among amphorae both neck- and belly-amphorae (Figs. 32 and 33); and among the two main types of red-figure cups we have Type A and Type B (Figs. 105 and 106).

Finally, there is, of course, the practical distinction between 'open' and 'closed' shapes, the open ones being generally painted inside (kraters, stamnoi, etc.), whereas the inside of the closed shapes is usually reserved (amphorae, oinochoai and the like, but Fig. 101 is an exception).

101*b*. Inside of jug of Fig. 101*a*.

101*a*. South Italian black-gloss jug.
Second half of fifth century B.C.

Different fabrics and their surface finish

The most basic division within pottery fabrics is between porous and non-porous ware. When fired below 1150 °C pots are for the most part porous. Greek pottery was fired at a far lower temperature (probably up to about 950 °C). This was not, as may perhaps be supposed, due to a lack of technical skill, since much higher temperatures were used in the production of iron (with charcoal as a fuel). At 1200 °C upwards pots become vitrified and non-porous. The distinction between porcelain, stoneware and earthenware is based on this principle, the first two being non-porous. Only the last-mentioned was known in antiquity. The kinds of clay used for the three types are different.

Clay is formed by the decomposition of rocks. For porcelain so-called primary (or residual) clay is used, i.e. clay that is perfectly clean and unmixed with other matter, because it has not been transported from where it was formed, by glaciers, rivers or rain; it fires white because of the absence of impurities such as iron oxides, and needs a high firing temperature (above 1250 °C, but usually much higher); this kind of clay, called kaolin, is dry, barely malleable and therefore difficult to throw on the wheel.

The clays used for earthenware are secondary clays, which have been carried from their original source by rivers and rain. As they are borne along they come into contact with all kinds of natural substances, including iron compounds; it is the iron that is responsible for the red and black colours of Greek pottery.

As we have seen, pottery fired at low temperatures is porous, a limitation that is not easily overcome, even by covering the surface with a glaze. Most modern earthenware pottery is decorated with coloured glazes. Lead glazes were known in Roman times and slightly earlier, but the surface decoration of Greek pots is not a glaze (though it is often misleadingly referred to as that) but a very fine slip. This slip (clay in a liquid state) must, of course, have the same shrinkage-rate as the clay of the pot if it is not to crack or flake off after (if not before) firing. This is a difficult problem that was never wholly solved. The black 'paint' on Corinthian black-figure pottery, for instance, has often flaked, and the same is even more true of later Corinthian red-figure ware.

The Greek painting slip or gloss (to which we shall return below) was prepared in such a way that the edges of the microscopically small particles (which are flake-like crystals) sintered together at a temperature of about 850 °C. Whereas vitreous glaze fuses into a uniform glassy surface, the flat crystals of the Greek painting slip are sintered only at their corners, rather like microscopic ice-floes, each preserving its individual flat surface. This causes the remarkable gloss of the best Greek vases, so distinct from the shiny smoothness of a genuine glaze.

Distinctions in Greek pottery can also be made by size and function, between very large, heavy vessels used for storage and transport, such as the enormous pithoi and capacious amphorae, and smaller, lightweight ware. The latter includes kitchenware, the less coarse tableware and fine ware. The fabric of kitchenware naturally differs from that of the other two; it has to withstand rough handling and often the heat of the stove. For these reasons the clay is mixed with grog (powder of fired clay) or, preferably, crushed volcanic rock, which produces a heavy, refractory fabric. These rough vessels were much simpler to make than the finer ware, especially Attic ware of the sixth and fifth centuries B.C. The huge storage pithoi proverbially required a very experienced craftsman.[1]

Scientific analysis of clay

Close scientific examination of the composition of the clay of Greek pottery and comparison with modern Greek clays can provide useful clues in pinpointing ancient centres of pottery production. An introduction to this rapidly developing multidisciplinary field is provided by the splendid study of R. E. Jones (1986) on which the following is based.

There are two methods of approach: chemical and petrological analysis, the former especially helpful for fine pottery, the latter better suited to coarse ware. The scientific techniques involved are numerous and their number is growing. At the same time they are necessarily becoming more sophisticated, since the differences between clays of different origins are minute.

An example of the success of clay analysis is the discovery that an important class of clay-ground Hadra hydriai (cf. Fig. 83), used as ash-urns in Alexandria in Hellenistic times, was made in Crete, and

not, as we would have expected, in Egypt. Another interesting result is the assignation to Miletus of much of the finest Wild Goat pottery of the late seventh century, and of Fikellura ware. In both cases scientific analysis has corrected archaeological assumptions.

Often, however, results are less helpful. For example, so far no analysis has proved that Chalcidian vases were *not* made in Euboea (as is generally assumed because of the places where they have been found). The case of the Caeretan hydriai is worse; their clay looks different from that of Etruscan and East Greek wares (except perhaps for Campana *dinoi*); its composition appears to be uniform but different from all these (but data for the Campana dinoi are lacking).

The problem of identifying the ancient clay is complicated by the fact that potters often mixed two kinds of clay (a white and red one) to improve the quality. Some centres possessed very good clays indeed: 'clay makes the potter' is a saying that certainly held true for Classical Athens. The common source of modern Attic clay is Amaroussi, a northern suburb of Athens, but the chemical and petrological composition of its clays is not convincingly similar to that of ancient Attic pottery; more similar is the clay from Cape Kolias (on the east coast near Hagios Kosmas), which is praised in two ancient texts.[2] This would have been a long way for the potters of the Kerameikos to fetch their clay, and it is more likely that the clay bed they used, if not exhausted in ancient times, is buried under the huge modern city.

Attic clay and gloss

Making pottery has always been dirty work and was usually looked down on in antiquity. It was also hard labour, especially the mining and transport of the clay, the collecting of the brushwood for the kiln, the firing (which could last a whole day or night), the treading and wedging of the clay, etc. 'To make pottery' was a Greek expression for hard work. Besides, competition was intense: 'Potter hates potter', in Hesiod's words (*Works and Days* 25).

Rough clay dug out from its bed had to be levigated (purified); this was done in settling basins filled with water in which the large particles sank to the bottom, while the upper layer of the water with the finer particles of the clay was drained off into another basin; this process was repeated several times, until the water was allowed to evaporate, leaving malleable clay behind.[3]

The gloss-slip used for the decoration was made of the same clay as the body of the vase. Potters used a levigated clay to build the vase and a more refined solution of this clay – a colloidal suspension of very fine particles – for the black gloss. Whether or not they added a deflocculant to keep the particles floating in this suspension (e.g. potash, obtained from wood-ash soaked in water) is not certain. The black gloss paint was not applied to a bone-dry surface but when the pot was still sufficiently moist, to minimise differential shrinkage.

Iron is the colouring agent of Greek pottery: ferric oxide (Fe_2O_3) is red, but when fired in reducing conditions this turns to ferrous oxide (FeO) and magnetite (Fe_3O_4) which are black. The process which produced the red–black effect is simple but requires precision and experience, not only in producing the gloss but especially in controlling the kiln temperature.

Attic pottery was subjected to a single firing (though executed in three stages) and not to two separate firings like modern glazed pottery. The phases were: an oxidising first stage, with air vents open, up to probably 800 °C (clay and gloss are red, Fe_2O_3); a second, reducing phase with air vents closed and, at first, the temperature rising to *c.* 950 °C and then cooling down under the same reducing conditions to *c.* 900 °C (vase and gloss black: FeO and Fe_3O_4); and a third and final reoxidising stage with air vents reopened, the firing concluded and the kiln cooling down: the gloss slip, having sintered, had become airtight and therefore remained black while the clay of the vase turned back to red – including those areas immediately under the black gloss.

The most remarkable technique employed in decorating Attic pottery is without doubt the painting of the relief line, which came into use before the introduction of red figure, around the middle of the sixth century. It was made from black slip by evaporating it further: it was a thick cream of a brownish colour with a slightly metallic sheen, quite different from the much thinner regular gloss. In vase-paintings we sometimes see two containers by the side of a painter's chair, one for the ordinary gloss and another from which a lid has just been lifted (it has apparently been used to prevent further evaporation) containing the very thick relief gloss.[4] The best red-figure painters worked miracles with it – as can be seen, for example, in the bronze scales on the corslets on the Sosias cup[5] – but all painters were able to draw closely-set, straight drapery lines ending in beautiful tense curves (cf.

Fig. 42). There is never any sign of a trembling hand, hardly ever any clumsiness in the lines themselves.

It has long been a mystery how these exquisite lines were drawn. More than one explanation has been given[6] and more than one method may actually have been used; however, the reconstruction proposed by G. Seiterle seems the most convincing. By careful experimentation he has shown that most, if not all, relief lines were not drawn with the tip of a brush or pen, but were *laid down* by means of a long-haired implement. One or two or, more probably, several tough and elastic hairs were attached to a handle (Fig. 102) and were covered evenly and thickly with the relief-gloss by drawing the hairs of this extremely thin brush through a thick, short brush saturated with the creamy solution; then the tip of the hairs was put down on the surface and the full length was laid out gently in the required direction (straight or ending in a curve; Figs. 103 and 102); lifting the brush was easy, and the clay slip formed a long ridge where the hairs had touched the surface. The 'self-portrait' of a vase-painter in Fig. 103 shows him holding what is probably a thick brush full of gloss in his left hand while with his right he is carefully laying a long line on the outside of a cup.

With this tool almost anyone could produce the closely set drapery lines which seemed so surprising so long as it was assumed that they had been drawn free-hand with the tip of a normal brush. It would have been easy to shorten or lengthen the implement according to the detail that was to be painted, but no doubt many of these very slender hair brushes of different lengths and elasticity were lying by the painter, ready for use; stiff and pliant ones, long and short ones, and some loop-shaped (Fig. 102).

The last mentioned, consisting of hairs bound to a handle to form a loop, provides strong support for the accuracy of Seiterle's reconstruction. Students have long been puzzled as to how the long and somewhat tedious rows of buds interconnected with relief-curves such as are shown in Fig. 104 were produced. Seiterle has shown that it is easy to apply these relief-curves with a broad loop like that in Fig. 102, and the solid black buds with the smaller loop filled with ordinary black gloss (much thinner than the solution used for the relief lines) more or less in the way in which children sometimes blow soap-bubbles.

A rare technical effect was a red (as opposed to a black) gloss, often called 'intentional' (or 'coral') red. This was probably produced by

102. Instruments such as used by G. Seiterle to reproduce relief lines and solid buds.

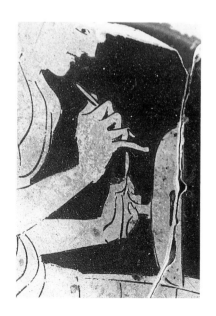

103. Attic red-figure cup fragment in the manner of the Antiphon Painter. Vase-painter at work. *c.* 480 B.C.

mixing the gloss slip with red ochre (clay with iron ore), resulting in a higher sintering temperature and greater porosity compared with black gloss; in the third phase of the firing, during which the vase (but not the black gloss) was reoxidised, the red gloss, having remained porous, was also reoxidised.

Ochre was called *miltos* by the Greeks and had to be imported into Athens. It was used on red-figure ware as a thin wash poured over the surface of a vase in order to colour the clay a deeper, slightly shiny red.

Accessory colours fired onto the surface of the pots were white (consisting of a white clay-slip) and purple, made of a solution of red ochre with a little black gloss. These colours were combined to produce intermediate colours such as yellow and shades of brown. They were usually laid over a black gloss underpaint. The white was also used (in one or two layers) to produce delicate white-ground vases often made as votive offerings and for funerary purposes (Figs. 3, 51).

104. Frieze of buds on the rim of a column-krater attributed to the Leningrad Painter.

Wheel and kiln

The Greek wheel[7] was a fast-revolving mechanism. It differed from the kick-wheel used by modern amateur potters, being low above the ground and worked by hand by an assistant sitting opposite the potter.[8] Its main characteristic was its large diameter, which served to provide the necessary momentum. A primitive kind of kick-wheel seems to have come into use in Hellenistic times, if we may judge from Egyptian representations.[9] Throwing takes place with the wheel spinning at between 50 and 150 rotations per minute, the speed inversely proportional to the diameter of the part of the pot being worked by the fingers (narrow necks at high speed, the edge of wide cups at a low one).

Kilns were of the up-draught type, the heat rising upwards and diminishing as it went, and consisted of a firebox, with a chamber for the pottery above it. Fuel (mainly brushwood) was put in the firebox through a stokehole which admitted the air. The flames rose through flues in the floor of the chamber towards an opening in the top; this 'chimney'-hole was closed for the reducing stage of the firing and again when the firing had ended and the kiln and its contents were allowed to cool off slowly. The firebox and the stokehole were usually built into the ground; there must have been a door in the chamber for loading, with a spy-hole in it to check the result of the firing.

Not much is known of the shape and construction of Greek kilns, but those used by the great Attic potters, such as Exekias and Amasis, must have been well built and fairly large;[10] they were certainly less primitive than those depicted on the well-known Corinthian plaques from Penteskouphia.[11] As a rule they were probably roughly circular in plan, with a central support for the floor of the chamber; the upper part was beehive shaped and provided with a fixed dome-like top. The total height may have been three metres or more, but all this is still hypothetical.

If draughts caused variations in temperature in the kiln (a common risk in up-draught kilns), some of the black gloss might turn brownish or reddish (either from overheating or from lack of reduction). Sometimes black gloss areas have a matt surface; this indicates that before and during firing the gloss was covered with white or purple (now lost): the added colour prevented the gloss surface from

acquiring its proper shine. In areas where, because of an air current, the black gloss has oxidised to brown or reddish-brown, parts that had once been covered by added colour now stand out as black, since the layer of colour prevented it from reoxidising. Thus, the colours may be nearly reversed, making it hard to recognise the original scheme.

Throwing the vase

The shaping of Attic vases could have a chapter to itself but here we must restrict ourselves to a few passing remarks pointing out some of the more interesting details.

A vase thrown in one piece is usually thicker-walled near the base, to enable the clay when it is still soft to support the weight of the vase. Sometimes rims (of calyx-kraters and volute-kraters, for example) are much thicker than the necks or bodies; these rims were produced by raising and thinning the wall of the neck, then flaring the top gradually outwards and finally rolling it downwards against the wall below, thus creating a rim of double thickness: a slight trace of this folding can sometimes be detected in the break of a fragmentary rim. In general, however, the differences in thickness between parts of a vase were kept small to prevent the clay bursting during shrinking (which amounts to a reduction in size of about 9.5 per cent). Rims, therefore, are often shaped in such a way that they look thicker and sturdier than they actually are, as we can see in the case of column-kraters where the rim seems solid but is actually hollow underneath.[12]

One of the curious features of Attic pots is that the centre of the underside, which is encircled by and visible within the ring of the foot, is never flat, but invariably rounded (cf. Fig. 96), except in the case of plates where the foot is a very low ring. (In Etruscan vases the underside may be flat.) This rounded base was created during the turning process (see below), but the reason for it is far from obvious – apart from the aesthetic pleasure that curving surfaces provide. However, there is probably a technical explanation: a flat base under a freshly thrown vase is liable to crack during drying, and later during firing.

The clay mixture used by Attic potters must have been of a remarkable consistency to allow such daring shapes as the cups of Figs. 105–108 to be thrown; Attic potters were particularly proud of these shapes, for they signed them more often than any other. In

105. Profile drawing of cup Type A. Name-vase of the Scheurleer Painter. *c.* 520 B.C.
Diam. 33.7 cm.

·106. Profile drawing of cup Type B attributed to the Splanchnopt Painter. *c.* 450 B.C.
Diam. 21.4 cm.

many of these cups it may seem as if the nearly horizontal 'wall' of the
bowl has sagged a little, causing the centre of the bowl, where it is
supported by the foot, to be slightly concave (forming an almost
imperceptible depression); this deviation from the intended curve may
be discerned in good section drawings (Figs. 105, 106). However, this
slight widening of the internal curve of a vase is also to be seen in
section drawings of other shapes, even of 'closed' pots; which suggests
that it is probably not due to sagging, but is produced in the final stage
of throwing when the wall is bent outwards into its final curve.

After throwing, the bodies or bowls of the vases were turned – a
process involving the trimming or refining of a thrown form with
metal and wooden tools. For this the clay had to be softish leather-
hard: it held its shape but could still be easily scored with a finger-nail.

107. Profile drawing of a Siana cup attributed to the C Painter. *c.* 570–565 B.C. Diam. 18.1 cm.

108. Profile drawing of a Siana cup attributed to the Heidelberg Painter. *c.* 560 B.C. Diam. 13.8 cm.

At this stage many Greek shapes still required additions (apart from the handles), usually feet but often necks as well. Sometimes this was done by 'coiling and throwing', as was the case with the feet of Siana cups (Figs. 107, 108). An evenly rolled-out ring-shaped coil, or small ball of clay, was placed on the bottom of the bowl which was left upside down on the wheel after the extra clay at the bottom had been trimmed off. The coil or ball was fingered down onto the leather-hard bowl and then thrown into a simple conical foot. This explains the 'unnecessary' thickness of the clay where foot and bowl meet (Figs. 107–8).

However, added parts were usually far more complicated than the feet of Siana cups and a different method was then required (well illustrated by Noble with a series of photographs of a potter making a

Little Master cup).[13] Let us here take a cup of Type B (Figs. 106 and 109). The bowl and the foot are thrown separately and then turned to achieve their final delicate shape. At the centre of the bottom of the bowl some extra clay is left and this is scored with a firm groove while the wheel is turning slowly; a similar groove is scored on the top of the foot (Fig. 109; an Etruscan cup to demonstrate an Attic technique). Both grooves are dampened with water and sticky gloss-slip and then stuck together. The wheel is revolved slowly to check that the foot is correctly centred. The foot is then pushed gently down until the slip emerges from the join. In cups of Type A (Fig. 105) the angular join was masked by a simple ring, but in Type B (Fig. 106) the join was worked over and made invisible. This was done as follows: the join itself was scored and dampened and a coil of appropriate thickness was wrapped around it. This coil was fingered carefully down and up, on to both bowl and stem, and the fingering subsequently smoothed out by throwing it into shape. Thus the coil formed a fluent transition between the stem and the bowl (Fig. 106).

Joining two more-or-less leather-hard shapes, rather than throwing

109. Fragmentary Etruscan red-figure cup (Clusium Group). Fourth century B.C.

wet clay into a foot on the bottom of a bowl, has the advantage that, provided both parts are of the same consistency, they are not subject to different rates of shrinkage. On the other hand, it is difficult to judge in advance whether the two parts are likely to form a perfect unity when brought together. There seem to have been especial difficulties in attaching the feet of Type B cups to their bowls, for the feet are often broken off at the join, exposing to view the spiral grooves on foot and bowl filled with black slip (Fig. 109). Apparently gloss-slip was used to glue the two parts together, and this slip fired black, just like the black gloss on the surface. The broken edge of the thin 'wall', formed by the coil thrown round the join, is also usually visible around the two grooved spirals; tiny cracks in its surface show that its consistency differed from that of the stem and the bowl, since it had to be wetter than these when it was applied and thrown into shape.

High-footed cups are a special case; but the shaping of other vases too would have involved one of the two methods mentioned above. Coiling and throwing was no doubt used for very large pithoi, but section-throwing and joining was used for large amphorae, kraters and the like. Similarly in Apulian pottery not only were the bodies of amphorae and loutrophoroi often thrown in two parts but their feet and necks too may also have been thrown separately.[14]

On the other hand, many vases were not too large to be thrown from a single lump of clay and the method of section-throwing was perhaps less common than has sometimes been assumed. For example, a good potter can easily throw a very sharp transition between a horizontal shoulder and a vertical neck from a single large ball of clay. He does not need to throw shoulder and neck separately and then join the two parts together, or (simpler but riskier) throw the neck from a wet coil laid on the leather-hard shoulder of the pot. Both methods leave traces on the inside which can been seen with a dentist's mirror or, if the neck is wide enough, felt with the finger-tips (Fig. 101*b*). If the potter was able to avoid these methods, why did he not do so all the time?

The answer is simple, at least in some cases: certain shapes cannot easily be put upside down on the wheel for turning or for the attachment of the foot, if they are already provided with their necks and mouths. This is true of oinochoai with delicately shaped, wide, three-lobed mouths (Fig. 101*a*), for it is difficult to shape a chuck (the clay support used in turning) to hold the body in an upside-down

position without damaging the mouth. This explains why even smallish wide-mouthed oinochoai very often show a marked ridge of clay on the inside of the transition between neck and shoulder (Fig. 101*b*), a ridge that is smoothed and rounded because it has been pressed onto the inside of the shoulder-edge on the turning wheel before the coil of wet clay was thrown into a neck. Surprisingly, a pelike may sometimes show the same ridge of clay on the inside between neck and shoulder, though neck and shoulder form a continuous curve and the pot can easily be centred upside down on the wheel, since it is a smallish vase furnished with a very sturdy lip.

An interesting case is the cylindrical lekythos (Fig. 51): as a rule the sharp angular shoulder was thrown in one piece with the body, but the neck had to be thrown from a coil placed in the markedly wide opening left in the shoulder (Fig. 110); this took place after the base had been trimmed and the foot added (probably by coil-throwing).

Like all potters the Greek artisan must usually have produced his

110. Inside of shoulder and neck of fragmentary red-figure lekythos. Early fifth century B.C.

pots in batches of one shape at a time. He would therefore need to form only one chuck on the wheelhead since the vessels were of a uniform size.

Finally we should glance at handles; some, such as those of volute-kraters (Fig. 10) and the beautiful flanged handles of belly amphorae of Type A (Fig. 34), were very elaborate and delicate. They must have been difficult to produce, but so far no study seems to have been made of them. Since handles dry faster than the body to which they are attached, they are at risk of becoming detached or spoiled during shrinking. A modern potter will cover his handles during the first drying, and the same may have been done in ancient times.

Identifying the potter

Why did painted pottery enjoy such popularity for so long? The question is rarely asked but poses a genuine problem. Probably the answer should be sought in the fact that ordinary people hardly ever possessed anything else in the way of an artistic representation at all. Yet there are many indications that the Greeks, and especially the Athenians, were highly responsive to the visual aspects of life and culture: they were, it has been said, not particularly talented in the abstract art of what was later called algebra, but exceedingly gifted in its visual counterpart, geometry; and even their literature, with its prolific output of drama, contained a highly visual element. The fine pictures on Attic pottery were, therefore, all the more welcome for the lack of other visual images in private homes.

This passion for images led to curious results. Admittedly, vases like calyx-kraters (Figs. 71 and 72) and tall cylindrical lekythoi (Figs. 51–3) provided a surface suitable for elaborate representations, but on strongly curving surfaces such as the body of the slender neck-amphora, the human figures are strangely bent, with head and shoulders thrown awkwardly backwards over the shoulder of the vase (cf. Figs. 4, 49). In fact, their position is sometimes so absurd that to photograph the entire figure is quite impossible, and in inspecting the vase the viewer is obliged to tilt it to and fro in order to follow the lines of the figure from head to foot. It is not clear how it came about that the Greeks felt that gods, men and horses could be subjected to these distortions without serious harm to the quality of both painting and pot. Nor is it clear to me why on the whole we agree with them in this respect: generations of amateurs and scholars alike, including

some of outstanding talent, have been fascinated by the charm of these images-on-pots.

In a lifelong devotion to the study of Attic vase-painting, Sir John Beazley developed an almost unfailing ability to recognise the hands of individual painters, as we saw in Chapter 1. Naturally, his method, based on stylistic analysis, is subjective and therefore open to dispute. Such research is not 'scientific': empirical proof is impossible. More-over, few of Beazley's successors possess anything like his acuteness of eye that enabled him to reconstruct on paper, using photographs and tracings, vases from fragments scattered world-wide. But his astonishing success in juggling with this global jigsaw puzzle con-vinced even the most sceptical that in this field solid results could be obtained.

Can a method similar to that used by Beazley for painters be applied to the potters of these vases? Here the answer is less certain, for the study of the hands of potters is far less advanced, and it is not clear how much more progress can be made.

Recognition of the style of a potter depends primarily on signa-tures, but also on close associations with individual painters. The best example of a potter known from signatures is Nikosthenes, for he signed more frequently than any other. His favourite product is the so-called Nikosthenic amphora (Fig. 56) which he produced in great numbers, providing many with his signature as potter. (It could be argued that the signature here signifies the owner of the workshop, not necessarily the potter, but Vincent Tosto has recently shown that in all likelihood these amphorae, though differing considerably in proportions and contour, *were* thrown by a single potter, so probably therefore by Nikosthenes himself.)[15] Nearly all of them were painted by a black-figure artist, Painter N, who may conceivably be identical with Nikosthenes. As a potter his most characteristic trait is his shaky sense of proportion – also to be seen in kyathoi and cups (with Nikosthenic foot-plates) and a volute-krater all signed by him; here we have a rare instance of different shapes (linked by signatures) which may be identified by eye as the work of a single potter.

Several scholars have shown that it is possible to attribute vases of a single shape, especially cups, to individual potters. Again, the associa-tion with a painter is the basis for such attributions. The cup-potter Python, for example, was closely associated with the painter Douris; from this connection it appears that he made cups which can be recog-nised by, among other things, the small size and dainty shape of their

foot-plates. Hieron worked almost exclusively with Makron as his painter, and their partnership has made it possible for Hieron's individual style as a cup-potter to be appreciated.

Hieron and Brygos were two of the most outstanding cup-potters of the first decades of the fifth century. Their products adhered closely to very narrowly defined proportions: the diameter of the foot-plate is almost always somewhere near 0.38 × the diameter of the bowl (0.38 = the proportion of the smaller division in the Golden Section). Since feet were thrown and turned separately and then attached to bowls (both no doubt made in batches of at least five or ten) the potters had to keep to certain standard measurements, otherwise it was impossible to match foot and bowl satisfactorily. Clearly there were measuring rods in the workshops, some of which seem to have been close to the foot-standards then in use (29–30 and 32–33 cm). On these they may have indicated the division of the Golden Section ($a:b = b:(a + b)$; the smaller division a being *circa* 0.38 × $(a + b)$), a division that could easily be marked on the rod with compasses. Python and Euphronios (as a potter), on the other hand, preferred different proportions: a smaller and a larger foot-plate respectively.

It is also possible to recognise potters in shapes other than cups; many Nolan amphorae may, according to Hans Euwe, be attributed to individual potters on the basis of their close association with one or more painters. No general criteria can be applied, since some potters are consistent and precise both in details and proportions, while others betray themselves by constant variation of the shape.[16]

Potters and painters

A good potter need not have a gift for drawing: the two talents seem unconnected and we would not necessarily expect a potter of refined Attic cups to be their painter as well. However, artistic talent may often develop in more than one direction at a time, and a number of the very best Attic artists were both potters and painters. Nearchos signed as both (on seven vases). The great painter Exekias signed as a potter before he is known to us as a painter. He seems to have been at least as great a potter as he was a painter: he created important new shapes such as the sturdy Eye Cup of Type A (cf. Fig. 105), perhaps the beautiful Type A belly-amphora, and invented the calyx-krater, which was to have a very long and successful career. We know this

lateral holes drilled through the stem (and also filled with the molten lead) would fix the cone of lead firmly. It is usually assumed that these repairs were made at the request of the owner after he had broken the vase (and this may be correct), but no doubt potters would have wished to sell an elaborately painted vase that had been broken in the workshop if they were able to repair it: painted vases required a lot of work; they seem to have fetched higher prices than unpainted ones (see above, p. 228).

Workshop personnel

There has been much speculation about the organisation of ancient potteries. The Cretan pithos-producers of the modern era may serve as a model: there was a master, a sub-master, a wheel turner, a servant to prepare the clay, a stoker and a carrier (for the wood, clay and water). In the heyday of Attic pottery, workshops may have been large and more complex, probably employing several wheels at the same time. However, a large output need not require a large number of workmen: the typical Cretan pithos workshop, for example, produced no less than 400 enormous pithoi each season, which lasted only a few months.

No doubt potteries the size of a family business were the rule. The names and dates of some of these families are known to us. Nearchos and his sons Tleson and Ergoteles were active for some thirty years around the middle of the sixth century; Ergotimos, famous potter of the François krater, had a son (Eucheiros) and a grandson who succeeded him as potters; Amasis and his son Kleophrades worked as potters over some fifty years down to the beginning of the fifth century. Such family ateliers at times achieved a certain social standing, as appears from a few votive offerings on the Athenian Acropolis (above, p. 212). It should be noted that most of the larger votive offerings came from potters who specialised in cups. The outlandish names of many artisans (Skythes, Brygos, etc.) demonstrate the cosmopolitan character of Athens and its pottery trade, in which resident aliens and slaves played an important role.

In the later sixth century B.C. Attic painters frequently moved from shop to shop, apparently according to where their help was needed (painting takes much more time than throwing). Thus, for example, the excellent draughtsman Epiktetos, who was proud of his talent and

signed many of his cups with his own name as painter, added the names of no less than six different potters on thirteen vases preserved. In addition, if we are to believe what he wrote on it, he potted a plate with his own hands to present as a thank-offering to Athena on the Acropolis, decorating it with a figure of the goddess herself. These confusing associations between colleagues in the trade were at this time the rule rather than the exception. We should be grateful that the signatures make this clear, for without them no one would ever have dared to propose such a bewildering reconstruction for the Late Archaic Attic workshops. It has been suggested that this was due to the lively expansion of the market for fine ware at the end of the sixth century; in the following decades the co-operation of potters and painters seems to have become more stable (e.g. Makron–Hieron and Douris–Python).

It is interesting that personal pride in the craft seems to have waned after about 470 B.C.; signatures grow more and more rare, and quality begins to diminish (see above, p. 117). Yet trade in pottery continued to flourish for many decades more.

In winter most pottery work was almost impossible, as the firing of the kiln was threatened by rain and the drying of newly thrown vases was nearly impracticable. Customarily potters have done other jobs during the winter months – often working as small farmers – but it is hard to believe that Exekias, Euphronios, Brygos and the other admirable artists of Attic pottery would have been unable to live the whole year round from the revenues of their trade.

Greek vase shapes

Some of the general principles of Greek shapes are outlined at the beginning of Chapter 10. For discussions of individual shapes see G. M. A. Richter and M. J. Milne, *Shapes and Names of Athenian Vases* (New York 1935); Cook, *GPP*[2] 216–39; M. G. Kanowski, *Containers of Classical Greece* (University of Queensland Press 1984). The purpose of this note is simply to draw attention to the principal shapes illustrated in this book, and in what follows it is assumed that the forms are Attic unless otherwise stated.

It is conventional to use ancient names for shapes, but the ancient sources are often vague or inconsistent, and the names now generally agreed on are not necessarily those the Greeks would have used for each specific shape. Hence the aryballos of Fig. 1 is actually inscribed 'lekythos'. It is also a convention, and often most convenient, to use ancient plurals (except for 'kraters' and 'psykters'), but English plurals are at last creeping in for names ending in a vowel.

ALABASTRON (pl. -RA). A small flask for unguents, with sagging profile. Fig. 27 illustrates an early version of the type popular at Corinth.

AMPHORA (Latin, pl. -AE). The neck-amphora is important in Geometric (Fig. 12), and in Late Geometric may reach monumental dimensions. The Tyrrhenian (Figs. 58, 59), and Nikosthenic (Fig. 56) and related (Fig. 90), are special sixth-century Attic forms made primarily for export to Etruria. For the neck-amphora common in late black figure see Fig. 32 (detail). Among other differences the amphora Type A (Fig. 34) has a more complex foot and handles that are squared in section. For the Panathenaic (prize) amphora: Fig. 100. Hellenistic amphoras can be dumpy (Fig. 79); more often they are slender (Fig. 76).

ARYBALLOS (pl. -OI). A small unguent flask, of varying forms. Only round aryballoi are featured here: Figs. 25 (Protocorinthian), 30 (Corinthian). The shape is less popular in Attic (Fig. 1).

HYDRIA (pl. -AI). A large jar with a vertical, as well as two horizontal handles, for carrying water, and often shown in use in scenes on black-figure hydrias. On red-figure examples other kinds of female activities are frequently shown (e.g. Fig. 4). The finest example of the shape here is Fig. 49. The Hellenistic Hadra hydria (Fig. 83) was used as a cremation urn.

KANTHAROS (pl. -OI). A drinking vessel with tall vertical handles: Fig. 57.

KRATER. A bowl for mixing wine, of varying proportions. There are a number of early examples here: Figs. 15 (Cretan Protogeometric), 16 and 19 (Attic Geometric). Fig. 14 shows a Euboean Geometric pedestalled krater with lid. The krater is a principal vehicle for Attic and South Italian red-figure decoration, where the main forms are the volute-krater: Figs. 10, 75; calyx-krater: Figs. 46, 72; and bell-krater: Figs. 62, 65.

KYATHOS (pl. -OI). A vessel with single vertical handle, used as a cup or ladle: Fig. 57.

KYLIX. A wide-bowled drinking vessel with horizontal handles, usually called simply a 'cup'. There are many forms. Greek cups are remarkably shallow, especially in Attic black and red figure. First of those with tall stems is the Siana cup (Figs. 107, 108), which gives way to the Little Master cups of the third quarter of the sixth century, of which only the Band cup (Fig. 87c) is represented here. Later come Type A (Fig. 105) and the delicate red-figure Type B (Fig. 106). The latter two forms are without a separate lip, as is also the East Greek 'Bird bowl' of the seventh century (Fig. 87b). Painters of cups are often keen to show cups in use (Fig. 6), and the cup interior provides an important field for decoration (Figs. 8, 11, 47).

LEKYTHOS (pl. -OI). A tall flask for oil. The standard cylindrical lekythos is seen in black figure (Fig. 45), red figure (Fig. 41), and white ground (Fig. 51). Earlier than these is Fig. 29, a Corinthian example copying the Attic 'Deianeira' form. The squat lekythos (Fig. 50) is aptly named.

OINOCHOE (pl. -AI). Literally a 'wine-pourer'; a jug, usually with a three-lobed mouth. It can be seen held by the woman in Fig. 8, while Fig. 101 shows an example in black gloss. The oinochoe does not figure prominently in Attic black and earlier red figure, but is an important shape in Geometric (Fig. 20 is Euboean colonial).

OLPE (pl. -AI). The term is used for a round-mouthed jug popular at Corinth from Late Protocorinthian (Fig. 21) on, and for a later Attic round-mouthed jug not illustrated here.

PELIKE (pl. -AI). A kind of amphora with sagging profile. Fig. 74 shows a South Italian example.

PYXIS (pl. IDES). The word means, literally, a 'box of box-wood'. Clay pyxides were used mainly by women, for holding cosmetics or jewellery. The shape is common in Attic Geometric, and Fig. 13 shows an extraordinarily elaborate example. Unlike Attic, Corinthian examples often have handles (Fig. 28).

SKYPHOS (pl. -OI). A drinking vessel with a deeper bowl than the kylix and with a short everted lip. Fig. 87*a* is early eighth-century Euboean.

The following shapes are also briefly mentioned in the text:

CHOUS (-OES). A small bulbous oinochoe common in red figure of the later fifth century.

DINOS (-OI). A large bowl, round-bottomed and requiring a separate stand.

KOTYLE (-AI). A tall cup not dissimilar to the skyphos, but lipless.

LAGYNOS (-OI). A Hellenistic narrow-necked oinochoe with depressed body (Fig. 77).

LEKANIS (-IDES). A lidded dish.

LOUTROPHOROS (-OI). A tall, very slender, ritual vessel, used at weddings and at funerals of the unmarried.

MASTOS (-OI). A cup shaped like a woman's breast.

PITHOS (-OI). A tall storage vessel of very large dimensions.

PSYKTER. Literally a 'cooler'. A mushroom-shaped vessel, itself placed in a krater, for cooling wine.

RHYTON (-TA). A drinking-horn. In pottery the lower part is in the form of an animal's head or even more elaborate support (Fig. 48).

STAMNOS (-OI). A wide-mouthed, short-necked vessel with flattish shoulder and horizontal handles.

Further reading and notes

ABBREVIATIONS

1. Books

ABV	J. D. Beazley, *Attic Black-Figure Vase-Painters* (Oxford 1956)
Addenda	L. Burn and R. Glynn (eds.), *Beazley Addenda* (Oxford 1982); 2nd edn 1989 (ed. T. H. Carpenter)
Ancient Greek and Related Pottery	Conference proceedings: *Ancient Greek and Related Pottery*, ed. H. A. G. Brijder (Amsterdam 1984); ed. J. Christiansen and T. Melander (Copenhagen 1988)
Arias, Hirmer, Shefton, *History*	P. E. Arias, M. Hirmer, B. Shefton, *A History of Greek Vase Painting* (London 1962)
ARV²	J. D. Beazley, *Attic Red-Figure Vase-Painters*, 2nd edn (Oxford 1963)
Boardman, *Black Figure*	J. Boardman, *Athenian Black Figure Vases* (London 1974)
Boardman, *Greeks Overseas³*	J. Boardman, *The Greeks Overseas*, 3rd edn (London 1980)
Boardman, *Red Figure: Archaic*	J. Boardman, *Athenian Red Figure Vases: The Archaic Period* (London 1975)
Boardman, *Red Figure: Classical*	J. Boardman, *Athenian Red Figure Vases: The Classical Period* (London 1989)
City of Images	C. Bérard et al., *A City of Images* (Princeton 1989)
Cook, *GPP²*	R. M. Cook, *Greek Painted Pottery*, 2nd edn (London 1972)
CVA	*Corpus Vasorum Antiquorum*
LIMC	*Lexicon Iconographicum Mythologiae Classicae* (Zurich 1981–)
Moon (ed.), *Iconography*	W. G. Moon (ed.), *Ancient Greek Art and Iconography* (Wisconsin 1983)

Paralipomena	J. D. Beazley, *Paralipomena* (Oxford 1971)
Robertson, *Painting*	M. Robertson, *Greek Painting* (Geneva 1959)
Williams, *Greek Vases*	D. Williams, *Greek Vases* (London 1985)

2. Journals

AJA	*American Journal of Archaeology*
AK	*Antike Kunst*
AM	*Athenische Mitteilungen*
BABesch	*Bulletin Antieke Beschaving*
BCH	*Bulletin de correspondance hellénique*
BSA	*Annual of the British School at Athens*
JdI	*Jahrbuch des deutschen archäologischen Instituts*
JHS	*Journal of Hellenic Studies*

GENERAL

The development of Greek vase-painting can be followed through Cook, *GPP*[2]. For discussion of both vase-painting and monumental painting see Robertson, *Painting* and *A History of Greek Art* (Cambridge 1975). The former has fine colour photographs, and colour is also included in the following: Arias, Hirmer, Shefton, *History*; E. Simon, *Die griechische Vasen* (Munich 1976); Williams, *Greek Vases* (drawing on the British Museum collections). For Attic black figure see J. D. Beazley, *The Development of Attic Black-Figure*, 2nd edn (University of California 1986) and Boardman, *Black Figure*; for Attic red figure: Boardman, *Red Figure: Archaic* and *Red Figure: Classical*.

Lately a number of conferences have focused on iconography: see especially Moon (ed.), *Iconography*, and *Ancient Greek and Related Pottery* 1984 and 1988, the latter two volumes also containing articles on other aspects such as trade and technical processes. For discussion, and beautiful illustrations, of sixth- and fifth-century Athenian vases see *City of Images*.

Of recent controversies mentioned at various points in this book several stem from the theory that black and red figure were created to imitate the colour schemes of decorated metal vases; the arguments for and against can be followed in M. Vickers (ed.), *Pots and Pans* (Oxford 1986) 137–51 and J. Boardman, *Revue archéologique* (1987) 279–95, and there are further references in the bibliography to Chapter 5. For the somewhat older suggestion that a number of classes of Athenian pottery were actually made in Italy see E. Langlotz, *Gymnasium* 84 (1977) 423–37.

Beazley's primary work is his catalogues *ABV*, *ARV*[2], and *Paralipomena*. For discussions and assessments of his achievement see D. Kurtz (ed.), *Beazley and Oxford* (Oxford 1985).

1 ADOPTING AN APPROACH

I

For Beazley's work and influence, see the volume edited by Kurtz cited above. Further criticisms of the notion of vases traded as ballast-cargo are made by Spivey in Chapter 6. On interpreting the Sotades Painter's cups: L. Burn, 'Honey pots: three white-ground cups by the Sotades Painter', *AK* 28 (1985.2) 93–105.

II

J. Berger, *Ways of Seeing* (Harmondsworth 1972). Essays on the meanings of
 images in general.
City of Images.
E. Keuls, *The Reign of the Phallus* (New York 1985). An excellent compilation
 of pictures.
D. Williams, 'Women on Athenian vases: problems of interpretation', in A.
 Cameron and A. Kuhrt (eds.), *Images of Women in Antiquity* (London
 1983) 92–106.

2 THE GEOMETRIC STYLE: BIRTH OF THE PICTURE

The development of Attic and other regional styles of Geometric pottery is fully treated by J. N. Coldstream in *Greek Geometric Pottery* (London 1968). The same author's *Geometric Greece* (London 1977) attempts to relate Geometric pottery and other contemporary archaeological evidence to a historical background. A more art-historical account of Geometric artifacts is given by B. Schweitzer, *Greek Geometric Art* (London 1971).

The generic funeral and battle scenes on Attic Geometric pottery receive careful scrutiny in G. Ahlberg's two books, *Prothesis and Ekphora in Greek Geometric Art* (Göteborg 1971) and *Fighting on Land and Sea in Greek Geometric Art* (Stockholm 1971). A more recent treatment of the latter topic is offered by C. Grünewald in 'Frühe attische Kampfdarstellungen', *Acta Praehistorica et Archaeologica* 15 (1983) 155–204. J. L. Benson, in *Horse, Bird and Man: The Origins of Greek Painting* (Amherst 1970), attributes the genesis of the Attic Geometric figured style to chance discoveries of figured Mycenaean pottery and other artifacts.

K. Schefold's *Myth and Legend in Early Greek Art* (London 1966) is a well illustrated compendium of Geometric and Archaic scenes which might be interpreted as mythical; the case against any Geometric mythical scenes is argued by K. Fittschen, *Untersuchungen zum Beginn der Sagendarstellungen bei den Griechen* (Berlin 1969). On this issue, intermediate positions are taken by J. M. Carter, 'The beginning of narrative art in the Greek Geometric period',

BSA 67 (1972) 25–58; by J. Boardman, 'Symbol and story in Geometric art' in Moon (ed.), *Iconography* 15–35; and by A. M. Snodgrass, *An Archaeology of Greece* (Berkeley, Calif. 1987) Chapter 5.

3 CORINTH AND THE ORIENTALISING PHENOMENON

The basic work on archaic Corinthian pottery is H. Payne, *Necrocorinthia* (Oxford 1931); see also his *Protokorinthische Vasenmalerei* (Berlin 1933). The best concise account of its development is Cook, *GPP*² 46–65. Attempts to update Payne include now D. A. Amyx, *Corinthian Vase-Painting of the Archaic Period* (3 vols., University of California 1988), the first volume of which, in the manner of Beazley for Attic, organises a vast body of material into lists by painter. J. L. Benson, *Earlier Corinthian Workshops* (Amsterdam 1989) is well illustrated for Protocorinthian, but his groupings are rather different from Amyx's. For Corinthian Geometric see J. N. Coldstream, *Greek Geometric Pottery* (London 1968) 91–111. J. B. Salmon, *Wealthy Corinth* (Oxford 1984) gives a full account of the historical and economic background. On Corinthian scent products and their identification from residues: W. R. Biers et al., in *Ancient Greek and Related Pottery* (1988) 33–50.

Colour details of the Chigi vase: Robertson, *Painting* 48–9; Arias, Hirmer, Shefton, *History* Pl. iv. The Macmillan aryballos in the B.M.: Akurgal (see below) Pls. 52–3 (colour); F. Johansen, *Les Vases sicyoniens* (Paris 1923) Pl. 31. Corinthian polychromy and free (monumental) painting are recently discussed by Amyx in Moon (ed.), *Iconography* 37–52, and G. P. Schaus, *JHS* 108 (1988) 107–17.

For a short survey of Orientalising see J. Boardman, *Pre-Classical* (Harmondsworth 1967) 73–108; for more detail see his *Greeks Overseas*³ 35–102 and E. Akurgal, *The Birth of Greek Art* (London 1966). There is a useful collation of Phoenician bowls in G. Markoe, *Phoenician Bronze and Silver Bowls from Cyprus and the Levant* (University of California 1985). Early representations of myth are discussed by K. Schefold, *Myth and Legend in Early Greek Art* (1966).

4 THE SIXTH-CENTURY POTTERS AND PAINTERS OF ATHENS AND THEIR PUBLIC

The principal sources of references to Attic black- and red-figure vases remain Beazley's lists of attributed vases in *ABV* and *ARV*², with supplementary references in *Addenda*². For a more general account of the painters, with some discussion of iconography, see the handbooks: Boardman, *Black Figure* and *Red Figure*. In general on iconography, T. H. Carpenter, *Art and Myth in Ancient Greece* (London 1991) and for a very detailed and illustrated account,

by figures and scenes, *LIMC*, of which Volume IV (1988) reaches 'Herakles'. Articles addressing various iconographic subjects are found in Moon (ed.), *Iconography*, with a full bibliography by subjects; and in *Ancient Greek and Related Pottery* (1984) with the writer's remarks on Herakles in Athens on pp. 239–47.

5 VASE-PAINTING IN FIFTH-CENTURY ATHENS

For all vase-painters and potters named, see the lists in Beazley's *ABV* and *ARV²*, and the handbooks by J. Boardman.

For the beginnings of the red-figure technique, see most recently J. Mertens, 'The Amasis Painter: artist and tradition', in *Papers on the Amasis Painter and his World* (Malibu 1987) 168–83, esp. 172–5, and B. Cohen, 'Oddities of very early red-figure and a new fragment at the Getty', in *Greek Vases in the J. Paul Getty Museum* 4 (1989) 73–82.

For white-ground vases, see D. Williams, 'An oinochoe in the British Museum and the Brygos Painter's work on a white ground', *Jahrbuch der Berliner Museen* 24 (1982) 17–40, and I. Wehgartner, *Attisch Weissgrundige Keramik* (Mainz 1983).

For the Six technique, see D. C. Kurtz, *Athenian White Lekythoi* (Oxford 1975) 116–20.

For the theory about gold- and silver-figured vases, see M. J. Vickers, 'Artful crafts: the influence of metalwork on Athenian painted pottery', *JHS* 105 (1985) 108–28. For a rebuttal see R. M. Cook, '"Artful crafts": a commentary', *JHS* 107 (1987) 169–71.

For the development of drawing in the works of the Pioneers and their pupils, see D. Williams, 'The drawing of the human figure on early red figure vases', in D. M. Buitron (ed.), *The Human Figure in Early Greek Art* (papers of a colloquium in 1988) forthcoming in *Studies in the History of Art* (National Gallery of Art, Washington, D.C.).

For the wall-paintings of the Theseion and vase-painting, see J. P. Barron, 'New light on old walls: the murals of the Theseion', *JHS* 92 (1972) 20–45, esp. 23–5.

For the extended quote from Beazley, see J. D. Beazley, *Attic Red-Figured Vases in American Museums* (Cambridge, Mass. 1918) 142.

For red-figured vases of the second half of the fifth century, see Boardman, *Red Figure: Classical* (painters, style and iconography); L. Burn, *The Meidias Painter* (Oxford 1987) (iconography).

For white-ground lekythoi, see Kurtz, *Athenian White Lekythoi* (development of shapes, styles, iconography); for Huge Lekythoi, see F. Brommer, 'Eine Lekythos in Madrid', *Madrider Mitteilungen* 10 (1969) 155–71, and (for the Madrid Huge Lekythos) R. Olmos Romera, *Catalogo de los vasos griegos* I (Madrid 1980) 130–4; for the style of the painter Parrhasios, see V. J. Bruno, *Form and Colour in Greek Painting* (London 1977) 35–40.

For the burial customs of ancient Greece, see J. Boardman and D. C. Kurtz, *Greek Burial Customs* (London 1971) and R. Garland, *The Greek Way of Death* (London 1985); for the idea that pottery vases were cheap imitations of metal: Vickers, *JHS* 105 (cited above), and H. Hoffmann, 'Why did the Greeks need imagery? An anthropological approach to the study of Greek vase painting', *Hephaistos* 9 (1988) 143–62.

6 GREEK VASES IN ETRURIA

Generally, I am indebted to the opening pages of E. H. Gombrich's *Symbolic Images* (London 1972), also to Hoffmann's article (cited above), *Hephaistos* 9 (1988) 143–62. Specifically, the following articles are pertinent to the argument of this chapter: M. Vickers, 'Imaginary Etruscans: the changing perceptions of Etruria since the fifteenth century', *Hephaistos* 7/8 (1985/6) 153–68; L. B. van der Meer, 'Kylikeia in Etruscan tomb painting', in *Ancient Greek and Related Pottery* (1984) 298–304; T. Rasmussen, 'Etruscan shapes in Attic pottery', *AK* 28 (1985) 33–9; T. H. Carpenter, 'On the dating of the Tyrrhenian Group', *Oxford Journal of Archaeology* 2 (1983) 279–93; F. Gilotta, 'Ceramica attica dall' area urbana di Caere', *Prospettiva* 46 (1986) 42–9; M. Martelli, 'La ceramica greca in Etruria: problemi e prospettive di ricerca', *Atti del Secondo Congresso Internazionale Etrusco* Vol. II (Rome 1989), 781–811.

The best attempts to see Greek vases through Etruscan eyes have been made by Juliette de la Genière, and I have drawn on two articles by her: 'Les acheteurs des cratères corinthiens', *BCH* 112 (1988) 83–90; and 'Rituali funebri e produzione di vasi', in M. B. Jovino and C. C. Treré (eds.), *Tarquinia: ricerche, scavi e prospettive*) (Milan 1987) 203–8.

Finally, Ernst Langlotz: again, two articles were useful: 'Vom Sinngehalt attischer Vasenbilder', in *Robert Behringer – eine Freundgabe* (Tübingen 1957) 397–421; and 'Der Sinn attischer Vasenbilder', in *Die Griechische Vase* (*Wissenschaftliche Zeitschrift der Universität Rostock* 1967) 473–80.

7 FARCE AND TRAGEDY IN SOUTH ITALIAN VASE-PAINTING

1. South Italian vase-painting

A short, but fairly detailed, and well illustrated survey of the whole field of red-figure vase-painting in South Italy and Sicily will be found in A. D. Trendall, *Red-Figure Vases of South Italy and Sicily* (London 1989), with a select bibliography on pp. 270–6 [= *RVSIS*].

Detailed studies of the principal fabrics, with extensive illustrative material, will be found in the following works:

A. D. Trendall, *The Red-figured Vases of Lucania, Campania and Sicily* (Oxford, 1967), with three Supplements published as Supplementary volumes to the *Bulletin of the Institute of Classical Studies*, London (26, 1970; 31, 1973; 41, 1983). [= *LCS*]

A. D. Trendall and A. Cambitoglou, *The Red-figured Vases of Apulia* (2 vols., Oxford, 1978 and 1983), with Supplements as above (I = *Bull. Supp.* 42, 1983; II (forthcoming in 1991). [= *RVAp*]

A. D. Trendall, *The Red-figured Vases of Paestum* (London 1987). [= *RVP*]

2. *Theatre and drama*

A. D. Trendall and T. B. L. Webster, *Illustrations of Greek Drama* (London 1971). [= *IGD*]

M. Bieber, *The History of the Greek and Roman Theater*, 2nd edn (Princeton 1961).

A. Pickard-Cambridge, *The Dramatic Festivals of Athens*, 2nd edn (Oxford 1968) revised by J. Gould and D. M. Lewis, reprinted 1988 with new supplement. [= *DFA*]

E. Simon, *The Ancient Theatre* (London 1982). [= *Anc. Theatre*]

C. W. Dearden, 'Phlyax comedy in Magna Graecia – a reassessment', in *Studies in Honour of T. B. L. Webster* II (Bristol 1988) 33–41.

The following provide annotated lists of relevant monuments:

A. D. Trendall, *Phlyax Vases*, 2nd edn (London 1967). [= *PhV²*]

T. B. L. Webster, *Monuments Illustrating Tragedy and Satyr-play* (London 1967).

T. B. L. Webster, *Monuments Illustrating Old and Middle Comedy*, 3rd edn, revised by J. R. Green (London 1978).

A. D. Trendall, 'Masks on Apulian red-figured vases', in *Studies in Honour of T. B. L. Webster* II (1988) 137–54. [= *Masks*]

Notes

1. T. H. Carpenter, *Dionysian Imagery in Archaic Greek Art* (Oxford 1986) 126.

2. E.g. the *Andromeda* of Sophocles; *IGD* 63.

3. *CVA* II, 59–61, Pl. 41.

4. *CVA* II, 61–63, Pls. 42–4; Simon, *Anc. Theatre* Pl. 8, and p. 20, Fig. 2.

5. Name-vase of the Pronomos Painter. *ARV²* 1336, 1; Simon, *Anc. Theatre* 18–20, Pl. 9.

6. The J. Paul Getty Museum has two fragmentary vases, published by M. Jentoft-Nilsen in *Ancient Greek and Related Pottery* (1988) 278–83, Figs. 1–6, which are Daunian in shape but were decorated in red figure by

Athenian vase-painters, and there is a *nestoris* (of Messapian type) in the
Guarini collection at Pulsano, which has panels with painting on a white
ground on the upper part of the body, also the work of an Athenian artist.
Vases like these raise the possible question of Athenian artists working in
Apulia (as was suggested by Ernst Langlotz some time ago) or of
Apulians placing specific orders in Athens for vases of familiar local
shapes.

7. *RVP* 45 no. 94 Pl. 11a; *RVSIS* Ill. 339.
8. *RVP* 46 no. 99 Pl. 12f; *RVSIS* Ill. 340.
9. *RVP* 46 no. 101 Pl. 13b; *RVSIS* Ill. 341.
10. E.g. *RVP* Pls. 99a and c, 102c and e, 104a, 105b.
11. New York 1989.11.4; colour-ill. in Sotheby's New York *Sale Cat.* 23
 June 1989, no. 196.
12. *IGD* 122, IV.8b; *RVP* no. 2/245 Pl. 92a.
13. *Masks* 140 no. 1 Pl. 15, 1; *RVSIS* Ill. 102.
14. *RVAp* I, 47 no. 12.
15. *RVAp* I, 35 no. 8; *Masks* 145 no. 25.
16. Simon, *Anc. Theatre* 17, Pl. 7.
17. *IGD* 30–1, II.3–4; 33, II.7–9.
18. *CVA* I, Pl. 32, 11–13; *ARV²* 1180, 3.
19. *LCS* 14 no. 1 Pl. 1, 1; *IGD* 33, II.10; *RVSIS* Ill. 2.
20. *LCS* 27 no. 85 Pl. 8, 1; *IGD* 36, II.11, *RVSIS* Ill. 9.
21. *IGD* 114, III.6, 2; *RVSIS* Ill. 430.
22. *LCS* 55 no. 280; also *RVAp* I, 8 no. 18 Pl. 11, 2.
23. *IGD* 38, II.13. For satyrs stealing food after the feast see McPhee, 'An
 Apulian oenochoe and the robbery of Herakles', in *AK* 22 (1979) 38–42
 Pl. 13, and S. Woodford, *JHS* 109 (1989) 201ff.
24. See A. Seeberg, *Corinthian Komos Vases* (London 1971).
25. *Greek Vases in the J. Paul Getty Museum* 2 (1985) 95–118; O. Taplin,
 'Phallology, *Phlyakes*, iconography and Aristophanes', *Proceedings of the
 Cambridge Philological Society* 213 (1987) 92–104, Pl. 1, where a possible
 connection with the *Clouds* is suggested.
26. *IGD* 117, IV.1.
27. *IGD* 117, IV.2, by the Nikias Painter; *ARV²* 1335, 34; *c.* 410 B.C.
28. *IGD* 119, IV.3, from the workshop of the Meidias Painter; *c.* 410–400 B.C.
29. *PhV²*, nos. 9–13; *IGD* 130, IV.5–6; Pickard-Cambridge, *DFA* 212, Figs.
 82–4, 86–7.
30. *PhV²*, no. 14.
31. *PhV²*, no. 84; *IGD*, 130, IV.13; *RVSIS* Ill. 105.
32. See note 23. *PhV²*, no. 45 pl. 2; *IGD* 132–4, IV.18.
33. F. Causey Frel in *Studies in Honor of Leo Mildenburg* (Wetteren 1984) 51–5,
 pl. 7; J. R. Green in *Greek Vases in the J. Paul Getty Museum* 3 (1986) 197,
 Fig. 31.

34. *PhV*² 40 no. 75; *LCS* 43 no. 212 Pl. 16,5; *IGD* 132, IV.15.
35. *LCS* Suppl. III, 63–4, nos. D 51b, 63, 64.
36. *LCS* Pl. 231, illustrates good examples; *IGD* 136–7, IV.24; *RVSIS* Ill. 424.
37. *RVP* 65 no. 19 Pl. 20c; *PhV*² 43 no. 58 Pl. 111b; *IGD* 140, IV.31.
38. *IGD* 131, IV.14; *RVSIS* Ill. 352; Simon, *Anc. Theatre* 30, Pl. 14.
39. *RVP* 85 no. 130 Pl. 54b; *PhV*² 54 no. 86; *RVSIS* Ill. 354.
40. *RVP* 124 no. 176 Pl. 73a and 72 no. 45 Pl. 28a.
41. *RVP* 159 no. 280 Pl. 103a.
42. *RVP* 163 no. 306 Pl. 107e.
43. *RVP* 271 nos. 2–3 Pl. 167a, c.
44. *RVSIS* Ill. 304.
45. *LCS* 410 nos. 336–7.
46. *PhV*² 67 no. 133 Pl. VID; *RVSIS* Ill. 294.
47. *IGD* 78, III.3, 10, Ill. on p. 80.
48. *LCS* 601 no. 98 Pl. 235, 2; *IGD* 114–15, III.6, 1.
49. *IGD* 101, III.3, 43; Simon, *Anc. Theatre* 22ff., Pl. 10 and n. 85. By the Konnakis Painter.
50. *IGD* 94, III.3, 31; Cambitoglou, *AK* 18 (1975) 62ff.
51. *RVP* 84 no. 127 and 89–90 Pl. 45; 86 no. 134 Pls. 55–6.
52. *RVAp* Suppl. I, 78 no. 44a and *RVAp* II, 532 no. 283 Pl. 195.
53. On the subject in general, see K. Phillips, 'Perseus and Andromeda', *JHS* 72 (1968) 1–23 Pls. 1–20; *IGD* 63–5, III.2, 1–3 and 78–82, III.3, 10–13. The pact is shown on *RVSIS* Ill. 44.
54. *RVAp* II, 500 no. 59 Pl. 179, 2; K. Schauenburg, 'Kreousa at Delphi', *Archäologischer Anzeiger* (1988) 633–51, Fig. 1.
55. *RVSIS* Ills. 61 and 29.
56. *RVSIS* Ill. 211; Trendall in *Enthousiasmos. Essays presented to J. M. Hemelrijk* (Amsterdam 1986) 163–5, Figs. 7–9.

8 FINE WARES IN THE HELLENISTIC WORLD

Hellenistic pottery has a wide geographical range, and the coverage of it available in English is very patchy. Here I concentrate on recent works.

General

H. A. Thompson, *Hesperia* 3 (1934) 311–480, with Pl. III. The basic outline of the Attic series, with numerous references to the earlier literature. Reissued in H. A. and D. B. Thompson, *Hellenistic Pottery and Terracottas* (Princeton 1987), with redating and updated bibliography by S. Rotroff (pp. 1–8).
J.-P. Morel, 'Céramiques d'Italie et céramiques hellénistiques (150–30 av.

J.-C.)', in P. Zanker (ed.), *Hellenismus in Mittelitalien* II (Göttingen 1976) 471–501.

V. R. Grace, 'Revisions in early Hellenistic chronology', *AM* 89 (1974) 193–200.

P. Lévêque and J.-P. Morel (eds.), *Céramiques hellénistiques et romaines* I (Paris 1980), II (1987). Includes important articles on relief bowls, transport amphorae, late Iberian and Punic wares, and Ampuritan grey ware.

Related metalware, etc.

Barr-Sharrar in B. Barr-Sharrar, and E. N. Borza (eds.), *Macedonia and Greece in Late Classical and Early Hellenistic Times* (Washington, D.C. 1982) 122–39.

M. T. Marabini Moevs, *Bollettino d' arte* 6 ser. 42 (1987) 1–36; also *ibid.* 12 (1981) 1–58; 22 (1983) 1–42. Hellenistic sources of motifs appearing on Arretine ware.

Note also:
A. Oliver, 'Glass lagynoi', *Journal of Glass Studies* 14 (1972) 17–22.

D. B. Thompson, *Ptolemaic Oinochoai and Portraits in Faience: Aspects of the Ruler-Cult* (Oxford 1973).

Major sites

G. R. Edwards, *Corinth* VII.3 (Princeton 1975). Discusses Corinthian products only.

J. Schäfer, *Hellenistische Keramik aus Pergamon* (Berlin 1968). Fundamental for the Pergamon series – but more material now available. Section on classic lagynoi.

P. M. Kenrick, *Excavations at Sidi Khrebish, Benghazi (Berenice)* III.1 (Tripoli 1985). A range of fine wares, eastern and western. Series of clay analyses.

F. O. Waagé, *Antioch-on-the Orontes* IV.1 (Princeton 1948) 1–31, Figs. 2–18, Pls. I–IV. The only source for Antioch.

Black-gloss wares
(See also site reports listed above.)

J.-P. Morel, *Mélanges de l'École Française de Rome* 81 (1969) 59–117. Fundamental for the origins of the Rome series.

J.-P. Morel, *Céramique campanienne: les formes* (Rome 1981). The first of three projected volumes on 'Campana' wares. Classification also comprises other (mostly Italian) wares. For interim statements, see the conference papers collected in *Archéologie en Languedoc* I (1978), especially Morel's survey, pp. 149–68.

J. W. Hayes, *Greek and Italian Black-gloss Wares and Related Wares in the Royal Ontario Museum* (Toronto 1984). A broad range of Classical and Hellenistic wares.

J.-P. Morel, *BCH* 110 (1986) 461–93. Campana wares from Delos.

Gnathia and related wares

J. R. Green, *Gnathia Pottery in the Akademisches Kunstmuseum, Bonn* (Mainz 1976) 1–16. Good survey of the ware and its derivatives.

J. R. Green in A. Cambitoglou (ed.), *Studies in Honour of A. D. Trendall* (Sydney 1979) 81–90, Pls. 20–2. Lists Gnathia vessels found in the eastern Mediterranean.

Relief bowls, etc.
(See also site reports listed above.)

S. I. Rotroff, *The Athenian Agora* XXII (*Hellenistic Pottery: Athenian and Imported Moldmade Bowls*) (Princeton 1982).

G. Siebert, *Recherches sur les ateliers de bols à reliefs du Péloponnèse à l'époque hellénistique* (Athens 1978).

A. Laumonier, *Délos* XXXI (*La Céramique hellénistique à reliefs. I. Ateliers 'ioniens'* (Paris 1977). The 'Ionian' series (formerly termed 'Delian').

M. T. Marabini Moevs, 'Italo-Megarian ware at Cosa', *Memoirs of the American Academy in Rome* 34 (1980) 161–227.

M.-O. Jentel, *CVA* Louvre 15 (1968) 3–16, Pls. 1–16. A good selection of complete bowls.

U. Sinn, *Die homerischen Becher. Hellenistische Reliefkeramik aus Makedonien* (Berlin 1979).

Painted funerary vases

TARENTINE

Reeder in E. D. Reeder (ed.), *Hellenistic Art in the Walters Art Gallery* (Baltimore 1988) 193–4.

CANOSAN

A. Rinuy et al., *Genava* N.S. 26 (1978) 141–69 (including technical studies).

P. J. Callaghan, *BSA* 76 (1981) 65–7. Offers a late terminal date.

F. van der Wielen-van Ommeren, in J. Swaddling (ed.), *Italian Iron Age Artefacts in the British Museum* (London 1986) 215–26.

CENTURIPE

U. Wintermeyer, *JdI* 90 (1975) 136–241.

Hadra vases and related wares

P. J. Callaghan, *BSA* 76 (1981) 35–58, Pls. 1–4; *id.*, *Bulletin of the Institute of Classical Studies* [London] 30 (1983) 31–9, Pl. 4; P. J. Callaghan and R. E. Jones, *BSA* 80 (1985) 1–17, Pls. 1–4. Cretan connections; clay analyses. A. Enklaar, *BABesch* 60 (1985) 106–51. On chronology and painters.

Braziers

C. Le Roy, 'Réchauds déliens', *BCH* 85 (1961) 474–500, Pls. XV–XVI; also G. Siebert in *Délos* XXVII 267–76, Pls. 50–2. A selection. Recent bibliography: J. A. Riley, in *Excavations at Sidi Khrebish, Benghazi (Berenice)* II (Tripoli 1979/82) 303–12.

9 GREEK VASES IN THE MARKETPLACE

There are few treatments in English which cover the whole range of topics discussed in this chapter. The topics tend to be treated more sporadically, often in less accessible periodicals. The subject of trade in the archaic and classical period is well treated by M. I. Finley in *The Ancient Economy* (London 1973), and by several authors in the volume of papers edited by P. Garnsey and others: *Trade in the Ancient Economy* (London 1983). R. M. Cook tackled aspects of rate of production in an article in German in *JdI* 74 (1959) 114–23. There is a good deal of relevance in Boardman, *The Greeks Overseas*[3], with very useful bibliographies, while the same author looked more closely at the distribution of Attic pots in *Expedition* (summer 1979) 33–9.

Amphorae are introduced by Virginia Grace in *Amphoras and the Ancient Wine Trade* (Excavations of the Athenian Agora, picture book 6, 1961), while a broad range of recent substantial contributions to the subject can be found in *Recherches sur les amphores grecques* (*BCH*, suppl. XIII, Paris and Athens 1986). Names and status are discussed by several authors, including the present one, in *Papers on the Amasis Painter and his World* (Malibu 1987). A line of argument concerning special commissions which is rather different from that followed above can be found in T. B. L. Webster, *Potter and Patron in Classical Athens* (London 1972).

Useful remarks on repaired vases can be found in D. von Bothmer's notes, *AJA* 76 (1972) 9–11, and here, p. 254. Trademarks are fully treated by the present writer in *Trademarks on Greek Vases* (Warminster 1979), and in summary in *Greece & Rome* 21 (1974) 138–52. Much of the scanty evidence for

prices of objects other than pots in the fifth century is gathered in an article by Pritchett in *Hesperia* 25 (1956) 178–317; for none do we have prices from two substantially different dates during the period. The only wreck of relevance fully published to date is that at El Sec: A. Arribas and others, *El Barco de El Sec* (Mallorca 1987) and *Revue d'Etudes Anciennes* 61 (1988) parts 3–4.

10 A CLOSER LOOK AT THE POTTER

Those who want to study Greek pottery from the points of view outlined in this chapter should read the following studies; and they would also be well advised to follow a practical course in potting and then maintain it as a hobby. It will give them some understanding of the difficulties of the craft and a proper appreciation of the technical problems which apparently caused no difficulties to the Attic potters, though in many cases we have not yet discovered how they solved them.

The works listed below are cited in the Notes by author's name alone.

J. D. Beazley, *Potter and Painter in Ancient Athens* (London 1946).

H. Bloesch, *Formen attischer Schalen* (Bern 1940).

Cook, *GPP*[2] Chapter 9 (technique).

R. Hampe and A. Winter, *Bei Töpfern und Töpferinnen in Kreta, Messenien und Zypern* (Mainz 1962).

R. Hampe and A. Winter, *Bei Töpfern und Zieglern in Süditalien, Sizilien und Griechenland* (Mainz 1965).

J. M. Hemelrijk, *Caeretan Hydriae* (Mainz 1984).

R. E. Jones, *Greek and Cypriot Pottery: A Review of Scientific Studies* (Athens 1986).

H. Lohmann, 'Zu technischen Besonderheiten apulischer Vasen', *JdI* 97 (1982) 191ff.

J. V. Noble, *The Techniques of Painted Attic Pottery*, rev. edn (London 1988).

W. Noll, 'Antike Keramik und ihre Dekoration in naturwissenschaftlicher Sicht', *Ancient Greek and Related Pottery* (1984) 42ff.

G. M. A. Richter, *The Craft of Athenian Pottery* (New Haven, Conn. 1923).

A. Rieth, *5000 Jahre Töpferscheibe* (Konstanz 1960).

I. Scheibler, *Griechische Töpferkunst* (Munich 1983).

W. Schiering, *Die griechischen Tongefässe* (Berlin 1983).

G. Seiterle, 'Die Zeichentechnik in der rotfigurigen Vasenmalerei', *Antike Welt* 7 (1976.2) 3ff.

G. Seiterle, 'Das Linierhaar des Andokides-Malers', in R. Pörtner and H. G. Niemeyer (eds.), *Die grossen Abenteuer der Archäologie* x (Salzburg 1987) 3659–66.

T. Seki, *Untersuchungen zum Verhältnis von Gefässform und Malerei attischer Schalen* (Berlin 1985).

A. Winter, *Die antike Glanztonkeramik* (Mainz 1978).

Some books on pottery for amateurs are:

J. Colbeck, *Pottery: The Technique of Throwing* (New York 1975).
G. Thomas, *Step by Step Guide to Pottery* (London 1973).
E. S. Woody, *Pottery on the Wheel* (London 1976).

Notes

1. Richter, p. 92.
2. Richter, pp. 97 and 102; Jones, pp. 151, 103.
3. Noble, Figs. 4–5.
4. Noble, Fig. 206.
5. Boardman, *Red Figure: Archaic*, Fig. 50.
6. Noble, pp. 118ff., Figs. 208–9 (small syringe); Winter, pp. 53ff. (sharp quill or reed filled with gloss-slip).
7. Scheibler, Fig. 68.
8. Noble, Fig. 6.
9. Rieth, Figs. 72–3.
10. For a reconstruction, see Scheibler, Fig. 91.
11. Noble, Figs. 231ff.
12. E.g. Noble, Fig. 102.
13. Noble, Figs. 7–64.
14. Compare Noble, Fig. 67.
15. V. Tosto, dissertation on Nikosthenes, forthcoming.
16. H. Euwe, *BABesch* 64 (1989) 114–33.
17. E.g. Hemelrijk, p. 96, compare Pls. 128–9 with 133; and *BABesch* 50(1) (1975) 30–2 (examples of vases by the Sabouroff Painter).
18. For templates see Hemelrijk, Pls. 146–7, pp. 88ff., 96ff., 105ff.
19. Noble, Fig. 206.
20. Noble, Figs. 178–80.
21. Noble, Figs. 254–5.
22. Hampe–Winter 1965, pp. 60–2, 198, 238; Noble, p. 175 (watertight with pitch); examples of remarkable repairs appear on Noble's colour plates xi–xii and Fig. 252.

Illustrations

Unless otherwise stated the following photographs were provided by the museums, institutions and collectors listed. The editors, authors and the publisher are grateful to all of them for supplying the photographs and for granting permission to publish them.

Frontispiece: *Photo*: DAI, Rome, Inst. neg. 1938.151.

1. Athens, Nat. Mus. 15375. From Athens. *ARV²* 447, 274.

2. Rome, Villa Giulia 50599. From Cerveteri. *ABV* 146, 20. *Photo*: Sopr. Arch. Etruria Meridionale.

3. London, BM D7. From Athens. *ARV²* 763, 3.

4. London, BM E215. From Nola. *ARV²* 1082.

5. London, BM E219. *ARV²* 1258.

6. Basel, Antikenmus. Kä 415. *ARV²* 868, 45. *Photo*: Claire Niggli.

7, 8. Toledo Mus. of Art 72.55. Gift of Edward Drummond Libbey.

9. Copenhagen, Nat. Mus. 153. From Nola. *ARV²* 1131, 161.

10. Agrigento, Mus. Arch. Naz. 8952 (formerly Palermo). From Gela. *ARV²* 599, 2. *Photo*: Hirmer.

11. Munich, Mus. Antiker Kleinkunst 2688. From Vulci. *ARV²* 879, 1. *Photo*: Hirmer.

12. Athens, Kerameikos 2140. From Geometric grave 42. *Photo*: DAI, Athens.

13. Athens, Agora P27646. From Areopagus grave H 16:6. *Photo*: American School of Classical Studies, Agora Excavation.

14. New York, Met Mus. 74.51.965. From Kourion, Cyprus.

15. Heraklion. From Knossos, Teke tomb E.

16. Paris, Louvre A517. From Athens, Dipylon cemetery. *Photo*: Chuzeville.

275

Index